Introduction to

Managing Digital Assets
Options for Cultural
and Educational Organizations

Diane M. Zorich

Getty Information Institute

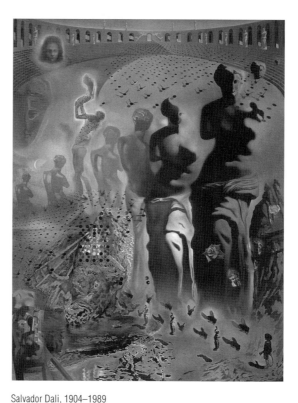

Cover image: Salvador Dali, 1904–1989
The Hallucinogenic Toreador, 1969–70. Oil on canvas, 118 × 157 inches
Salvador Dali Museum, St. Petersburg, Florida

© 1999 The J. Paul Getty Trust
except Chapter 10, Section B
© 1999 Canadian Heritage
Information Network
Printed in the United States of
America

Design by Hespenheide Design

Library of Congress Cataloging-in-
Publication Data
Zorich, Diane.
Managing digital assets : options for
 cultural and educational organiza-
 tions / Diane M. Zorich.
 p. cm.
 Includes bibliographical
 references.

ISBN 0-89236-546-3
(alk. paper)
 1. Intellectual property—United
States. 2. Associations, institutions,
etc.—Law and legislation—United
States. 3. United States—Cultural
policy. I. Title.
KF2979.Z67 1998
346.7304'8--dc21
 98-36300
 CIP

Contents

Foreword

Digital networks offer unprecedented opportunities to preserve and promote the world's cultural patrimony. The Getty Information Institute encourages those who are responsible for preserving the cultural heritage to take advantage of these opportunities by collaborating to build a cultural information infrastructure. Through its advocacy and education programs, the Institute cultivates worldwide awareness of global information infrastructure issues, and addresses barriers that impede universal access to cultural heritage information.

Foremost among these barriers are intellectual property rights. As custodians and consumers of vast amounts of intellectual property, cultural heritage organizations are understandably concerned about the challenges that digital networks present in rights administration and content distribution. These networks, characterized by speed, ubiquity, and ease of reproduction, can thwart cultural institutions' efforts to manage their content effectively.

New management and distribution services are arising in response to these challenges. Traditional rights and reproduction practices are yielding to a variety of forms of collective administration, such as consortia, cooperatives, and other intermediary service organizations. The result is a confusing array of choices. Cultural institutions, which have minimal experience with collective administration of rights and content, are uncertain about what strategies to pursue, and which partners to select, for managing their intellectual property in electronic environments.

To assist cultural heritage organizations in surmounting the barriers that rights administration poses for them on digital networks, the Getty Information Institute commissioned this report on current and emerging options for managing intellectual property, particularly in networked environments. The report reviews traditions of rights administration and content distribution across genres, and offers a generic and thematic assessment of issues an institution should consider when

developing intellectual property management strategies and selecting partners to assist in those strategies.

As cultural materials are digitized and made available on worldwide networks, intellectual property issues assume greater importance for reasons of authenticity, appropriation, and economics. Cultural heritage organizations must take the lead in selecting the mechanisms for administering their intellectual property on these networks, thereby ensuring that the cultural heritage is made accessible for public enjoyment, education, and scholarly endeavors under terms and conditions that do not compromise their mission and purpose.

Eleanor E. Fink
Director
The Getty Information Institute

Acknowledgments

The author extends her thanks to the following individuals who offered advice, assistance, or information at various stages of this project.

Rachel Allen
National Museum of American Art, Smithsonian Institution

Nathan Benn
Consultant

J. Scott Bentley
Image Directory, Academic Press

Howard Besser
University of California at Berkeley

Nancy Bryan
The Getty Information Institute

Joanne Calfee
Picture Network International

Mary Case
Association of Research Libraries

Ben Davis
The Getty Information Institute

Jeannette Dixon
The Museum of Fine Arts, Houston

Margaret Drum
The Harry Fox Agency, Inc.

Theodore Feder
Artists Rights Society

Eleanor Fink
The Getty Information Institute

Lori Franklin
The Bridgeman Art Library

David Green
National Initiative for a Networked Cultural Heritage

Peter B. Hirtle
Kroch Library, Cornell University

Lauren Kafka
Corbis Corporation

Janice Kash
The Getty Information Institute

Terry King
The Authors Registry

Sal Landicina
Motion Picture Licensing
Corporation

Melissa Smith Levine
National Digital Library Project
Library of Congress

Wendy Lougee
University of Michigan Library

Clifford Lynch
Coalition for Networked
Information

Patricia McClung
Digital Collaboration Associates

Kathleen McDonnell
The Getty Information Institute

Irvin Muchnick
Publication Rights Clearinghouse
(of the National Writers Union)

Lewis Orr
The Bridgeman Art Library

Rina Elster Pantalony
Canadian Heritage Information
Network

Robert Panzer
Visual Artists and Galleries
Association

Susan Parkinson-Wiberg
The Getty Information Institute

Cheryl Redmond
Copyright Clearance Center

Barbara Rottenberg
Canadian Heritage Information
Network

Geoffrey Samuels
Museum Digital Library Collection

Ellen Sauer
Project Muse

Lyn Eliot Sherwood
Canadian Heritage Information
Network

Jane Sledge
The Getty Information Institute

Christine Steiner
The J. Paul Getty Trust

Christie Stephenson
Bobst Library, New York
University

Sarah Sully
Journal Storage (JSTOR)

Christine Sundt
Architecture and Allied Arts
Library, University of Oregon

Barry Szczesny
American Association of Museums

Patricia Williams
American Association of Museums

Richard Weisgrau
Media Photographers Copyright
Association

Holly Witchey
San Diego Museum of Art

Robert C. Yamashita
California State University,
San Marcos

**Participants in the Museum
Educational Site Licensing
Project (MESL)**

Executive Summary

Intellectual property rights are a major barrier for cultural heritage organizations that wish to place their content on digital networks. Problems are rooted in the technology as well as the inability of cultural organizations to administer and distribute intellectual property effectively in this environment. A number of new management and distribution services have emerged in response, and some existing organizations have assumed new roles. Collectively referred to as intellectual property management service providers, these organizations serve as facilitators between rightsholders and users in the administration, organization, and distribution of intellectual property.

Intellectual property management service providers will be playing a larger role in the intellectual property management strategy of cultural organizations. Unlike other creative sectors, however, the cultural heritage community has little experience with these service providers, and few guidelines for reviewing their operations. This report seeks to redress this situation by reviewing the traditions of rights administration and content distribution in various creative sectors, identifying common structures and functions of these organizations, clarifying aspects of the service provider/rightsholder/user relationship, and highlighting issues of particular relevance to the cultural community and their frequent partners in the educational community.

The information in this report, based on a strategic analysis of U.S. organizations that administer intellectual property across various genres, is synthesized and assessed broadly by themes that are relevant to the entire cultural community. Included as Appendix D to this report is a questionnaire developed for use by cultural heritage institutions that wish to consider partnering with individual intellectual property management organizations.

1. Introduction

Cultural and educational institutions are veritable warehouses of **intellectual property**.* From the research conducted in their laboratories, to the works placed on their shelves, cultural and educational institutions are arguably the trustees of the largest and most diverse assortment of intellectual properties in existence. Among the intellectual properties in their care are works of art, photographs, manuscripts, books, films, videos, and sound recordings. Equally important are exhibitions, educational and interpretive materials and programs, databases, Web sites, multimedia kiosks, catalogs, and other creative works produced by these organizations.

Until recently, in cultural and educational institutions intellectual property was fairly well defined by communities and types of use. With the development of technologies that allow for digital display, distribution, and replication, both uses and **users** are changing rapidly, forcing cultural and educational organizations to reexamine nearly all aspects of their policies governing intellectual property.

Included in this reexamination is the role of electronic networks in intellectual property management. Cultural and educational organizations recognize that their current systems for administering intellectual property cannot meet the needs of, and demands imposed by, digital media and network distribution. In response, these communities are reviewing their current strategies for administering intellectual property and are exploring new opportunities emerging in other arenas. Among the latter are intellectual property management organizations,† which play an intermediary role between **rightsholders** and **users** in the organization,

* Words or phrases that appear in boldface type in the text are defined in the glossary.

† The terms "intellectual property management organization" or "intellectual property service provider" are used interchangeably throughout this report to refer to organizations that offer services for distributing and managing intellectual property. Included in these terms are performance rights societies, publishers, collecting societies, rights and reproduction organizations, information brokers, collectives, consortia, and proof of concept projects. Categorizing this diverse cluster under one rubric is a compromise solution chosen for ease of reference within the text.

administration, and distribution of content on electronic networks. What services can these organizations offer to cultural and educational institutions? And how do cultural and educational institutions determine which, if any, of these organizations may be suitable for their intellectual property management needs? The options are diverse and the assortment of opportunities and players confusing.

A. Project History and Genesis

This report examines issues associated with administering intellectual property over electronic networks, the effect these issues have on cultural heritage institutions, and the organizations developing to address these issues. The report originates in recommendations made by participants in the Museum Educational Site Licensing Project (MESL).[1] The MESL project was an exploratory effort sponsored by the Getty Information Institute[2] and MUSE Educational Media[3] to distribute museum images over electronic networks for use in teaching and research in higher education. Seven museums and seven universities were selected through a competitive Request For Proposal (RFP) process to participate in this experiment and analyze the results.[4]

Midway through the project, participants expressed interest in a profile of the options for rights administration, intellectual property management, and the distribution of digital information. They noted that cultural and educational institutions struggling with ways to manage their content on electronic networks needed such a profile to make informed choices. The MESL participants had identified their own intellectual property issues for licensing terms and conditions[5] and wanted an independent review of structures already in use (or in development) for various types of content in various industries. In 1997, the Getty Information Institute agreed to fund a study separate and independent from MESL to examine these issues and to distribute the results to the broader cultural heritage community. This report reviews the findings of that study in the context of cultural heritage organizations and intellectual property laws in the United States.

B. Goals and Assumptions

This report is a reference resource for cultural and educational organizations that are examining various service providers as possible partners in the administration of their intellectual property. To bring greater understanding and a wider context to the topic, the report explores issues of administering and distributing intellectual property over electronic networks and examines how they resonate in cultural heritage organizations. The current ways of managing intellectual property distribution, such as

using professional and commercial organizations to administer content, or in-house rights and reproductions departments, are described both theoretically and practically to underscore the risks and rewards inherent in the various choices. To inform this work, several dozen intellectual property management organizations were reviewed; aspects of their structure, function, and operations are summarized in the latter half of this report.

Because intellectual service providers vary in the types of rights they administer, an important assumption of this study is that content owners and content users will have to employ several options to meet their different needs and purposes. Conceivably, an institution may wish to participate in a rightsholders' collective, contract with a **stock photography agency**, maintain its own in-house **rights and reproductions department**, turn over distribution of its intellectual property to a third-party **content broker**, or choose any number of combinations and permutations that are possible. Because many options are available, and new ones are emerging rapidly, cultural and educational institutions will have innumerable choices that can "work" for them in different contexts. Consequently, the report does not endorse or recommend a particular approach, model, or intellectual property management organization. By outlining the current options for managing and distributing intellectual property, the goal is to help the reader better understand the issues, questions, and steps that must be considered when selecting any one option over another.

Because this report is intended as a practical introductory document for an audience of cultural heritage professionals, it does not address details of copyright law, technology, or terms and conditions of licenses. (Readers are referred to the bibliography for references on these topics.) Nor does it offer a "Consumer Reports™" type of comparison of services or service providers. As useful as such an analysis would be, there are several reasons that this approach was not employed. First, the field of intellectual property management is extremely dynamic. New options emerge continually in this area: Even the more established providers constantly retool their services to accommodate new technologies, new markets, and new rightsholders. Any comparisons made during a review process would be out of date by the time of publication. (Approximately half of the intellectual property rights management service providers reviewed as background for this report significantly altered or expanded their service offerings, markets, licenses, and pricing structures at least once during the research phase of this study, May through August 1997.) Second, intellectual property management is a service industry, and services—especially the rapidly evolving ones that characterize this industry—are difficult to compare on an equitable, objective, and replicable basis yielding meaningful results. But the primary reason that individual providers and organizations are not compared directly is philosophical: The selection of one type

of intellectual property management strategy over another is a highly individualized choice that depends on the nature, goals, and objectives of each institution. There is no "one size fits all." Comparisons of various providers are useful only when undertaken by each institution, based upon a strategic analysis of its own needs, preferences, and resources.

The report is divided into several thematic chapters. Chapter 2 provides a brief background on intellectual property, the history of copyright, the nature and complexity of rights in an electronic environment, and a description of the two primary ways intellectual property is administered (i.e., direct and collective administration). Chapter 3 focuses on key issues in distributing intellectual property over digital networks, chronicling the role of these networks as new mechanisms for access, and identifying specific issues that affect cultural and educational institutions in this environment. Chapter 4 summarizes the ways intellectual property is currently administered in cultural organizations. Chapters 5 through 8 present a generalized analysis of the structure, function, and operations of intellectual property service providers, their management of content and usage, rightsholder and user issues, and economic considerations. These chapters are based on a review of more than thirty U.S. organizations representing several intellectual property genres (the methodology employed in this review is outlined in Appendix A). A summary of the issues, trends, and continuing challenges in the area of intellectual property management is presented in Chapter 9. Chapter 10, written by Rina Elster Pantalony, a Senior Policy Advisor for the Canadian Heritage Information Network, highlights some of the report's issues from the perspective of the Canadian cultural community and illustrates how differences in the copyright law and in traditions of intellectual property management between nations affects the structure and function of service providers and their offerings.

Accompanying this report is a series of appendices providing background or reference information such as the methodology employed in the review of intellectual property management organizations (Appendix A), names and contact information of the organizations examined for the latter half of this study (Appendix B), questions used in the review (Appendix C); a list of acronyms; a glossary; and a topical bibliography of books, articles, and Web sites for those who wish to investigate various issues in more detail.

An important accompaniment to this report is the "Questionnaire for Reviewing Intellectual Property Management Service Providers" in Appendix D. Readers are encouraged to use this questionnaire as a data-gathering instrument when conducting their own review of intellectual property management organizations. It converts the issues discussed in this report into practical inquiries, and may be used as one component in a formal institutional review that includes an analysis of institutional

needs, formal and informal discussions with various providers, and advice from legal counsel.

Notes

[1] The Getty Information Institute, the Museum Educational Site Licensing Project [http://www.gii.getty.edu/mesl/home.html#WG] (1997).

[2] The Getty Information Institute [http://www.gii.getty.edu] (June 1998).

[3] MUSE Educational Media, c/o Geoffrey Samuels, 530 Park Avenue, New York, NY 10021. Telephone: 212/980-5720; Fax: 212/980-2093.

[4] The institutions that participated in the MESL project were the Fowler Museum of Cultural History, the George Eastman House, the Harvard University Art Museums, the Library of Congress, the Museum of Fine Arts, Houston, the National Gallery of Art, the National Museum of American Art, American University, Columbia University, Cornell University, University of Illinois at Urbana–Champaign, University of Maryland, University of Michigan, University of Virginia.

[5] See Christie Stephenson and Patricia McClung, eds. *Delivering Digital Images: Cultural Heritage Resources for Education* (Los Angeles: Getty Information Institute, 1998).

2. What Are Intellectual Property Rights?

A. Intellectual Property Rights in the United States

Intellectual property rights are social and legal ownership rights conveyed to the creators of works that exist in tangible forms. These rights evolve from many sources, of which national laws on the use of artistic, literary, and cultural works are perhaps the most commonly cited. International treaties and conventions also add to the development of intellectual property rights concepts. Case law, the body of legal decisions made by courts and tribunals in private disputes, plays an important role in the articulation of intellectual property rights because it interprets laws and regulations within a practical legal framework. Legal doctrines such as "fair use" represent policy principles on certain questions of law, and their tenets are respected and considered in legal interpretations of intellectual property rights. No less important are customs and traditions of use, which contribute to the form and substance of intellectual property rights within a profession.[1]

Intellectual property rights are codified from country to country in laws that vary in type, interpretation, and use. Efforts have been under way for a long time to harmonize these various rights across countries and legal systems via treaties (e.g., the **Berne Convention** and **Universal Copyright Convention**)[2] and organizations (e.g., **World Intellectual Property Organization** [WIPO]).[3] As more intellectual property is distributed on electronic networks, these efforts will become increasingly important, since it will be difficult to enforce the laws of individual nations when information freely and continually crosses geographic boundaries.

In the United States, intellectual property rights fall within the purview of three separate legal regimes: **trademark**, **patent**, and **copyright**. Many organizations possess intellectual property that falls under all three. For example, Apple Computer, Inc.™ owns the trademark on its name and logo, the patent to many of the inventions used in its products, and the copyright to the software it has created to run on its computers.

Educational institutions, with their research emphasis, tend to have intellectual property that spans all three regimes. In cultural heritage organizations, most intellectual property falls within the copyright or trademark regimes.

Trademark confers a protection for words, short phrases, names, symbols, and other devices that identify and distinguish goods and services. It signals a "flag of recognition in the marketplace . . . a source of a product or service, an indication of quality, or an association with a person, company or institution."[4] McDonald's™, Coca Cola™, and Disney™ all have trademarks on their names and their distinctive corporate logos. A patent is a form of protection for an invention that excludes others from making, using, or selling the invention without permission. For a patent to be granted, the invention must be new, not obvious, and useful. Patents have been granted for items as variable as machines, software features, and genetically engineered mice. Copyright is a protection for "original works of authorship" including literary, dramatic, musical, artistic, and certain other intellectual works fixed in a tangible medium of expression. Ideas, concepts, procedures, and processes cannot be copyrighted until they are converted from a mental construct to a physical form. In other words, copyright vests in the form that conveys a thought, not in the thought conveyed.[5]

Because copyright is the intellectual property regime that cultural organizations most frequently encounter, it is the regime referred to in the remainder of this report. Trademark and patent address a different set of intellectual property rights, and merit separate and specialized consideration outside the scope of this report.

The primary objective of copyright in the United States is to "promote the progress of Science and the Useful Arts."[6] However, current debates and challenges increasingly emphasize economic aspects, which obscure the Enlightenment values from which copyright emerged in the United States more than two hundred years ago. These values fostered the nurturing and distributing of ideas that would serve as the impetus for new creative pursuits. Copyright was perceived as a balance of rights between creators' needs for an economic return on their efforts and society's need for a free exchange of ideas to ensure the production of more creative efforts. The economic aspect was simply an incentive to promote continued creative works, and was envisioned as only one part of the equation.

Today, much of the dialogue about copyright in the United States emphasizes the economic rights of creators, recognizing that they will have little incentive to create if they will not be remunerated for their work. This peculiarly American view of copyright has been termed a "cultural bargain" based on a "conviction that encouraging individual creativity by personal gain is the best way to advance the public welfare."[7] Thus

creators are given a finite monopoly on their works as an incentive or encouragement to produce and make available more creative works that can be used for the public good. In other countries, the underlying emphasis of the legal code for copyright is the natural or "**moral rights**" of the creator—those rights that guard the integrity and association of works and their creators more than their economic interests.

Under current U.S. copyright law, a creator of a work is given **exclusive rights**, for a limited period of time,[8] to reproduce the work in any form, create derivative works based on the work, distribute copies of the work, perform the work, or display the work in public. Copyright is endowed from the moment a work exists in a fixed or tangible form of expression (e.g., in a publication, work of art, a performance, a recording, etc.), whether the creator registers it with the U.S. Copyright Office or not.

Copyright is granted to the creator of a work; it is a right that exists separately from the work itself. Thus ownership of a work does not include copyright, unless the creator has explicitly transferred the copyright, in writing, with the transfer of ownership.[9] This distinction is important, particularly for cultural and educational institutions. The role an institution can play in managing the intellectual property in its care is determined by whether it owns the work, owns the copyright to the work, or serves as custodian of works whose copyright and ownership belong to others.

Some of the rights associated with ownership of intellectual property include the right to sell, transfer, or dispose of it, as well as the right to display it where it is located. Those who own the copyright on intellectual property have the right to reproduce it, to distribute it to the public, to perform it publicly, to display it publicly, and to create **derivative works** from it. Institutions that own intellectual property, but do not own its copyright, can assert their ownership rights but cannot assert the rights of copyright ownership. Conversely, institutions that own copyright to intellectual property, but do not own the intellectual property itself, can assert the rights of copyright but not the rights of ownership. Those institutions that serve as custodians for intellectual property whose copyright and ownership belong to others can assert neither set of rights. These latter institutions are highly constrained in how they use and manage the works in their care, and can do little more than store and safeguard the intellectual property unless they seek permission from owners and/or copyright owners.

For the vast majority of cultural heritage materials, copyright resides with the creators of works or their estates, has never existed, or has expired and the works are in the **public domain**. With works in the public domain, owners or caretakers cannot assert copyright ownership, but they may have access policies that effectively restrict or hinder the use of the

materials in their care. Museums, for example, often prohibit photography in their galleries, or limit research access to bona fide scholars only. As owners or legal caretakers of these materials, they are within their rights to do so, unless other obligations (such as federal funding, donor conditions, etc.) prohibit them.

U.S. copyright law has recently been expanded to include rights of integrity and rights of attribution for certain works of visual art. The right of attribution allows artists to claim authorship of their works and to have their names used in conjunction with a display. It also allows them to prevent the use of their names on a work that was not created by them, or to have their names removed from their work if it has been mutilated or distorted. The right of artistic integrity prevents any intentional distortion or modification of a work that is prejudicial to the honor or reputation of the artist.[10]

Several exemptions to copyright exist under the U.S. legal code. The most well known of these is the doctrine of "fair use." This exemption allows for the use of copyrighted materials, without permission of the creator or copyright owner, in a limited number of contexts and for certain purposes, including "criticism, commentary, news reporting, teaching. . . , scholarship or research. . . ."[11] In determining whether a use falls within this exemption, a series of criteria, popularly called the "four factors," identified in copyright law are to be applied when determining whether a particular use is a fair use. These factors, and a brief explanation of the issues embedded within them, are:

- **The purpose or character of the use**
 What is the work being used for, and who is using it? Teaching and research uses are more likely to be considered fair use than is a commercial endeavor. Works that are "transformed" in their use rather than merely reproduced are also more likely to be favored as fair use.
- **The nature of the copyrighted work**
 What forms or attributes are unique to the work, and how does this uniqueness come into play as it is used? Is the work original, a compilation, or a derivative work? Factual compilations are more likely be seen as fair use than are fictional works.
- **The amount and substantiality of the portion of the work used in relation to the copyrighted work as a whole**
 How much of the work is being used, and is this portion the most substantive segment of the work? Is a single chapter from a book being used, or the entire book? If a chapter, is it the "heart" of the entire book? Fair use is more likely to be accorded for modest portions that are used rather than complete or nearly

complete works. This interpretation is problematic for images, which by their nature do not lend themselves to be used in "portions" or "segments."

- **The effect of the use on the market for the work**
 Will the use interfere with the present or potential ability of the creator or copyright owner to make a living from the work? This factor requires some predictions or assumptions about the potential market for a work or the economic value of the work.

Fair use is a highly interpretive concept, and the simplistic description outlined here is intended only as a summary. Actual rulings are much more complex.[12] The scope of fair use has been argued both broadly and narrowly by various constituencies because the doctrine, although codified in the law, is not specifically defined. Thus proposed instances of fair use always require a case-by-case analysis.

The fair use exemption is generating resurgent controversy as the impact of copyright in the digital world is debated anew. In 1994, the Conference on Fair Use (CONFU) was created as part of the Clinton Administration's efforts to identify and debate intellectual property rights issues in the digital arena.[13] Before it concluded, CONFU issued a series of guidelines on fair use that were highly debated, and that many U.S. cultural and educational communities refused to endorse.[14] Despite its failure to result in agreed-upon guidelines for fair use, CONFU did provide the catalyst for a continuing series of discussions and examinations that have increased awareness of fair use issues among the cultural and educational communities.[15]

B. A Brief History of Copyright

Copyright has changed and adapted to political, economic, social, and technological circumstances throughout its history. Our present notion of copyright evolved from political circumstances and a history of legal rulings rather than any rational sense of guiding principles.[16] The initial concept of copyright, which emerged in the fifteenth century, bears very little resemblance to copyright as we conceive of it today. In its earliest manifestations, copyright was granted mostly to publishers and was perceived as a publisher's right, with no concern for author or creator.

Copyright in the United States has its origins in English statutes dating to 1709 ("the Statute of Anne") and from precepts set as far back as the sixteenth century.[17] In England during this time, censorship and control of the press were primary concerns of the monarchy (especially during the reigns of Henry VIII, Edward VI, and Mary Stuart), who wished to prevent religious and political sedition being printed. Royal charters were

granted to the publishing guild, giving them a monopoly in return for cooperation in controlling the press. Copyright effectively functioned as a device for maintaining order and monopoly among the book trade. It was fostered in this form for more than 150 years without any legal interference because it served the purposes of various governments. Thus copyright emerged as an instrument for controlling ideas rather than helping to proliferate them.[18]

The demise of censorship in England eventually led to a series of changes that slowly transformed the concept of copyright from a publisher's to a creator's right.[19] By the time the United States was emerging as a nation, this transfer was complete. Copyright was perceived as such an important concept that it was the subject of legislation from nearly the beginning of U.S. legal history.

Although the development of copyright, and the body of law that codifies it, has been framed by political and historical circumstances, the key driver throughout its history has been technology. The invention of the printing press in the 1400s begat an era of mechanical reproduction that, with inventions such as photography, the phonograph, radio, television, photocopiers, computers, and electronic networks, continues to this day. These technologies make it possible to reproduce cheaply, rapidly, and in great quantities original works that people can distribute and profit from without concern for uses or compensation.

Historically there has been a "lag time" between the creation and use of a technology, and the appearance of laws protecting newly perceived threats generated by the technology. The first copyright laws, for example, emerged in England nearly two and one half centuries *after* the invention of the printing press, when a healthy production and trade in books had already developed and practices (monopolies) emerged that were seen by society as detrimental to the public good.[20] This lag time has diminished significantly with successive technologies. The debates and legislative discussions about the effect of electronic networks on copyright law have emerged only twenty years after the development of these networks, and only two or three years after the development of the World Wide Web, which made these networks more publicly accessible.

Understanding the historical context of copyright is useful for those concerned about present-day challenges to the copyright regime. The digital era is simply the latest in a long series of challenges that have shaped and formed the concept of copyright. Technology-induced disruptions have threatened its balance of rights in the past, and solutions of one sort or another have been found.[21] Many of the issues arising from the role of copyright in an electronic environment are based on the concern that the "balance" is being disrupted and "corrections" are needed to bring it into line once again.

C. The Nature of Rights in Copyright

Copyright bestows what is commonly referred to as a "bundle" of privileges and rights on creators for exclusive use of their creations. This "bundle" can be reserved ("all rights reserved") or transferred in its entirety, or it can be divided, conferred, or restricted individually or in groups, depending on circumstances and inclination.

A creator can divide rights in myriad ways according to a seemingly endless "divisibility principle."[22] Among the more common ways to divide rights is by chronology (e.g., "right to publish until the year 2000"), geography (e.g., "North American rights"), and media (e.g., "motion picture rights"). Certain sectors also have subsidiary rights specific to their industries. Book publishing, for example, usually separates hardback, paperback, and serialization rights, and U.S. and international publication rights.

Rights are conveyed under **exclusive** or **nonexclusive** terms. Rights conveyed nonexclusively can be conveyed (usually by license) to any number of individuals or entities any number of times. Nonexclusive terms are preferred by rightsholders in licensing agreements because they keep the rightsholders' options open for further economic exploitation of their rights. An exclusive right is a right or set of rights conveyed to a particular user to the exclusion of all others. Commercial users often desire exclusive rights because it gives them a market advantage (none of their competitors can use the intellectual property) as well as a unique identity in the marketplace (no other commercial users will have the intellectual property). In reality, exclusive rights can yield satisfactory results for both rightsholders and users if conveyed in a very narrow and well-defined context.[23]

While copyright law is a framework for protecting creators' rights to the use of their work, it operates in a broader framework of overlapping rights guaranteed within the U.S. Constitution and the laws of individual states. The right to privacy is one example. Although the scope of this right varies from state to state, in general individuals can expect that their privacy is protected as long as they do nothing illegal. The intersection of this right with copyright occurs most frequently in photography or films that depict people. A photographer who shoots a scene that includes children certainly owns the copyright to the image, but cannot publish it (one of the rights conferred to him or her by copyright) without securing permissions from the legal guardians of those children. Among cultural organizations, privacy issues arise most frequently in archival repositories that contain manuscripts, photographs, and other holdings that portray known individuals. While a repository may hold copyright to these materials, their use in certain circumstances may violate privacy laws unless permission is obtained from the individuals portrayed.

Another right that intersects with copyright is the right of publicity, which acknowledges the potential economic and social value inherent in one's name, appearance, and other aspects of one's persona. In most states, laws exist that allow people to control this value during their lifetime, and (in some states) allows their heirs to control it after their death. This is why advertisers must pay celebrities for the use of their name or image in connection with a product ("endorsements") and why, in an economic sense, Elvis lives through the income his estate generates by licensing the use of his image and name. Among cultural organizations, the publicity right is likely to arise when images or other aspects of a celebrity's persona are used for commercial ends such as in merchandising.[24]

D. The Complexity of Rights in an Electronic Environment

Managing the "bundle" of rights for a creative work becomes increasingly complex in an electronic environment. The primary problem is the sheer quantity of rights that must be administered. Web sites, for example, contain text, audio, design elements, and still and moving images that appear inextricably bound together on the site, but each may arise from separate sources with separate copyright interests. To legally use these works on the site, the site's creator must identify and clear the copyright for each source. Creators of multimedia works struggle with this issue continually. Multimedia works are created from a series of separate "products" protected by copyright (images, text, audio, software programs), as well as materials that are not protected by copyright (background noises, public domain works), all assembled in a way that itself forms a new, and separately copyrightable, creative work.

The complexity inherent in various kinds of intellectual property adds to the confusion. Images, for example, can have extremely intricate layers of rights that make their digital distribution legally complicated. Multiple copies or "generations" of an image can be developed, with different rights emerging at each step in the process.[25] For example, use of a digital image may involve rights clearance with a publisher, the original photographer, one or more copy photographers, and the creator of the work portrayed in the image. Even documentary photographs of works in the public domain may have layers of rights associated with them.[26] The complex and often futile task of securing rights through all the derivative forms of a particular intellectual property has been likened to "tagging migratory animals."[27]

The worldwide scope of electronic networks adds international copyright law, and the laws of individual nations, to the equation. Materials distributed over electronic networks will not have a geographically restricted

audience. The administration of foreign rights will need to be considered anew. How will they be implemented, monitored, and enforced?

The various traditions for managing intellectual property add another layer of complexity to rights management in an electronic environment. The music industry issues **blanket licenses** that give users access to all works in a **repertoire** for one fee. Stock photography agencies **license** their images individually for one-time use in very specific contexts. Software has been licensed by individual computer, or by licenses based on specifically defined network parameters. Since most uses of intellectual property in an electronic environment involve content from multiple sectors, conforming to and managing all the variations in licensing traditions is an enormous undertaking.

E. Current Rights Management Methods

Logistically, it can be difficult for copyright owners to enforce their individual rights because the costs of doing so are often greater than any potential gain. For every children's movie that generates a multibillion-dollar product line, there are thousands of creators whose works are being used in small contexts that yield only a few cents per use. These **small rights**, or rights for which the cost of administration is large relative to their value,[28] are prevalent in many industries and fields, and make administering, managing, and enforcing intellectual property rights a complicated task that traditionally has been undertaken in one of two ways: by direct or by collective administration.

Direct Administration

A rightsholder can manage his or her intellectual property by administering it directly. In these circumstances, user requests are made to the rightsholder, who responds to them individually. This method gives the rightsholder complete control over the use and circulation of the work, and 100 percent of the royalties or use fees that may result.

But direct administration places substantial burdens on the rightsholder. Negotiating every license individually is time-consuming. Monitoring infringement requires experience and incurs legal costs. Negotiating international use agreements requires knowledge of international copyright and contract laws. A large number of licenses must be negotiated to make direct licensing of small rights economically worthwhile, but administering large volumes of licenses, each with potentially different terms and conditions, is a difficult undertaking.

Direct administration is also cumbersome for users. Identifying and locating the rightsholder, negotiating individual rights and uses, and

managing and administering the rights that are granted can be a difficult task, exacerbated if many rights are being sought from many different rightsholders (as is the case with multimedia products). The onerous nature of this process can be a powerful disincentive for users, who may respond by 1) abandoning their projects, 2) excluding from their projects works by creators who cannot be identified or located, or who will not negotiate acceptable terms, or 3) using works without permission, taking a calculated risk that the rightsholder will not pursue legal action because the resources required to do so are too great to justify the return.

Of course, none of these scenarios is desirable. Abandoning a project because of difficulty with procuring rights runs counter to copyright's philosophical intent to foster creativity. Excluding content from a project because one cannot locate its rightsholders foils the economic opportunity that copyright offers to rightsholders. Committing a deliberate infringement is perhaps the least desirable outcome for rightsholders. Often when a work is appropriated without the rightsholders' permission, the rightsholders find themselves without a realistic chance of seeking restitution because the cost of doing so exceeds their means.

Direct administration is usually undertaken by large corporations with sufficient resources to establish legal, marketing, and distribution channels dedicated to overseeing licensing transactions. The software industry licenses its intellectual property in this fashion, with individual software corporations establishing their own in-house licensing bureaus. It is rarely economically viable for individuals to administer their intellectual property directly, especially for small rights, because the time and effort far exceeds the income generated and the distribution that can be achieved. Of late, some individuals (particularly those in the graphic arts) are using electronic networks to facilitate the direct administration of their works. While electronic networks can expand distribution, they do not address the other key limitations of direct administration: the current inability to monitor uses, to negotiate a high volume of individual agreements efficiently, to administer charges and payments effectively, and to ease the burden on users to locate and negotiate properties from many different rightsholders.

Collective Administration

Groups of rightsholders often join or form an organization that centralizes the administration of their intellectual property and, in some cases, the distribution of their copyrighted works. The interests of the rightsholders are collectively represented by these organizations, which usually market the works, license their uses, collect fees, distribute royalties back to the rightsholders, and monitor infringements on their behalf.

The benefits of collective administration far exceed the disadvantages for individual rightsholders whose work generates income primarily from small rights like radio airplay for music, versus **grand rights**, like those vested in a Broadway show. Collective administration introduces economies of scale (e.g., lower transaction costs, more effective marketing efforts, greater capacity to handle large volumes of requests, etc.) that foster increased use of copyrighted works while minimizing the burdens on the rightsholder. By pooling assets from various rightsholders, it also enhances the economic value of those assets in the marketplace. However, collective administration provides these benefits only if there is a high volume and turnover of use for the members' works.

Another important benefit of collective administration is the ability to pursue international markets and negotiate international rights agreements for members' works. Most organizations do this by entering into reciprocal agreements with "sister" organizations in other countries. Reciprocity arrangements minimize the need to navigate the myriad copyright laws of various nations while giving members of the collective access to international markets. The "terms" of reciprocal agreements vary, but often include the very services that the collective offers its members in its own nation.

Collective administration also provides more efficient services for intellectual property users by providing a single point of contact for all of their rights needs. Users can locate both rightsholders and content at one location instead of searching across vast and disparate resources. When a user identifies the appropriate content or rightsholder, the collective assists him or her in obtaining rights by negotiating and administering license agreements. Collective administration offers users more predictable terms and conditions, as well as more consistent pricing structures than they would otherwise encounter in multiple direct licensing transactions. For organizations that distribute content as well as manage rights, such as stock photography or graphic arts agencies, collective administration offers more efficient distribution mechanisms so content can be disseminated to users quickly.

In addition to its economic and management role, collective administration has important social functions. It offers a source of legal advice to members and social advocacy for their efforts. By representing and promoting certain intellectual properties, it helps establish the importance and legitimacy of this work in society. This social aspect is particularly important for those in arts and humanities disciplines, who rarely possess the social and economic clout that influences society in its regard and compensation for creative endeavors.

To provide all these benefits, collective administration imposes many compromises on rightsholders. It requires them to relinquish some

individual power and control over their works to a collective body in return for better management of those works. Individual rightsholder compensation will be less than with direct administration because the collective must use some of the revenues to cover its overhead costs. (These losses may be offset by decreased administrative costs and increased usage and larger royalty figures resulting from the collective's superior marketing capabilities.) Finally, the collective must operate in the best interests of all of its members, which may not always be the best interests of a particular member. For these reasons, collective administration has been called the most effective overall method for administering intellectual property rights, but not necessarily the best solution.[29]

Collective administration has many forms and permutations. Some collective societies have grown into large organizations that dominate their sectors and have a near-monopolistic control over rights administration within them. To regulate these and other forms of collective administration, some organizations (particularly in European countries) are created by legislation or are under the legislative control of their governments, which monitor their structure and activities.[30] The United States is unique in that it imposes few legislative structures on organizations that collectively administer intellectual property. Although antitrust laws and consent decrees do impose some regulatory constraints on the administration and organization of collectives in this country, particularly in the music industry,[31] none of these organizations has been created by nor is operated under legislative statutes.

The earliest collective rights administration in the United States began in the music industry, when the American Society of Composers, Authors and Publishers (ASCAP) was founded in 1914 to collectively administer the licensing of nondramatic performances of music. Collective administration continues to this day, and is undergoing a resurgence as a result of the opportunities and issues arising from the increased use of digital media. The last few years have seen the development of new organizations that collectively administer intellectual property for organizations such as museums and other repositories of collections, as well as groups of professionals such as writers, artists, photographers, and font designers.

F. The Emergence and Perseverance of Rights Management

Although the concept of the natural rights (often called "moral rights") of the creator emerged before the 1700s, the Enlightenment gave it form, sustenance, and expression. The earliest organization formed to strengthen and enforce a creator's natural rights was founded in France in the late 1700s when Caron de Beaumarchais, the author of *The Barber of Seville* and *The Marriage of Figaro*, joined with fellow authors to create the

Societé des Auteurs Dramatiques, an authors' rights society. The Societé worked for changes in compensation practices,[32] promoted moral and social rights for its members, and sought to ensure that these rights were guaranteed in France's code of law.[33]

Beaumarchais's early efforts were motivated by unfair remuneration practices and lack of control over his creative works. These issues remain primary incentives for the development of rights management organizations, but over the last century they have been bolstered by the influence of technology and its effect on various creative sectors. The music industry, for instance, was transformed by the invention of the phonograph and radio (and later motion pictures and television). Before these technologies were developed, the main source of income for musicians and composers was the sale of sheet music and live performances. Now the income generated from these original sources is truly minuscule compared to the royalties generated from radio airplay, motion picture soundtracks, television broadcasts, the sale of tapes and CDs, and (perhaps soon) from Internet use.

Technology continues to hasten the pace of development and the push for rights management solutions. The emergence of the Internet as a popular access and distribution technology is presenting new challenges in rights management. The ease of copying in an electronic environment, combined with instantaneous delivery and worldwide distribution channels, make rights and usage issues omnipresent in this medium. In response, both new and established intellectual property management agencies are addressing rights issues in this medium.

Notes

[1] Gilles Vercken, *Practical Guide to Copyright for Multimedia Producers*, EUR 16128 (Luxembourg: Office for Official Publications of the European Communities, 1996).

[2] The entire text of the Berne Convention for the Protection of Literary and Artistic Works is available online at [http://www.law.cornell.edu/treaties/berne/overview.html] (June 1998). The entire text of the Universal Copyright Convention is available online at [http://itl.irv.uit.no/trade_law/doc/WIPO.Universal.Copyright.Convention.Revision.1971.html] (June 1998).

[3] World Intellectual Property Organization [http://www.wipo.org/] (June 1998).

[4] Robert Lind, "Institutional Trademarks," *WestMuse*, Western Museums Association Newsletter (Fall 1997): 8–9; 37.

[5] John Perry Barlow, "The Economy of Ideas," *Wired* 2, no. 3 (1994): 84–90ff. [http://www.hotwired.com/wired/2.03/features/economy.ideas.html] (1993).

[6] U.S. Constitution, Article I, Section 8.

[7] See Michael Shapiro, "Not Control, Progress," *Museum News* 76, no. 5 (September/October 1997): 37–38.

[8] The general "rule" is the author's lifetime plus seventy years after his or her death. There are some exceptions to this term. For specifics, see 17 U.S.C. §302–305.

[9] 17 U.S.C. §204(a).

[10] For full details, see the Visual Artists Rights Act, 17 U.S.C. §101.

[11] 17 U.S.C. §107.

[12] For more detailed and thoughtful analyses of fair use as it applies to cultural and educational organizations, see Christine Steiner, "The Double-Edged Sword: Museums and the Fair Use Doctrine," *Museum News* 76, no. 5 (September/October 1997): 32–35, 47–48; Stephen Weil, "Not Use, Control," *Museum News* 76, no. 5 (September/October 1997): 36, 38, 41; Shapiro, "Not Control, Progress," 37–38; and Georgia Harper, "Fair Use," Copyright Crash Course [http://www.utsystem.edu/ogc/IntellectualProperty/copypol2.htm#test?] (1997).

[13] The Conference on Fair Use was sponsored by the U.S. Department of Commerce Working Group on Intellectual Property Rights and the National Information Infrastructure, chaired by Bruce Lehman, U.S. Patent and Trademark Office. For a copy of the Committee's final report to Commissioner Lehman, see [http://www.uspto.gov/web/offices/dcom/olia/confu/conclutoc.html].

[14] For various assessments and interpretations of CONFU and the impact of the guidelines on the cultural and educational community, see Harper, Copyright Crash Course [http://www.utsystem.edu/ogc/IntellectualProperty/confu.htm] (1997); Christine Sundt, Copyright Information: Copyright and Art Issues [http://oregon.uoregon.edu/~csundt/cweb.htm] (1997); and David Green, "CONFU Continues: Is It Time to Regroup?" NINCH Newsbrief [http://www-ninch.cni.org/News/CONFU_Report.html] (May 23, 1997).

[15] See Fair Use Town Meetings and Other Events at [http://www-ninch.cni.org/ISSUES/COPYRIGHT/FAIR_USE_EDUCATION/FAIR_USE_EDUCATION.html#events] for a list of symposia, meetings, conferences, and lectures, and other fair use educational events that have taken place in the cultural and educational community since CONFU. Among the more prominent of these events was a series of Town Meetings organized by the American Council of Learned Societies, the College Art Association, and the National Initiative for a Networked Cultural Heritage, with financial assistance from the Kress Foundation. These meetings were held "to highlight the CONFU guidelines and their implications for teaching, research, curatorial and scholarly publication, and artistic production and exhibition with digital images, as well as to elicit responses from the community."

[16] Lyman Ray Patterson, *Copyright in Historical Perspective* (Nashville: Vanderbilt University Press, 1968), 222.

[17] Ibid., 222–223.

[18] Ibid., 224.

[19] Ibid., 223.

[20] Pamela Samuelson, "Copyright and Digital Libraries," *Communications of the ACM* 38, no. 4 (April 1995): 16.

[21] Ibid., 15–21; 110.

[22] William S. Strong, *The Copyright Book* (Cambridge: MIT Press, 1990), 45.

[23] An example of a creative assignment of exclusive rights for philanthropic ends was demonstrated in 1998, when the popular rock band, the Rolling Stones, granted the Public Broadcasting Service (PBS) exclusive rights to sell videotapes of its "1997–1998 Bridges to Babylon Tour" for a seven-month period after the Tour's television broadcast premiere on PBS. In conveying this exclusive right to PBS at this point in time, the Rolling Stones gave PBS a market advantage by removing competition among sales agents when interest in the videotape would be at its peak. PBS, as sole sales agent for seven months following the premiere, would gain more income from videotape sales than if it was competing for sales with other agents. See Laurie Mifflin, "Mick Jagger Tote Bags?" *The New York Times* (February 4, 1998), B7.

[24] Melissa Smith Levine and Lauryn Guttenplan Grant, "Copyrights of the Rich and Famous," *Museum News* 73, no. 6 (November/December 1994): 48–55.

[25] For a schema of the various contexts in which images are created and reproduced, and the possible layers of rights that are associated within each of these contexts, see Jennifer Trant's article "Exploring New Models for Administering Intellectual Property: The Museum Educational Site Licensing (MESL) Project" [http://www.archimuse.com/papers/jt.illinois.html#intellectual] (1996). Also in *Digital Imaging Access and Retrieval*. Papers presented at the 1996 Clinic on Library Applications of Data Processing, University of Illinois at Urbana–Champaign, March 1996, ed. P. Bryan Heidorn and Beth Sandore (Urbana–Champaign: University of Illinois at Urbana–Champaign, 1997), 29–41. Also see Christine Sundt's article entitled CONFU Digital Image and Multimedia Guidelines: The Consequences for Libraries and Educators [http://oregon.uoregon.edu/~csundt/indy.htm] (1997).

[26] Maryly Snow of the University of California at Berkeley notes that copyright was once claimed for the use of a digital thumbnail image of a drawing in the public domain that was taken from a slide made from a second- or third-generation photographic reproduction. See her article entitled "Digital Images and Fair Use Web Sites," *VRA Bulletin* 24, no. 4 (1998): 40–43.

[27] Strong, *The Copyright Book*, 10.

[28] Stanley M. Besen and Sheila Nataraj Kirby, *Compensating Creators of Intellectual Property: Collectives That Collect*, #R-3751-MF (Santa Monica: RAND Corporation, 1989), 3.

[29] Ariane Claverie, "The One-Stop Shop and Arguments for or against Individual or Collective Administration of Rights. Minutes, Part 2," European Commission DG XIII Legal Advisory Board Meeting on the Information Society: Copyright and Multimedia, Discussion Panel [http://www.strath.ac.uk/Departments/Law/diglib/ec/min2.html] (April 16, 1995).

[30] Thomas Hoeren, *An Assessment of Long-term Solutions in the Context of Copyright and Electronic Delivery Services and Multimedia Products*, European Commission Directorate-General XIII E-1 (Luxembourg: Office for Official Publications of the European Communities, 1995), 34–35.

[31] See *U.S. v. ASCAP*, 1940–43 Trade Ca. (CCH) ¶ 56,104 (S.D.N.Y. 1941); *U.S. v. ASCAP*, 1950–51 Trade Ca. (CCH) ¶ 62,595; *U.S. v. BMI*, 1940–43 Trade Ca. (CCH) ¶ 56,096 (E.D. Wis. 1941); *U.S. v. BMI*, 1966 Trade Ca. (CCH) ¶ 71,941 (S.D.N.Y 1996).

[32] The practice in France at this time was for actors to employ writers to create theatrical works for them. The actors paid the writers a flat rate for each work.

[33] Jean-Loup Tournier, "The Future of Collective Administration of Authors' Rights," European Commission DG XIII Legal Advisory Board Meeting on the Information Society: Copyright and Multimedia [http://www.strath.ac.uk/Departments/Law/diglib/ec/tournier.html] (April 16, 1995).

3. The Distribution of Intellectual Property over Electronic Networks

A. Access Issues

Electronic networks, particularly the Internet and its primary mode of access, the World Wide Web, are perceived as a new type of technology that threatens the current balance of rights put forth by copyright law. Historically, when new technologies disrupted the balance sought by copyright laws, social and legislative adjustments were enacted to realign the balance.[1] Do electronic networks pose new scenarios that challenge this history of compromise and resolution? While opinions vary, electronic networks do challenge the flexibility of the current copyright regime in a variety of ways.

Ease of Reproduction

Perhaps the most threatening aspect of electronic networks is their potential for making the copying of intellectual property easier, cheaper, and faster. The concern is over unauthorized reproductions that can cause creators to lose control of the use and quality of their work, as well as lose potential revenue from sale, licensing, or rental of their work.[2] This loss threatens to tip the copyright balance away from the creator by jeopardizing the remuneration incentive that the law holds important for continued development of creative pursuits.

While it is true that older technologies (e.g., photocopiers, videocassette recorders, etc.) posed a similar threat, electronic networks have an added dimension. The copies created using other technologies have always resulted in a product inferior to the original source material. But copies of digital information are exact replicas of the original digital version. The digital content that is transmitted on electronic networks, combined with the speed and geographic scope of these networks, means that an unprecedented number of exact replicas can be generated and distributed worldwide with very little effort. The possibility of "millions of unauthorized

perfect copies"[3] is not hyperbole. The potential for unauthorized copying, which increases exponentially in the networked world, can threaten the viability of entire industries, the life's work of creative individuals, and ultimately the concept of copyright as a balance of rights nurturing the flow of ideas necessary to a vital society.

A number of preventive methods can be employed to minimize the threat of rampant, unremunerated copying. Among the most controversial of methods are those that "lock up" the technology or the content and make it accessible only by license, subscription, encryption key, "pay-per-view," or some other "unlocking" mechanism. These methods can tip the copyright balance away from the public good by restricting access to the free flow of ideas and information that copyright holds as an important part of the "cultural bargain."

Social mechanisms, such as educating users about copyright and fair use limitations, offer another means of preventing misappropriation of intellectual property. Many Web sites, particularly university sites, now display extensive copyright awareness information. Videocassettes of movies customarily begin with notices prohibiting copying and identifying the penalties for doing so (the "FBI Warning"). Photocopiers in universities and copy shops have copyright notices posted on them. The notion of a social conscience is also called into play with concepts like **shareware**, premised on the belief that users of a product will voluntarily compensate the creator because they value the product and appreciate the time, effort, and creativity that went into making it.

The threat of sanctions is another effective social mechanism for preventing misuse of intellectual property. Universities attempt to keep student and faculty use of intellectual property in line by threatening sanctions such as suspension, expulsion, or prosecution. The software industry encourages (via 800 telephone numbers and the promise of confidentiality) employees and others to report illegal software use observed in their companies or in other organizations. These programs have identified many highly publicized cases of infringement that serve as effective deterrents to companies against casual use of software products.[4]

Even with strong social incentives and the threat of legal action, some unauthorized copying is inevitable. There are those who argue that small amounts of unauthorized copying actually encourage copyright compliance in the long run. Poor-quality copies send people to stores to purchase originals. Value-added materials made available only with the purchase of a product (such as manuals and technical support for software programs) prompt a user to buy, rather than illegally use, a copy of a given work. The challenge for creators who place their works in electronic environments, or to the organizations who do so for them, is to provide incentives that will get users to buy rather than "borrow."[5]

Reproduction as a Prerequisite to Use

In the physical (or "analog") world, one does not need to copy a work in order to use it. Books can be read or recited. One can listen to, or sing along with, a musical recording. But with electronic networks, replication and use are linked. A digital work cannot be used without the aid of a computer to translate that work, and in the process of translation, the computer copies the work into a temporary space. In order to see, read, or use anything in digital form, you *must* copy it.

Copying as a prerequisite to use in the digital domain has raised the question of whether *all* uses of digital works violate the rightsholder's own reproduction right. Opponents of this view believe that it jeopardizes copyright's efforts to ensure the free flow of ideas that are seen as central to the public good. They argue that the reproduction is not the end objective but rather a "technological accident."[6]

Proponents believe that the copying required to use any digital information, while initially occurring in a temporary and ephemeral space, can (and will) readily be "fixed" in a more permanent space (such as on a hard drive or a printout), and consequently want to control the copying at its original source. Requiring rightsholder permission for all uses of digital works, even for viewing or reading, is extreme and probably not enforceable. Nevertheless a large "gray zone" for acceptable uses has emerged because the nature of digital works and their distribution requires that they be reproduced in order to be used in any manner. This gray zone begs clarification by users and rightsholders.

Worldwide Distribution Channels

A third issue unique to electronic networks is their potential ubiquity. While these networks do not currently have the market penetration of technologies such as radio and television, they have the potential to become the foremost communications medium for the developed world. Already they are proving to be a viable substitute for telephone, fax, mail, newspapers, reference sources, and even social interactions.[7] As they develop and become more prevalent, electronic networks create worldwide distribution channels unlike anything that currently exists. Information can be moved around in this environment without regard for geographic boundaries, time zones, or tariffs. The current copyright laws of individual nations lose meaning and enforcement in such an environment. Can the current copyright regime accommodate all the implications of such change? How will domestic and international copyright laws respond to these changes?

The extensive scope of digital networks is a double-edged sword for many organizations, which are drawn to the potential opportunities of

reaching worldwide audiences and markets, but which are concerned about the loss of control that results from using such an extensive, decentralized distribution system. An equally compelling concern is the impact of such worldwide exposure on an organization. Will it result in increased demands and unachievable expectations? How will cultural organizations, for example, respond to requests made by new audiences located around the world? Will they be capable of handling large volumes of requests in a timely manner? The implications of access to global audiences, and the impact of global audiences on local institutions, need to be explored more fully.

Transformative Effect

Communications technologies are redefining existing notions of environments, settings, and communities, and electronic networks are at the forefront in initiating these transformations. Classrooms are no longer confined to schools; formal learning now takes place at home, in dormitory rooms, or in any remote location. The trend toward home-based workers is rising as the need for a physical presence in a centralized location is eliminated by the ability to communicate and work via electronic networks. Even the concept of corporations is being redefined, with "virtual corporations" whose employees communicate not by virtue of physical proximity but by access to electronic networks. More and more people are undertaking traditional tasks in nontraditional settings because of electronic networks. How will copyright address the increasingly transitory nature and demand for uses of creative work?

The software industry has started to address these changes in its licensing practices. Acknowledging the increasingly transient nature of where people work and where their product is needed and used, some software companies are modifying the permitted uses of their product to include the creation of "multiple copies" on different machines used by the same person but not at the same time. Such a license permits a person to install and use a software product on his office, laptop, and home computers, allowing use of the product when working in the office, on the road, or at home.

Electronic networks are also transforming the notions of authorship. Many works that reside in electronic environments are multimedia objects (e.g., Web sites) or cumulative, collaborative efforts (e.g., jointly written papers, distributed database collaborations, threaded discussion groups), which have not traditionally acknowledged authorship. However, there are signs that this situation is changing. Web sites now routinely carry copyright notices, and it is not unrealistic to expect that other electronic collaborations will follow suit. Who is the "author" of these types

of works? Who owns copyright? How can these collaborative "works" be used? Are they analogous to print compilations, in which the individual author retains copyright to his or her work and the "publisher" retains copyright to the compilation?

One of the conundrums of electronic networks is that they can function as both an enabling and a restricting technology. They offer the potential for unprecedented access to information, as well as for security measures that restrict or mediate this access.[8] Underlying this tension between protection and the free flow of ideas is, once again, the balance between creators' and society's rights to control and use information.

The still evolving and dynamic nature of digital technologies makes it difficult to identify any practices and rules that should prevail in this environment. Unlike most other technologies, digital technologies convey works in many forms (images, text, sound), from different industries (graphics, art, music, software, print publishing), using numerous types of media (video, audio, still image).[9] The ability to provide access to and distribute such a broad array of creative works, and often to subsume existing technologies (such as radio, television, phonographs, or photocopiers) makes electronic networks the most encompassing technology to date. Its importance and influence challenge the equilibrium that copyright law strives for to an extent that previous technologies have not.

B. Special Issues for Cultural and Educational Institutions

Widespread distribution of information, ideas, and the works that embody them is at the heart of cultural and educational institutions. Until recently, this open mode of expression and exchange was an unchallenged norm. However, scholarly and cultural communities are beginning to acknowledge the social and economic value of their work in new ways, and are looking to administer these works more advantageously. They face significant issues in undertaking this challenge.

The State of Intellectual Property in Cultural Organizations

Cultural heritage organizations harbor a diverse array of intellectual property. In addition to high-profile materials like works of art, photographs, manuscripts, films, and sound recordings, these organizations also have intellectual property embodied in exhibitions, educational and interpretive materials and programs, collections databases, and multimedia works.

Despite this wealth of material, cultural heritage organizations are poorly positioned to offer the contextual information that will make their intellectual property "valuable" in a networked environment. Most of their intellectual property is not digitized, nor is it documented so as to

take advantage of the superior access features of electronic networks. In part, this state of affairs is due to the nature of cultural collections, which frequently result from a confluence of historical and anecdotal circumstances. (The reemergence of works that disappeared during times of political or social upheaval provides high-profile examples of such circumstances.) It is not unusual to find materials in a collection with unknown or unclear acquisition data. Many materials lack accompanying information and may not have received the study needed to extend their documentation fully. The varied acquisition histories and research patterns for objects in collections result in uneven documentation for these materials.

Erratic recording methodologies have also played a part in the irregular state of cultural information. Cataloging methods have improved over time, but often are not comprehensively or retrospectively applied to all materials in a collection. Community-based recording standards, begun nearly a decade ago, need to develop further and gain wider acceptance and use.

The costs of digitization also play a role. These costs, which seem minuscule for a single item, become prohibitive for cultural organizations faced with digitizing thousands (and in the case of natural history repositories, millions) of materials. While funding exists to digitize select materials, few sources exist for comprehensive digitization programs. The result is a piecemeal approach in which the most popular works are available on electronic networks (because they have been digitized and fully documented), but the vast majority of cultural materials remain "offline" awaiting substantial modifications and efforts before they can be delivered as a coherent resource within a networked environment.

Given this state of affairs, the cultural heritage community is at risk of having its intellectual property subsumed by commercial interests that can bring content to electronic networks faster and more efficiently. If this scenario develops, it will be difficult for cultural organizations to penetrate the markets and reach the audiences that the commercial sector has had a lead in cultivating. They may face a significant struggle in promoting the value of their intellectual property over that provided by commercial interests.

Determining Value

In order to manage intellectual property, cultural and educational institutions must clearly identify just what their intellectual property encompasses, and determine both its social and its economic value. Who wants their creative works, and why? Are the values of the potential user community consistent with the educational or cultural organization's mission? What drives the economic value for its intellectual property? These questions are difficult to answer in the digital domain, where audiences are not easily ascertained

and uses are difficult to identify or anticipate. Electronic networks bring the entire concept of "value" into question, because processes and services in this environment may be valued more than the intellectual property itself.[10] If this is the case, the true value of cultural heritage works on global networks will lie in the information and services that allow one to access and use these works, not from the works themselves.

One instance in which value differences are apparent is in the type of intellectual property favored by various industries. For example, the commercial markets for cultural content favor a subset of popular themes, images, personages, or events. This focus has been termed a "greatest hits" approach to content selection and use, and is at odds with cultural and educational institutions in need of a critical mass of material (not just the "best" or "most popular") in order to pursue their educational and cultural missions.

Fair Use and the Digital Environment

The doctrine of fair use has held a central place in cultural and educational organizations in the United States. But will this doctrine survive in a networked environment? Those who believe that access to intellectual property will occur solely through licensing and similar schemes feel that fair use is unnecessary. Others believe that fair uses exist both inside and outside licensing schemes.[11] Efforts to determine the place or value of fair use in a networked environment are complicated because the fair use concept is unclear even in the analog world. It may be that digital networks will not eliminate the need for fair use but will instead present an opportunity to develop a different way to achieve its benefits.[12]

The Conference on Fair Use (CONFU) was created to examine the role of fair use in an electronic environment, and to develop guidelines for determining fair uses in this medium. Although the work of this committee has concluded and its proposed guidelines have no official sanction or enforcement, its recommendations have generated debate in the U.S. cultural heritage community. While the issues of fair use in a digital environment remain unresolved, commentators on the CONFU process note that many fair uses accepted (or at least left unquestioned) in the analog world will be challenged in the digital world by commercial interests, which, viewing the promise of larger markets, will find it financially and strategically feasible to mount legal campaigns to secure their place within these markets.[13]

Other Uncertainties: Licensing, Assurances, Economics, and Markets

The proposed mechanisms for administering intellectual property and distributing it in a networked environment fall short of being panaceas.

Licenses, for example, which are emerging as the most popular tool for administering these properties, are the subject of intense debate. While licensing is a powerful mechanism, it falls under the umbrella of contract, not copyright, law. Thus licenses can be structured creatively to extend and exceed the uses allowed under copyright,[14] but they can also constrain and limit those rights[15] depending on how they are negotiated. (For further information about licensing for cultural and educational institutions, see the bibliography.)

The use of intermediaries to administer intellectual property for cultural and educational organizations presents more uncertainties. What assurances do cultural and educational institutions have about the stability and integrity of these intermediaries? What assurances do users have that the repertoires compiled and licensed by these groups will continue in some form in the event that the intermediary organization ceases to exist, or the resource proves to be economically unfeasible?

Economic and market issues are another unknown factor. Cultural and educational institutions make assumptions about audiences and markets for their intellectual property that have yet to be proven. The educational community may be an important market for cultural organizations, but will it be sustainable? (In countries in which cultural and educational funding comes largely from one governmental source, the effect will be to "shift" funds from one governmental budget to another, with one community profiting to the detriment of the other.) Is there a popular market for cultural information? Among software and media developers, the suggestion has been raised that the true market for cultural heritage information may be the cultural heritage community itself.[16]

Given the climate of fiscal uncertainties and budgetary restraints, there is a tendency to expect that electronic networks will lead to economies of scale resulting in lower costs for users and rightsholders. Thus far, this belief is not being borne out. On average, licenses to electronic products for libraries are running 30 percent more than the costs of print equivalents.[17] Publishers are finding that the economic models used for print production cannot be carried into a networked environment without modification.[18] Administering intellectual property over electronic networks may not be a cost-saving measure as much as a new method for managing products and services that yields noneconomic benefits.

It is difficult to determine whether the distribution issues that arise with intellectual property on electronic networks have stifled use of this medium by rightsholders and users. While the ease of reproduction and worldwide distribution channels that characterize these networks are of concern to all creative industries, the cultural heritage community has its own distinct challenges in this domain, which will affect its participa-

tion. How will cultural and educational organizations address these challenges? What structures and methodologies will they find amenable? The following section looks at the current ways cultural organizations administer their intellectual property, and explores existing as well as newly emerging options for how they may administer this property on electronic networks in the future.

Notes

[1] Pamela Samuelson, "Copyright and Digital Libraries," *Communications of the ACM* 38, no. 4 (April 1995): 20–21.

[2] Christine Steiner, Electronic Media Agreement Issues: Negotiating Museum Licensed Products. Paper presented for the American Law Institute–American Bar Association (ALI–ABA) Legal Problems of Museum Administration, March 20–22, 1994.

[3] Comment made by Douglas Bennett, formerly of the American Council of Learned Societies, at the CONFU Town Meeting held at the 1997 Annual Meeting of the American Association of Museums, Minneapolis.

[4] See the Web sites of the Software Publishers Association at [http://www.spa.org/piracy/homepage.htm] and the Business Software Alliance at [http://www.bsa.org/piracy/naprgrm.html].

[5] Samuelson, 21.

[6] Law professor James Boyle of American University succinctly frames the problem by stating that, "on the Net, transmission means the generation of lots of temporary, unstable copies. That's what transmission is. Thus if one labels each of these temporary and evanescent copies as 'copies' for the purposes of copyright, one has dramatically shifted the balance of power from users and future creators, to current rights holders, and done so solely on the basis of a technological accident. [This] violates . . . the principle of 'technological transparency'. . . the principle that the social meaning of rules and standards should not be undermined or inflated, simply because an accidental technological change transforms one of the triggers to liability." In James Boyle, Intellectual Property Online: A Young Person's Guide [http://www.wcl.american.edu/pub/faculty/boyle/joltart.htm] (1996).

[7] Jessica Littman, Reforming Information Law in Copyright's Image [http://www.msen.com/~litman/dayton.htm#fn0]. Forthcoming in the *University of Dayton Law Review*.

[8] Brian Kahin, "The Strategic Environment for Protecting Multimedia," Proceedings: Technological Strategies for Protecting IP in a Networked Multimedia Environment [http://www.cni.org/docs/ima.ip-workshop/Kahin.html] (1994).

[9] National Humanities Alliance Committee on Libraries and Intellectual Property, Basic Principles for Managing Intellectual Property in the Digital Environment [http://www-ninch.cni.org/ISSUES/COPYRIGHT/PRINCIPLES/NHA_Complete.html] (1997).

[10] Esther Dyson, "Intellectual Value," *Wired* 3, no. 7 (1995): 146–141; 182–184 [http://www.wired.com/wired/3.07/features/dyson.html].

[11] Barbara Hoffman, "Fair Use of Digital Art Images and Academia: A View from the Trenches of the Conference on Fair Use (CONFU)," *Copyright and Fair Use: The Great Image Debate*, ed. Robert Baron, *Visual Resources* 12, nos. 3–4 (1997): 389; and Georgia Harper, CONFU: The Conference on Fair Use [http://www.utsystem.edu/ogc/intellectualproperty/confu.htm] (1997).

[12] Georgia Harper, Will We Need Fair Use in the Twenty-First Century? [http://www.utsystem.edu/ogc/intellectualproperty/fair_use.htm] (1997).

[13] See Hoffman, 389; and Virginia Hall, "Fair Use of Digital Images Archives: A Report on the National Information Infrastructure Conference on Fair Use," *Copyright and Fair Use: The Great Image Debate*, ed. Robert Baron, *Visual Resources* 12, nos. 3–4 (1997): 398.

[14] Jennifer Trant, Beyond "Putting It Up": Licensing Museum Content for Educational Use. Paper presented at the Annual Meeting of the Museum Computer Network, St. Louis, October 18, 1997.

[15] Ann S. Okerson, "Buy or Lease? Two Models for Scholarly Information at the End (or the Beginning) of an Era," *Daedalus* 125, no. 4 (1996): 55–76 [http://www.library.yale.edu/~okerson/daedalus.html].

[16] Comments made at a planning meeting on private/public partnerships attended by software marketers, product and project managers, and media developers, at the Getty Information Institute, October 10, 1996.

[17] Okerson, "Buy or Lease?"

[18] One area in which the models differ is technical support and training. Electronic publications require some level of technical support and training that is irrelevant for print publications. These services are expensive, and contribute to the high costs of electronic products.

4. Administering Intellectual Property in Cultural Organizations

A. Current State of Affairs: Direct Administration

Most requests that cultural organizations receive for use of their intellectual properties involve images (i.e., historic photographs, documentary films, videos, or other image-based surrogates for objects such as art or manuscripts) and sound recordings. Use of these works by individuals outside the institution requires direct negotiation for each work in question. All the issues of direct administration discussed earlier (in Chapter 2, Section E, "Direct Administration," pages 15 to 16) come to fruition in this process. Huge efforts are expended by staff who must locate, identify, and clear any underlying rights. A contract for use and payment must be negotiated with each use of each image. Surrogates of the image or recording must be made in the format requested by the user, and sent to the user in the time specified. With all these tasks involved, a seemingly innocuous request can take days or weeks of effort to fulfill. Each of the tasks undertaken in the process has a cost associated with it in terms of time and labor expended. The user also has spent time and money in the process of locating the image or recording, identifying the rightsholder, and initiating contact and negotiations.

In addition to handling rights and permissions on a case-by-case basis, each institution has a slightly different approach to how it handles intellectual property requests.[1] The staff responsible for overseeing this function may vary from one organization to another. Various tasks may be assigned to an individual (e.g., curators, registrars, photographers) as an added duty, or to a subsection of a department (e.g., "photographic services" within a publication department). If volume is particularly high, an entire department may be established (e.g., "Rights and Reproductions") to manage requests.

Fee structures for rights and reproductions services are even more diverse than the administrative infrastructures overseeing these services. Pricing does not reflect actual costs because cultural institutions have

never ascertained what those costs are.[2] Until recently, this gap in knowledge was not perceived as a problem, since outreach and acknowledgment were considered part of an intangible payment the institution would receive for allowing use of its intellectual property. In this spirit, fees were often waived if the use was judged to bring an institution more visibility or a higher profile in specific communities.[3]

Historically, cultural organizations have addressed rights and reproductions passively by responding to requests but not actively marketing or encouraging external use of their intellectual property. Several factors are now forcing cultural institutions to reconsider this stance. As budgets continue to tighten, new revenue streams are becoming ever more important to sustain an organization's operations. The increase in multimedia products and various entertainment technologies have spawned a growing market for content, and the traditional external uses for the intellectual property of cultural institutions have expanded beyond print publication and research. Audiences are also becoming more selective in their use of leisure time and are eager to view cultural content in interactive, technology-mediated ways. Cultural institutions are being forced to abandon what has been referred to as their "polite policy"[4] and move toward a more businesslike model that capitalizes on the growing market for online uses.

B. Changes on the Horizon: Options for the Cultural Heritage Community

The vastly increasing volume of intellectual property requests spawned by new technologies will make those who handle rights and reproductions in cultural organizations busier than ever. But restructuring staff, departments, or tasks will not yield greater efficiencies unless the process itself can be streamlined. The current process—case-by-case negotiations, time-consuming administration and research, fee structures based on estimated rather than actual costs—will not generate profits or cost-recovery revenue. Increased volume will simply tax an already burdened system.

While cultural institutions may be tempted to increase fee structures to cover the costs of handling a greater volume of requests, price increases alone are not a viable solution. New technology applications require so many "pieces" of intellectual property that the market will probably not tolerate large fees for each "piece," and will seek cheaper content elsewhere.[5] Efficiencies are needed in administration and research, and in negotiating terms and conditions for use. How can they be achieved?

Several possibilities are available to the cultural heritage community for managing or distributing its intellectual properties: Each can be pursued singly or in combination with other options. The uncertainty of

markets, legal implications, technologies, and budgets presupposes that organizations may opt for several choices, depending on circumstances and needs. Indeed, some institutions are proactive consumers in this area, identifying possibilities, contracting with multiple intellectual property management agencies or projects, and participating in a variety of initiatives to expand their market reach and gain experience in the practical implications of working with various providers of rights and content administration services. The options currently available to cultural organizations for managing and/or distributing their intellectual property can be grouped into four areas: 1) continue with the current process of direct administration, 2) expand and centralize in-house rights and reproductions responsibilities, 3) outsource with an external intellectual property rights agency, or 4) join a rightsholders' collective, cooperative, or consortium.

Continuing with Direct Administration

Before selecting any particular administrative option, cultural heritage organizations need to decide which intellectual properties they are capable of administering (or must administer) themselves, and which are best administered by another provider. Sometimes in-house administration of rights and content distribution is the preferred approach, particularly when collections are sensitive in nature, or when one wishes to maintain a special relationship with a particular user.

However, given the ever-increasing volume of digital rights requests and the burden they place on institutional resources, direct administration is unwise *if* pursued as a sole solution. If it is one option in a broad-based approach to intellectual property management (that includes other options, such as arrangements with other agencies for the administration or resale of rights and content, participation in a rights collective, cooperative, or consortium, or any combination thereof), then direct administration will continue to have a legitimate, but limited, role in an institution's intellectual property management strategy.

Given the risky nature of the current environment, few cultural organizations are ready to abandon their current administrative setup for rights and reproductions to enter into a new and untested situation. They may, however, be more willing to participate in new ventures and contract with external agencies if they can do so without jeopardizing their existing infrastructure for intellectual property management.

In-house Expansion and Restructuring

Many cultural organizations are restructuring their in-house rights and reproductions staff and tasks to address rights management in a more

strategic manner.[6] In the long run, it is doubtful that such reorganization will be any more useful than the status quo as a solution to managing intellectual property. Restructuring may introduce efficiencies in operation and added resources, but its premise is still direct administration between rightsholder and user, which has been shown to be burdensome unless extensive infrastructures such as marketing, licensing, and legal affairs departments are in place to support it.

Organizations developing a more structured approach to their in-house intellectual property administration will soon have available to them new electronic tools for managing and tracking these properties. **Electronic Rights Management Systems** (ERMS) are an emerging application that will regulate automatic rights clearance on a transaction-by-transaction basis, using the requirements of the content provider and rightsholders. These systems are still in development and vary greatly in their architecture, but their general structure consists of networked databases containing information on users, licenses, uses, content, and fees, which regulate the automatic licensing and distribution of content over electronic networks. (See the Bibliography for more information.) These functions will reduce the amount of manual tracking and disparate task flow that in-house rights administration entails by bringing all the "pieces" of licensing administration into one system. However, insofar as ERMS replicate direct licensing models, they do nothing to offset many of the disadvantages of this method of administration. Rightsholders must still monitor uses and pursue infringements individually. And users must locate rightsholders and properties, and administer the various agreements they may have with multiple rightsholders.

Outsourcing with an External Agency

Many types of external or third-party agencies and organizations worldwide offer management, administration, resale, brokering, and/or distribution services for rights and content from other professions or organizations. These groups, usually formed independently of the rightsholders they serve, tend to specialize in certain types of content (e.g., film, images) or represent the works of certain professionals (e.g., photographers, publishers). Of late, these agencies are expanding their scope to encompass related (and, in some cases, unrelated) sectors. Stock photography agencies, for example, are now licensing Web graphics. This trend of agencies expanding their rights management arenas is being fed by marketplace competition and new technologies. For cultural heritage organizations, this trend may result in many more "nontraditional" players vying to be their intellectual property management partners.

There are substantial benefits to having third-party groups administer intellectual property. They can offer wider and more established distribution and marketing channels, a single contact point for users seeking access to materials, and removal of a rightsholder's administrative burdens. However, rightsholders have little if any say in the management of these types of organizations, receive smaller royalty percentages than they would by direct administration or through a membership collective, and may have to compromise on the intellectual property they wish to have represented.

Joining a Rightsholders' Collective, Cooperative, or Consortium

The collective strengths of rightsholders' groups have a long, established history that is experiencing a resurgence in this era of electronic technologies. What was once the purview of the music and reprographics industry is now taking hold among museums,[7] writers,[8] photographers,[9] and indigenous artists and craftspeople.[10]

Intellectual property management collectives, consortia, and cooperatives are organizations founded by rightsholders to address the joint intellectual property needs of a particular creative community or sector. Rightsholders participate because they believe the collective brings them benefits that they could not garner individually (such as sharing in overhead costs and burdens and streamlining operations), and because they can maintain some level of input into the management and operations of the organization.

Consortia present a special instance of collective administration that is often project-based. Rightsholders form or join consortia because they wish to distribute their intellectual properties among groups of users for mutually agreed upon ends. The MESL project, for example, was a consortium of museums and universities exploring the challenges of distributing museum images across electronic networks to universities for teaching and research use.

Collectives and cooperatives work most effectively in the administration of small rights, where much of the value of intellectual property in cultural heritage organizations exists. They represent rightsholders' interests and act on behalf of these interests in dealings with potential users. Most of these organizations are authorized to 1) negotiate with prospective users, 2) license, collect fees for the use of works, and redistribute fees back to the rightsholders, and 3) monitor the uses of works. This general operational framework manifests itself in many ways. Some differences are found at the level of collectivization (total to partial), in the definition of who may participate (all rightsholders within a profession or

only members of a particular organization), in the distribution of royalties (to individual rightsholders or to the collective), or in the method for distributing intellectual property.

While the types of external options for administering intellectual property have existed for some time, they are relatively new to the cultural heritage community. But as electronic networks increase the demand for and distribution of intellectual property, the current system of in-house administration will break down, and the cultural heritage community will find itself turning to other options out of necessity. When it does, it will find a confusing array of choices. The number and types of methods now available for administering the intellectual property of the cultural heritage community demand a careful and considered analysis of the options. The following chapters of this report provide background for such an analysis by examining the structures, functions, and operational frameworks of providers that offer intellectual property management services, with particular reference to issues relevant for cultural and educational institutions.

Notes

[1] See Mary Lampe's *Guide to Rights and Reproduction at American Art Museums*, Visual Resources Association Special Bulletin 10 (1996), which illustrates the diversity of procedures and staffing in place for the handling of rights and reproductions in art museums and galleries.

[2] A study currently is under way at the University of California at Berkeley to provide an economic assessment of the MESL project. Funded by a grant from the Andrew W. Mellon Foundation, this study will compare the costs of digital image distribution in the MESL project with the costs of analog distribution from slide libraries. When completed, this study will provide one of the first documented instances of costs associated with distributing images. For further information, see Robert Yamashita's article entitled "The Economics of Networked Information: Theory, Methods and Preliminary Results of the Mellon Project," in *Delivering Digital Images: Cultural Heritage Resources for Education*, ed. Christie Stephenson and Patricia McClung (Los Angeles: Getty Information Institute, 1998): 134–156.

[3] Janice Sorkow, "Pricing and Licensing for Museum Digital Content," *Museums and the Web '97: Selected Papers* (Pittsburgh: Archives and Museum Informatics, 1997), 43.

[4] Ibid.

[5] Bahar Gidwani, owner of Index Stock Photography, states that multimedia producers do not want the cost of licensing images to exceed 3 percent of the wholesale price of their product. Thus, on a product whose wholesale price is $30, the

licensing fee limit per image is $0.90. See Bahar Gidwani, "Licensing Still Images: Some Basic Information for Multimedia Producers," Index Stock Photography [http://www.index.com] (1994).

[6] Janice Sorkow's discussion of how the Museum of Fine Arts, Boston, has re-organized its efforts in this area, starting with the renaming of the museum's Photographic Services Department to the Department of Rights and Licensing, bespeaks what many organizations are considering: "Now there is a fast-paced, retail-oriented approach. There are two messages: first, get those images 'out there' and, second, increase revenue by broadening accessibility to the Museum's collection, while maintaining high standards in the use of MFA [Museum of Fine Arts] images." These sentiments reveal a proactive approach to intellectual property on the part of the organization, whereby new audiences for intellectual property are being pursued and increased volume is desired. See Sorkow, 42.

[7] See the Art Museum Image Consortium [http://www.amn.org/AMICO/] and Museum Digital Library Collection [http: //www.museumlicensing.org/].

[8] See the Authors Registry [http://www.webcom.com/registry/] and the Publications Rights Clearinghouse [http://www.nwu.org/nwu/prc/prchome. htm] (1998).

[9] See the Media Photographers Copyright Association [http: //www.mpca.com/].

[10] Barbara Lang Rottenberg and Rina Elster Pantalony, "Moral Rights and Exhibition Rights: A Canadian Museum's Perspective," *Copyright and Fair Use: The Great Image Debate*, ed. Robert Baron, *Visual Resources* 12, no. 3–4 (1997): 416.

5. The Structure, Function, and Operations of Intellectual Property Service Providers

Those who enter into an agreement with an intellectual property service provider commit themselves to a relationship that has advantages and expectations specific to that relationship. For this reason, direct comparisons of service providers outside an institutional context is of limited utility. A more useful analysis (and one that has more long-term viability given the rapidly changing nature of intellectual property and its management) identifies the underlying issues that all service providers, users, and rightsholders must consider when they explore different options for managing intellectual property in an increasingly electronic world. An awareness of these issues makes all parties to an intellectual property agreement more knowledgeable about the relationships they enter into, more aware of risks and responsibilities, and more likely to achieve their intellectual property management goals.

A review of service providers' activities highlights some of the most important issues that arise in intellectual property management relationships. (Readers are referred to Appendix A for information on the methodology used in conducting this review.) In this chapter, the structure, function, and operations of intellectual property service providers are discussed, with particular focus on context and background issues and methods of operation. Subsequent chapters focus on content and usage management, and specific rightsholder, user, and economic issues.

A. Formation and Development

The genesis and growth of intellectual property management organizations are influenced by innovations in technology, market opportunities, and even political and world events. The music industry illustrates how a confluence of circumstances can shape the formation of intellectual property management organizations in a particular sector. ASCAP, the oldest intellectual property management organization in the United States, was founded by a group of songwriters disturbed over their inability to receive

compensation for the performance of their works. Until the invention of radio, ASCAP members received their royalties from the sale of sheet music and licenses issued to restaurants, cabarets, hotels, and other public places where music was performed. The escalating popularity of radio broadcasting in the 1920s exponentially widened the market and brought new royalty opportunities for ASCAP members.[1] Broadcast Music Inc. (BMI), another intellectual property management organization serving the music industry, emerged as a response to ASCAP's attempts in the 1930s to increase broadcast stations' license fees for the use of their members' works. In protest, broadcasters boycotted ASCAP music and created their own alternative rights agency. SESAC (the Society of European Stage Authors and Composers) was founded in 1930 by a former ASCAP member to manage the rights and usage of European music. World War II made it impossible for the organization to obtain European rights, and SESAC turned its emphasis to country western and gospel works in the United States.[2] (Although a misnomer, the organization's name was never changed, perhaps because its acronym—SESAC—has achieved name recognition status in the industry.)

Grassroots efforts within particular communities are another catalyst in the creation of intellectual property service providers. The Publications Rights Clearinghouse (PRC), for example, formed in 1996 because of concerns by members of its parent organization, the National Writers Union, about unauthorized secondary uses of their works in electronic media.[3] Competition from outside a community also plays a formative role. Initiatives such as the Art Museum Image Consortium (AMICO) and the Museum Digital Library Collection (MDLC) are, in part, a response by the cultural heritage community to the increasing number of commercially oriented third-party service providers vying for the visual imagery owned by museums. In addition, many entrepreneurial efforts resulted in the formation of intellectual property management organizations: Corbis Corporation (founded by Microsoft CEO Bill Gates), the Bridgeman Art Library (founded by Harriet Bridgeman), and the plethora of stock photography agencies (founded by various individuals) differ greatly in their philosophy and function, but all were founded by entrepreneurs responding to market demands for visual imagery.

History and Startup Relationships

Few service providers develop as individual entities; most are offshoots of a founding organization, partners with a larger "parent" or "umbrella" association, collaborations with like-minded groups, or sponsored projects of a funding agency. These "founding relationships" vary widely in their form and structure. They may emerge as projects within a larger organization

(such as Academic Press's Image Directory) or as licensing subsidiaries of a professional group (such as the Harry Fox Agency, a rights licensing arm of the National Music Publishers' Association). Many begin as projects funded by foundations (such as JSTOR, a journal storage and archiving project initially supported by the Mellon Foundation) or by a joint partnership between several organizations (such as the Authors Registry, an organization founded by the Authors Guild, the Dramatists Guild, the Association of Authors' Representatives, and the American Society of Journalists and Authors). Others evolve out of earlier business endeavors, such as Master Series Illustrations, which is a spin-off of an advertising agency.

The circumstances underlying the creation and development of an intellectual property service provider, and its founding relationships with other groups, shed light on a provider's operations and membership base. A parent or founding partner may impose on a service provider certain conditions that affect its structure and function. For example, organizations founded by membership associations frequently limit representation to their members. Privately held organizations may not be as forthcoming with rightsholders and users as publicly held agencies or collectives. The circumstances under which a given service provider was founded offer insights into organizational incentives and influences that may affect rightsholders and users.

The strength and duration of founding relationships is also important. Is the relationship temporary or long-term? Relationships between service providers and their founding agencies are often designed to be temporary: The founding group offers startup assistance for a finite time period with the understanding that the service provider must become independent thereafter. This is commonly the case with special projects sponsored by foundations. Short-term relationships can result in significant structural and organizational changes at the end of the relationship that can be disruptive to rightsholders and users. Identifying the duration and commitment of founding relationships can alert one to changes in the provider's future directions.

Size and Scale

The size and scale of a service provider's operations can be gauged from several parameters. Two important indicators are size of repertoire (the collection of works represented by the service provider), and the number of rightsholders represented, although both these factors must be considered in the context of a particular industry. In the music sector, for example, the repertoires contain millions of works and represent the creative efforts of hundreds of thousands of rightsholders.[4] However, only three service

providers manage performing rights for the entire U.S. music industry, and each of them has had more than sixty years to build up their representation.

Newer service providers have smaller repertoires and fewer rights-holders because of their short time in the market. However, even new providers can grow very quickly by pursuing an aggressive acquisition strategy that targets rightsholders with a large volume of intellectual property. Corbis Corporation, for example, enlarged its repertoire overnight from one million to sixteen million images with its 1995 purchase of the Bettmann Archive. Resource consolidation can also result in rapid growth for new providers. Several stock photography and film service providers are taking advantage of electronic networks to consolidate their services (through mergers or collaborations) and offer them jointly over the Internet (e.g., Picture Network International (PNI) and FOOTAGE.net). These efforts result in "virtual content warehouses"[5] with expanded repertoires containing intellectual property from several agencies.

Repertoire size and rightsholder numbers must also be viewed in the context of other issues such as the nature of the content being represented; the philosophy and mission of the service provider; the length of time in business; the number of competing organizations within an industry; and the way a provider has positioned itself in an industry. Providers with small repertoires and few rightsholders may have very high standards and selection criteria that reflect a level of quality or specialization not offered by a larger provider in the same industry. For example, SESAC, the smallest of the music industry service providers, reported having only 2,300 rightsholder members in 1997 (compared with 75,000 in ASCAP), but SESAC maintains that "smallness" is part of its strategy. SESAC has a selective membership process that emphasizes high-quality works, and the organization contends that its size allows it to offer more personalized services to rightsholders.[6]

Staffing information offers another indication of the size and scale of operations. Organizational charts and employee titles reveal much about the placement of resources and priorities. Older and larger providers typically have a "corporate" organizational profile, with Chief Executive and Operating Officers, Legal Counsel, Marketing, Member Services Departments, Licensing Divisions, etc. Smaller and newly emerging providers are more loosely structured, with each staff member performing a number of administrative and organizational duties. Providers that have emerged as a result of collaborations among several organizations may "borrow" staff from their collaborating partners.

The nature of an industry sometimes determines the types of professionals or specialists on staff. Providers of visual imagery have a cadre of researchers or photo editors to assist users in finding materials in

their repertoires. Electronic journal projects are likely to involve publishers and librarians. Providers of graphic art have professional artists or designers on staff who both acquire and create content for the provider.

Revenues are another indicator of size and scale of operation, although such figures are difficult to obtain. Privately held agencies are not required by law to publicly report their financial status, and most will not voluntarily do so. New startups often do not yet know their revenues and are tentative about making projections. Many providers downplay revenues, seeing them as a byproduct of their larger mission to promote awareness and secure the rights of their members.

Even when revenue figures are available, they can be deceiving, and should be examined in the context of other size and scale indicators such as staff size, number of offices, and extent of infrastructure. Royalty figures in particular must be examined carefully. While the ratio of royalty revenue to total annual revenue can indicate how much income is used for administrative overhead in an established agency, it cannot be gauged in the same way with a new startup, which will generally need several years to break even. Moreover, yearly royalty figures should not be construed to represent an amount equally divided among all members. Indeed, many service providers do not reveal their royalty figures precisely because they do not want to rankle rightsholders whose works are infrequently used and who receive little or no share of the annual royalty distribution.

For providers who serve solely as content brokers for rightsholders and users (such as Academic Press's Image Directory), there is no linkage whatsoever between revenue and royalties. Here the service provider generates revenues by selling subscriptions or access to its brokerage service or products. Royalties for use of the intellectual properties identified through its services or in its products are collected and retained by individual rightsholders.

Organizational Mission

A provider's operational philosophy can be inferred from the services and information it offers to users and rightsholders, as well as from its corporate statements of purpose. Most service providers have crafted mission statements (some even publicize goals, objectives, and strategic plans) that are revealing sources for rightsholders and users investigating the provider's services. The information and sentiments expressed in these statements reveal the tone and priorities of the organization and may foreshadow the experience one can expect with a particular provider.

The mission statement of the Motion Picture Licensing Corporation (MPLC), for example, succinctly identifies its services, authority, licensing structure, user base, and content, as well as the rights it adminis-

ters.[7] It clearly reflects the tenor and purpose of the organization, which was formed by the major motion picture studios to administer the small rights involved in public viewing of home videos. Other service provider statements may strongly emphasize rightsholder representation or user services. Often a mission statement will emphasize goals and objectives that may not be readily apparent from descriptions of the provider's operations. For example, the journal archiving project JSTOR has had to implement a licensing and distribution scheme for administering journals over electronic networks in order to pursue project objectives. But JSTOR's management of intellectual property is a byproduct of the larger goals articulated in its mission statement, not a goal in itself.[8]

Governance Structures

The governance structure of any organization offers clues as to its legal, philosophical, and corporate form. The most broadly defined governance structures for service providers are not-for-profit, government-based, or for-profit. There are currently no government-based service providers in the United States. Sometimes, however, service providers are subject to some form of government scrutiny, most notably among collectives because of their potential to develop into monopolistic entities. ASCAP and BMI, for example, operate under antitrust **consent decrees** designed to address issues of industry monopoly. Government also intervenes in the creation of entities (such as the former Copyright Royalty Tribunal) given jurisdiction to set the **compulsory license** rates for certain works (e.g., the administration of **mechanical licenses** for music) administered by some service providers.

Governance structures are not always as clear-cut as they appear. For-profit and not-for-profit status can be as much a philosophical distinction as a legal one. The Media Photographers Copyright Association (MPCA), for example, is a member collective registered in New York State as a for-profit corporation because of that state's particular regulations regarding **collecting societies**. However, the MPCA's central mission is to foster fair and equitable business practices between photographers and users; profit is not its goal, nor is it the impetus for its creation.[9] Other service providers incorporated in New York State find themselves similarly defined by a legal status that fails to reflect their mission or goals.

Both for-profit and not-for-profit providers have Boards of Directors/Trustees responsible for the financial health and/or programmatic direction of the organization. Rightsholders' collectives usually have boards composed of rightsholder members. The Copyright Clearance Center (CCC) has on its board individuals from the various communities it represents (publishers, authors, author membership associations, and even a

prominent manufacturer of photocopiers).[10] Consortia often receive their formal governance from the entity hosting or sponsoring them, but their day-to-day governance may be administered by a management committee deputized for the task. Outside of the United States, where government-based providers are common, governmental departments, ministries, or sections define the providers' structure and operations.

Governance structures also hint at a service provider's reporting accountability to the public. Government-based providers have their budgets and reports available as public documents. Among for-profit commercial providers, public reporting requirements vary depending on whether the for-profit is privately or publicly owned. Publicly owned service providers are required to report to their stockholders on the financial status of their organizations in an annual report. Privately owned providers have no such requirement, and it may be difficult to gather financial and other corporate information on these organizations.

B. Methods of Operation

Management Traditions by Genre

The intellectual properties in various sectors have their own traditions of management that play a part in the types of service providers that emerge in any particular sector, and the types of rights they administer. Understanding a particular industry tradition is a prerequisite to reviewing service providers in that industry. What follows is a very brief synopsis of the traditions that exist in some major intellectual property genres.

1. **Literary works.** Texts and literary works are direct-licensed in agreements between authors and publishers. These agreements often involve extensive assignment of rights to the publisher, and authors may use a literary agent to help negotiate these agreements on their behalf. In the past it was not uncommon for authors to convey "all rights" to the publisher, but this practice is coming under increasing scrutiny by authors' rights groups like the National Writers Union, which is urging its members to shun "all rights" and "all electronic use rights" contracts.[11]

 Publishers license reproduction rights to literary works through collective licensing with reprographic rights organizations like the CCC. New collective licensing initiatives (i.e., the PRC and the Authors Registry) are being developed by authors to manage the reuse rights (also called secondary use rights) for their works in electronic environments.

2. **Music.** Composers or lyricists generally enter into a direct licensing agreement with a music publisher in which all rights, *excluding* those for the public performance of their works, are assigned to the publisher. These creators (and sometimes the publisher, if the creators have transferred all rights to the publisher) assign the public performance rights to one of the three collective societies (ASCAP, BMI, SESAC) that administer these types of rights in the United States. Creators can also administer their public performance rights directly, since they assign them to the music societies on a nonexclusive basis.

 Music publishers may assign mechanical reproduction rights to an agency that handles negotiations for these rights (e.g., the Harry Fox Agency), or they may direct-license them. Grand rights for large dramatic productions like theater, opera, ballet, or musicals are directly negotiated and licensed by the creators and/or their publisher because they are relatively rare, individually more valuable, and involve issues of artistic control and integrity as well as remuneration. The rights to publish the written score of a musical work also is direct-licensed, either by the creators or by their publisher, although these rights may be collectively licensed in certain circumstances (such as in the case of reprography, if the score is being photocopied).

3. **Visual imagery**—still and moving images. The management of rights for visual imagery is a complex mixture of traditions and independent efforts. Images produced by professional photographers may be direct-licensed by the photographer, assigned to a stock photography agency for centralized marketing and rights administration, or considered under a **work for hire** arrangement (where rights lie with the hiring agent). Rights assigned to a stock photography agency are usually exclusive for a set period of time.

 Images that reside in visual resource repositories in universities or museums are traditionally direct-licensed or used under fair use provisions. The increasing demand for such images on electronic networks, and the recent work of the MESL project (which explored the feasibility of licensing these resources for educational use in this environment), has been the catalyst for two collective licensing initiatives (AMICO and MDLC) for these properties.

 Moving images present a complex intellectual property management scenario of direct licensing between sources and distributors. So many creators are involved in the production of a motion picture (e.g., screenwriter, producer, director, actors), with so many varied interests at stake, that most uses are direct-licensed. There is, however, at least one instance in which collective licensing is more feasible: the administration of public performance rights for home videos. The major

motion picture studios created the MPLC to administer the licensing of these rights so that the studios would not have to expend corporate resources to negotiate them individually.[12]

4. **Works of art.** Works of art that are still under copyright are direct-licensed by either the rightsholder (usually the artist, or his or her estate or heir) or an artists' rights organization assigned to act as an agent on the rightsholder's behalf. Galleries representing an artist also may act as an agent for certain rights. Many, if not most, artworks are in the public domain and can be displayed, reproduced, have derivative works made from them, and so on, without permission. In reality, however, even works in the public domain are difficult to "use," since they are often owned by individuals or institutions that can restrict access to them.

 Because most museums, private collections, and other repositories that own art works often do not own copyright to the works, the administration of this type of intellectual property can be complex. These repositories may own the copyright on the images they make of these works, but the underlying right to the artwork represented in the image must be cleared with the rightsholder before the image can be used in display or publication.

5. **Software.** Software is licensed directly by the creator or company that developed the software product. (Videogames, which are sold rather than licensed, are a notable exception.) The software industry pioneered the concept of the "shrink-wrapped" license for individual users, in which license terms are deemed accepted by the opening of a sealed envelope containing the software, and by use of the software. There are questions as to whether one can legally enforce a license that can be read only after purchase of the product,[13] but from the software industry's perspective, shrink-wrapped licenses allow them to distribute low-cost software in great volume without the overhead and delay associated with contracts negotiated individually.

 Large-scale software use in multiuser environments (businesses, schools, government offices, etc.) is negotiated via contracts such as network, site, or volume licenses. There are associations of software publishers that collectively work to combat **software piracy** (i.e., the Business Software Alliance [BSA] and the Software Publishers Association [SPA]), but they do not collectively license software products.

 Electronic networks are fostering new developments in software distribution. Software brokers are emerging on the Internet with repertoires of software components that users can browse, purchase, and acquire electronically.[14] A new trend toward making software available freely for individual use (such as World Wide Web browsers), and the rising popularity of concepts such as **superdistribution** (an approach to software distribution in which a software product is made

available freely but usage is metered for payment) may alter the licensing and distribution paradigm under which the software industry currently operates.

6. **Graphics.** The graphics industry has grown exponentially with the development of multimedia and the World Wide Web, which have opened up new markets for these works (and for the software used to create them). Graphic works are both directly and collectively administered. The graphic arts industry is represented by a trade association (the Graphic Artists Guild), which has announced plans to develop a licensing collective in conjunction with the CCC and the American Society of Media Photographers (ASMP).[15] Currently, most collective licensing for graphics takes place through stock photography and illustration agencies that manage both traditional graphics (i.e., works on paper such as line drawings and illustrations) and the newly emerging field of digitally generated graphics (i.e., clip art and illustrations, fonts, textures, backgrounds, and special effects).

 Fonts present a unique category of intellectual property because they are an amalgamation of software and graphic art. (Throughout this report, fonts are grouped with graphic works, although some providers treat them as a specialty software.) Before computers were developed, type was created by designers and sold to typesetting businesses as part of typesetting equipment. The introduction of the Macintosh™ computer in 1984 made it possible for anyone to create a typeface, and the field grew exponentially as a result. Today, personal computers and electronic networks have transformed fonts from "add-ons" for a mechanical device to a category of intellectual property in its own right.[16] Fonts are licensed directly (by their creators or by foundries) and collectively (by stock agencies). A cursory review of typeface foundries on the World Wide Web reveals that these organizations, which previously had licensed only fonts produced in-house, are increasingly serving as brokers for fonts created by others.

7. **Dance.** Choreography (the arrangement and composition of dance) is eligible for copyright if, like other creative works, it is recorded in a fixed format. In the past, dance was often reproduced by teaching movements to others through demonstration, repetition, and memorization. Today, dance choreography is routinely recorded on video, on paper (using stick figure drawings, textual descriptions, or movement notation methods such as labanotation), or in digital form (using dance notation and animation software). Copyright ownership of dance choreography belongs to the individual who *records* the dance in a fixed format. If a choreographer is employed by a dance company to create works specifically for the company, the copyright to the work belongs to the company as a "work for hire." However, if a choreogra-

pher is commissioned to create a work for an individual or dance company, copyright ownership is negotiated as part of the terms of the contract between the choreographer and the commissioning agent.[17]

Dance is considered a dramatic work under copyright law, and its uses generally entail complex staging and issues of artistic interpretation. Because of these factors, the rights issued for dance are usually grand rights, which are negotiated individually (i.e., direct-licensed) between the copyright owner and user.

8. **Multimedia works.** The newest and most complex genre of intellectual property, multimedia works combine two or more of the previously described intellectual property genres in a way that itself constitutes a new creative work. The copyright issues in a multimedia work can be overwhelming, particularly if the work contains hundreds or thousands of separately copyrighted works within it. Most copyrighted items in a multimedia work must be direct-licensed. However, the burden of undertaking direct licensing with so many rightsholders for so many items has led more users to support the idea of collectives or large multimedia licensing clearinghouses that can facilitate the rights acquisition process. No such clearinghouse has materialized, although if intellectual property management organizations continue their trend toward administering content from various genres they may eventually evolve into clearinghouse-like organizations.

Models of Operation

Service providers are frequently categorized by various structural, business, or management models such as brokers, collectives, or resellers,[18] categories that often mask the variation and complexity in intellectual property management organizations. The increasing trend for service providers to perform roles that are traditionally aligned with different models (e.g., collectives that also serve as brokers, brokers that serve as resellers) suggests that the picture is not so clear-cut as categorizations might imply. Moreover, the inconsistent usage of typological distinctions and terminology among authors (e.g., one person's "broker" is another person's "locator service") creates more confusion than clarity.

At best, classifying service providers by organizational models provides a general sense of the underpinnings of an organization's setup, but not of its operations. An extensive study of collecting societies in Australia, and a comparison with their counterparts around the world, revealed that organizations defined under the model of a "collective" differed in everything from the way they undertake similar tasks, to their organizational and legal structures.[19]

In the United States, the music performing rights organizations offer a good example of how the collective model can vary in the area of governance. While all three providers (ASCAP, BMI, and SESAC) are universally referred to as collectives, only ASCAP is a collective in the sense that it is a member-run organization, with a member board and membership-wide voting. SESAC is a privately held family corporation. BMI is a corporation owned by broadcasters: Composers, writers, and other members have no voice in its management.[20] All "collectively" administer the performing rights of their rightsholders' works, but do so through differing governance and operating structures.

Basic Services

The primary function of an intellectual property management organization is to fill an intermediary role between rightsholders and users in the administration, access, and procurement of intellectual property. While each provider fulfills this function in its own unique way, there are six basic tasks that all providers must undertake to function as a useful intermediary:

1. Compiling a repertoire of select materials (e.g., images, journals, musical compositions, illustrations) for use by various communities. These repertoires may be centrally located on- or offsite, or may be located at the rightsholders' site.
2. Organizing and documenting the intellectual properties in the repertoires to facilitate internal management, to allow identification and retrieval of works based on varying criteria, and to offer appropriate descriptor information for external inquiries.
3. Developing procedures for permitting use of the intellectual property in the repertoire (e.g., licensing, online access permissions, pay-per-use, etc.)
4. Distributing intellectual property *or* directing the user to the appropriate place for procuring the intellectual property.
5. Securing payment (e.g., fees, subscriptions, usage charges) in return for services offered.
6. Monitoring usage of works in the repertoire.

In performing these basic functions, service providers have developed a wealth of specific services that are attractive to both rightsholders and users. Technical assistance is among the most highly valued of all services, particularly when the intellectual property is managed and distributed electronically. Technical services include offerings such as scanning images, text, graphics, and other data sources for use in the service

provider's database, data formatting, and Web site development. For users, these services may also include converting digital (or even conventional analog) images into different formats for use in specific applications.

Data enhancement services form another category of offerings. Captioning, indexing, cataloging, editing, and data standardization are included here, as are security procedures like **watermarking** and **encryption** for providers that also distribute intellectual properties and want to protect their use on electronic networks. The enhancements that service providers add to the works in their repertoires often increase the value and useful-ness of the intellectual property, and rightsholders frequently request the enhancements for their own internal use. Service providers may comply with such requests by offering the enhancements (often copies of a digital image or record) to the rightsholder at no charge, or at a reduced fee.

Providers also offer usage monitoring and surveillance services. Usage information and statistics are necessary for internal bookkeeping, identifying new markets and commonly used intellectual properties, determining the frequency in types of usage, and calculating royalties. Monitoring methodologies are often a compromise between resource expenditure and the need to derive accurate usage statistics from a variety of sources. The music industry monitors performing rights usage by means of an elaborate system of surveys, samplings, logs, and projections. The process is complex and frequently criticized for being unfair and inexact, but it evolved from a need to establish a workable monitoring methodology that would not consume all the resources of the collective.[21]

Providers with less complex monitoring needs may allow users to "self-monitor" within an honor system, or may require the user to imple-ment a monitoring strategy that is subject to audit by the service provider. Electronic monitoring technologies, which hold the promise of more accurate tracking capabilities, are now appearing on the market. SESAC is using a state-of-the-art system that identifies, using a digital pattern recog-nition system, any song in the SESAC repertoire whenever it is played on the radio.[22] BMI has developed a Web robot that monitors the use of music from the BMI repertoire in cyberspace.[23] Digimarc™, a digital watermark technology company, now offers a Web spider that tracks watermarked digital images across the Internet.[24]

Some intellectual property management organizations provide legal services as one of their offerings, although the need for legal services varies depending on the provider's policy on infringements. Larger organi-zations have fully staffed legal departments that actively seek out and pur-sue infringements all the way to and including litigation. Others rely on the occasional services of an outside law firm to issue "cease and desist" warnings, but do not enter into litigation. Some providers may choose not to pursue infringements because of resource limitations, or because they

have chosen to leave this option to the discretion of individual rights-holders. Other providers will pursue infringements only if they take place against a group of their rightsholders. And some service providers find that it is unnecessary to pursue infringements because the incidence in their industry is relatively infrequent and can usually be stopped with a telephone call or a letter.

Providers that diligently pursue large-scale infringements often do so to educate rather than litigate. A high-profile infringement case presents a rare opportunity to reach a large group of users, and to curtail infringements that are at risk of becoming tolerated because "everyone does it." But most providers pursue infringement cases judiciously. They can tie up the financial and administrative resources of an organization, create a public relations fiasco (as was the case of *ASCAP v. the Girl Scouts of America*),[25] or result in a ruling that runs counter to the provider's intent.

Education and advocacy also form a core area of service provider offerings. Organizations representing professional memberships such as photographers, writers, or artists frequently have advocacy programs to monitor copyright legislation and its impact on their constituencies. Educational programs include copyright awareness training, membership outreach, and training on issues specific to rightsholders' and users' interests.

Providers affiliated with a membership organization may offer personal member benefits such as insurance (ASCAP offers musical instrument insurance at a reduced rate, for example), professional career services, and personal Web site development. Some will act as agents for an artist, photographer, illustrator, or others seeking special assignments, or for users who are seeking content that is not available in the provider's database.

Other Operational Issues

1. **Managing specific rights.** Service providers rarely manage all the rights associated with an intellectual property; they focus instead on a bundle of rights determined by rightsholder and user needs, markets, and the objectives of the provider. The music collectives, for example, administer only the nondramatic performance rights of their members' musical work because these are small rights with a large market that cannot be administered effectively by individual rightsholders. The grand rights for dramatic performances (which are rarer and more commercially lucrative) are licensed directly from the rights owner. **Mechanical, synchronization**, and **electrical transcription rights** require more individual negotiation, and thus are licensed either directly or through an intermediary agent.

 The rights managed by some service providers are very narrowly defined. The Publication Rights Clearinghouse administers only the

electronic reuse rights of its members' works because the **first-use rights** are managed by publishers or literary agents. The Authors Registry, which is still in a formative phase, is structuring itself to manage reprographic, electronic, and multimedia rights, and other forms of reuse or extrause (i.e., beyond first use) rights for written works. Because service providers administer only a select group of rights, rightsholders may find they need to employ a strategy for intellectual property management that includes a number of service providers overseeing separate groups of rights, and perhaps some direct licensing between the rightsholder and user as well.

2. **Markets and marketing.** Access to markets and marketing strategies is one of the many reasons rightsholders partner with service providers. Providers have better knowledge of user markets and have systems in place for reaching those markets that rightsholders do not have the means to develop. But providers target only markets consistent with their organizational goals, which may or may not include markets that a rightsholder wishes to address. Stock photography agencies have traditionally focused on marketing their images to the publishing and advertising industries. Of late, the educational market is receiving considerable attention from journal publishers, resulting in projects like JSTOR and Project Muse (which provides networked access to journals), and from the museum community, resulting in initiatives such as AMICO and MDLC.

A key assumption held by rightsholders and intellectual property service providers is that markets are expanding at a tremendous rate because of electronic networks. Service providers are responding accordingly by using (and relying on) these networks to reach international audiences and enlarge their marketing channels. Those organizations that serviced the "trade only" are moving toward a more open policy of allowing anyone to access their repertoire databases. Contracts are being developed that allow for the legal use of images, music, and graphic arts on Web sites. The availability of new online markets is undoubtedly contributing to providers' expansion of services and the move toward administering intellectual property from several different genres.

A provider's goals and objectives most frequently drive its marketing strategy, but other variables (e.g., founding organizations, collaborators, tradition) have an impact as well. Image Directory is using the marketing powers of its parent company, Academic Press, to promote its product and services. Stock photography agencies and other image providers have traditionally used print catalogs of selected works from their repertoires as a marketing device. They are continuing this tradition in the electronic world by publishing these catalogs on CD-ROM

rather than in print. More and more service providers are collaborating with other groups to market their materials jointly (e.g., Picture Network International, a large stock photography agency composed of smaller stock agencies) or to expand their marketing reach through relationships with their third-party distributors (which develop their own marketing for the service provider's product).

The types of materials service providers use in their marketing strategy range from traditional brochures, pamphlets, and other print literature to more interactive Web sites and sample CD-ROMS. Community outreach workshops and a display presence at conferences are common ways for service providers to engage the interest of both rightsholder and user communities. Of late, service providers are offering free access to their repertoires for a limited time period as a way to introduce their offerings to rightsholders and users.

Marketing is important to all parties in an intellectual property management relationship, albeit for differing reasons. From a service provider's perspective, it is the primary way to gain new and renewed business. For rightsholders who have entered into an agreement with a provider, marketing strategies affect how much their intellectual property is used and who uses it. For users, marketing provides information on a content source and the means for legally procuring it.

But marketing is an odd mix of education and promotion, which calls into question its reliability as an objective representation of information. Because marketing is so vital to all the key players in the intellectual property rights management arena, a service provider's marketing strategy is an important factor for consideration. Rightsholders in particular must determine whether a provider's marketing will generate the results they anticipate. A rightsholder must also decide whether the provider's marketing strategy is compatible with their individual or institutional ethos. A strategy that aggressively pursues a direction with which the rightsholding organization is not comfortable is certain to bring on conflict and difficulties in the service provider/rightsholder relationship.

3. **International administration.** Foreign markets present an interesting problem for service providers. The impracticality of keeping abreast with every national and international copyright law, and the inability to administer their members' rights in every country, has led providers to develop reciprocal agreements with similar agencies in foreign countries to manage their members' rights in those countries. Works by artists represented by VAGA (the Visual Artists and Galleries Association), for example, are protected in France by ADAGP (Societé des Auteurs des Arts Graphiques), and vice versa.[26] Uses are negotiated

and royalties are collected and sent back to the "home" provider, which usually takes a commission or a percentage of the royalty for handling the transaction, as does the affiliate.

Some providers have an extensive network of agreements with foreign organizations (e.g., ASCAP has agreements with more than forty-five foreign affiliates). As electronic networks extend access to global audiences and render geographical boundaries irrelevant, and as copyright in the digital realm is debated and negotiated on an international stage, the nature and extent of these relationships are certain to change in response.

Notes

[1] Al Kohn and Bob Kohn, *The Art of Music Licensing* (Upper Saddle River, NJ: Prentice Hall, 1992), 623–625.

[2] Stanley M. Besen and Sheila Nataraj Kirby, *Compensating Creators of Intellectual Property: Collectives That Collect*, #R-3751-MF (Santa Monica: RAND Corporation, 1989), 17.

[3] See the Publications Rights Clearinghouse [http://www.nwu.org/nwu/prc/prchome.htm] (1998).

[4] Figures reported on the Web sites of ASCAP [http://www.ascap.com] and BMI [http://www.bmi.com].

[5] Picture Network International [http://www.publishersdepot.com/pubdepot/guest/act/about] (1997).

[6] "Nobody Listens like SESAC," Promotional brochure available from SESAC, 53 Music Square East, Nashville, TN 37203.

[7] "The Motion Picture Licensing Corporation is an independent copyright licensing service exclusively authorized to grant Umbrella Licenses to organizations and institutions for public performances of home videocassettes and videodiscs." [http://www.mplc.com/] (1997).

[8] JSTOR's mission is to "help the scholarly community take advantage of advances in information technologies. In pursuing this mission, JSTOR has adopted a system-wide perspective, taking into account the sometimes conflicting needs of libraries, publishers, and scholars. JSTOR's goals include the following: To build a reliable and comprehensive archive of important scholarly journal literature; To improve dramatically access to these journals; To help fill gaps in existing library collections of journal backfiles; To address preservation issues such as mutilated pages and long-term deterioration of paper copy; To reduce long-term capital and operating costs of libraries associated with the storage and care of journal collections; To assist scholarly associations and publishers in making the transition to electronic modes of publication; To study the impact of providing elec-

tronic access on the use of these scholarly materials." [http://www.jstor.org/about/mission.html] (1997).

9 Richard Weisgrau, Media Photographers Copyright Association, personal communication, (1997). MPCA's mission, as stated on the organization's Web site, is: "MPCA will be a positive force in global industry, striving to facilitate the business relationship between photographers and their clients, and to reduce costs of transactions, thus increasing the profitability of both, while advancing ethical, clear, fair and acceptable business practices. MPCA will strive to develop existing and new markets, providing new opportunities for photographers and their clients. It will seek to provide fine photographic imagery for all applications consistent with advancement of the publication photography business. MPCA will address the posterity interests of photographers and encourage cooperative enforcement by providers and users of photographic images. MPCA will see technology as a benefit and a tool to be exploited, not feared. It will employ new technology to advance the interests of photographers and their clients, and fulfill this mission." [http://www.mpca.com/].

10 See Copyright Clearance Center Annual Report to Rightsholders. 1996. Available from the Copyright Clearance Center at 222 Rosewood Drive, Danvers, MA 01923.

11 See the National Writers Union Web site [http://www.nwu.org/nwu/] (1997).

12 Sal Landicina, Motion Picture Licensing Corporation, personal communication (1997).

13 F. Greguras and S.J. Wong, Software Licensing Flexibility Complements the Digital Age [http://www.globetrotter.com/art5.htm] (1994).

14 Richard Lucash, Licensing Strategies in the Global Marketplace. Materials prepared for a presentation at the Massachusetts Legal Education Seminar [http://www.lgu.com/con51.htm] (1997).

15 See Copyright Clearance Center, "Collective Copyright Licensing to Benefit Individual Photographers, Artists, and Writers," press release [http:www.copyright.com] (1997).

16 Rudy VanderLands, Copping an Attitude [http://www.emigre.com/Copping.htm] (1995); Fontworks UK Ltd. [http://www.type.co.uk/fnet/fwks/] (1996). The status of fonts as intellectual property protected under U.S. copyright law remains in dispute. For information on the legal history and basis for this dispute, and the current status of typefaces as a form of intellectual property, see the Web site of Typeright [http://www.typeright.com] (March 1998), which represents a coalition of typeface designers working "to promote typefaces as creative works and to advocate for their legal protection as intellectual property." Jack Yan, a typeface designer, also provides information on legal aspects of the dispute at his business's Web site [http://www.jyanet.com/font-10.htm] (March 1998).

17 "Aspects in Dance," CopyRong [http://edie.cprost.sfu.ca/~jacsen7/dance.html] (January 26, 1998).

18 See David Bearman, "New Economic Models for Administering Cultural Intellectual Property," *The Wired Museum*, ed. Kathy Jones-Garmil (Washington, D.C.: American Association of Museums, 1997), 254–259; Jennifer Trant, "Exploring New Models for Administering Intellectual Property: The Museum Educational Site Licensing (MESL) Project," Digital Imaging Access and Retrieval. Papers presented at the 1996 Clinic on Library Applications of Data Processing, March 24–26, 1997, Graduate School of Library and Information Science, University of Illinois at Urbana–Champaign, ed. P. Bryan Heidorn and Beth Sandore [http://www.archimuse.com/papers/ jt.illinois.html] (1996); Kelly Frey, "Text of Intervention," Copyright Clearance Center [http://www.copyright.
com] (1997); Glen Bloom, *Administering Museum Intellectual Property. A Report Prepared for the Canadian Heritage Information Network* (Ottawa: Canadian Heritage Information Network, 1997). Available online by subscription at [http://www.chin.gc.ca/Resources/Research_Ref/Reference_Info/e_reference.html#INTELLEC] (1997).

19 Shane Simpson, Review of Australian Copyright Collecting Societies. A Report to the Minister for Communications and the Arts and the Minister for Justice [http://www.dca.gov/au/pubs/simpson/simpson2.htm] (June 1995).

20 Besen and Kirby, *Compensating Creators*, 17.

21 See Barry M. Massarsky, "The Operating Dynamics Behind ASCAP, BMI and SESAC, The U.S. Performing Rights Societies," Proceedings: Technological Strategies for Protecting Intellectual Property in the Networked Multimedia Environment [http://www.cni.org/docs/ima.ip-workshop] (1994) and Ralph Blumenthal, "King of the Jingle Hunts Royalties," *New York Times* (April 29, 1997): B4.

22 SESAC Expands Electronic Monitoring System [http://www.sesac.com/focus1.htm#SES].

23 BMI Introduces MusicBot™ to Monitor Music on the Internet [http://www.bmi.com/reading/news/musicbot.html].

24 See Digimarc™ Web site at [http://www.digimarc.com/prod_fam.html].

25 Blumenthal, "King of the Jingle Hunts Royalties," B4.

26 "Your Rights Are Protected Worldwide," *The Eye: VAGA Newsletter* [n.p., n.d.].

6. Managing Content and Usage

A. Content

Until recently, the types of intellectual properties managed by service providers existed in physical formats such as books, records or audio compact discs, works of art, movies, and so on. Increasingly, **digital objects** are emerging alongside these works. Some of these objects are unique to the digital realm (e.g., software), and others are a recasting of a physical work into a digital form (e.g., transparencies into digital images). Nearly all the nondigital intellectual properties examined in this study are being transferred, in whole or in part, into digital forms to take advantage of the access and distribution channels afforded by electronic networks.

The type of content, and its traditions of use and availability, may dictate distribution and management. Music and reprography collectives, for example, do not distribute the intellectual property they manage because it is readily available from other sources (e.g., stores, publishers, etc.). Images, on the other hand, reside with a limited number of sources, and a service provider must provide the distribution channel for the user.

Service providers that also serve as distributors for intellectual property can do so only if rightsholders deposit copies of their works with the provider. Providers have preferences for how, and in what form, they wish to receive these copies. Digitized versions are often preferred, but digitization presents a roadblock for many rightsholders, so providers do not yet insist upon it. Instead, they may accept content in various analog forms and digitize it themselves. Sometimes a service provider will insist on doing its own digitization, even when a rightsholder can provide a digital copy, in order to maintain quality control for all the digital content in its repertoire. Providers that do offer (or insist) on in-house scanning and data conversion usually charge a fee for doing so. They may also insist on copyright for the digital copies they create, which is a source of contention in the cultural heritage community.[1]

Providers that distribute works in nondigital formats require deposit of at least one high-quality copy or (in the case of images and illustrations) an original, from which duplicates are made for distribution. The costs of making duplicate copies are usually passed along to the rightsholder. In addition, a few providers charge "processing fees" for incorporating content into their repertoires, with payment due at time of submission or to be deducted from initial royalties.

Selection

The intellectual properties selected for inclusion in a service provider's repertoire may be chosen by the provider, the rightsholder, or representatives of both parties. Collectives like ASCAP and BMI require that all of a rightsholder's musical works be included; others (like the CCC and Media Photographers Copyright Association) ask members to register or submit the particular works they want included. Consortia tend to select content based on member consensus of what best addresses a given consortium's goals.

The criteria used for selecting content are equally variable. For service providers, the selection criteria are most often driven by market potential and demand, although some providers will accept whatever a rightsholder can make available at a particular time. If the decision is left to the rightsholder, the selecting criteria are most often availability and quality of content, as well as known demand for particular types of works.

JSTOR is devising a unique selection method that includes objective and subjective criteria linked directly to its long-term goals. Objective criteria include such factors as the number of institutional subscribers to a journal (an indicator of its importance in the community), the length of its print run (journals with long print runs are preferred because one of JSTOR's goals is archiving), the frequency of citations to a journal (another indicator of the value of its content within the community), and the interdisciplinary nature of the journal. Subjective criteria include scholarly appraisal of the importance of a journal to a particular discipline.[2] JSTOR's carefully articulated selection criteria are an anomaly among service providers. The prevailing selection methodology for most providers relies heavily on informed intuition about markets and the availability of "good" content (i.e., well documented and of high fidelity).

Service providers that administer and distribute image-based works are more particular in their selection than providers in other industries. Their more stringent standards stem from the traditionally commercial market for images (e.g., publishing and advertising), which demands high quality and distinct types of subject matter. While rightsholders may initially select the content they wish to contribute, the service provider has

traditionally had the final say, and may radically cull a rightsholder's initial submission. Stock photography agencies, for example, typically review hundreds or thousands of high-quality images submitted by a particular photographer, but accept only a small percentage of them based on perceptions of whether the subject matter is marketable.

Because of the different ways content is selected, repertoires can be highly biased resources. Stock photography and footage agencies prefer images of landscapes, people, animals, and events, the topics heavily favored by commercial markets such as advertisers. The music performing rights collectives accept works that have been published or recorded, which means that most indigenous music, sound effects, and related works are not represented. Consortia that function as service providers may have a very selective repertoire designed to test specific assumptions, or they may use only those materials that are readily available in digital form. Nearly all providers exclude intellectual properties that they consider problematic for one reason or another. Consequently, works by contemporary artists, works whose copyright status is uncertain, or works published before or after a certain date may be excluded.

For cultural and educational organizations, such biases present a special concern for the long term. If economic markets drive the availability of intellectual property, there will be a constant recycling of a select subset of cultural heritage works. Scholarly research, which relies on breadth and depth of resources, will be compromised. The majority of cultural materials will continue to remain unavailable because they present copyright "problems" or do not offer attractive economic returns.

Quality and Quantity

The intellectual property in a service provider's repertoire may vary in quality or fidelity. A number of providers will accept content in any condition or form, usually as an incentive for rightsholder participation. Font agencies, for example, accept typefaces in various stages of development—from initial "concept" through completion of entire analog and digital character sets. Providers that broker access to content—but do not distribute it—accept minimal quality levels as well, referring users to rightsholders for higher-fidelity versions.

Incentives that might encourage rightsholders to submit high-quality content are not common. Font agencies offer higher royalty percentages to creators who submit completed typefaces, and two museum initiatives (AMICO and MDLC) will be defining incentives as their programs develop. Other providers do not offer incentives of this sort either because they do not distribute content (and thus do not have to provide users with a high-quality version of a work) or because anything less than

high-quality content is rejected as a matter of course (as with stock photography providers).

Rightsholders may be required to contribute large amounts of content to a service provider's repertoire as a condition of participation. Initial content contributions must usually be received shortly after an agreement has been signed (within two to three months) to ensure that a rightsholder is committed to the relationship. Annual content contributions may also be required to enlarge the repertoire and to continually refresh it with an influx of new materials.

Contextual Information

Service providers require rightsholders to provide identifying contextual information for each of the intellectual properties they contribute to the repertoire. This information is used to track and monitor the works, and often forms the basis for searchable databases, indices, and other user tools that the provider builds to enhance access to the repertoire. Users also value this information because it places a given item of intellectual property within an identifiable framework. Well-documented intellectual properties are a frequently cited incentive among users in their selection of service providers. (See Chapter 7, Section B, "User Incentives," pages 79 to 81.)

The actual amount of contextual information that a service provider requires can vary from a simple caption to detailed records. (For examples of the range of variation, see Chapter 7, Section A, "Administrative Burdens," pages 76 to 78.) In some industries, a wealth of contextual information is not necessary. Users who license with music collectives do not need to know much more than the name of the work, the recording artist, or the publisher. Users of fonts tend to search for content by font "families," an organizational schema similar to genres in art. But users of cultural heritage works require extensive information on these properties. Providers of cultural materials are stymied in their efforts to meet this demand by the lack of documentation standards in the cultural heritage community. To solve this problem, some providers create their own recording structures (e.g., data dictionaries) that rightsholders are asked to comply with when submitting their content so that the provider's repertoire will have some internal consistency.

Location and Distribution

There are different models for how and where content can be stored and distributed. Service providers may hold duplicate copies of all the content at their sites, or the content may reside only with the rightsholder, who

will be called upon to make it available for distribution when a user requests the material. Sometimes content location is determined by the technical and administrative infrastructures of the service provider and the rightsholder. Providers that distribute content in nondigital media, such as stock photography and footage agencies, require that copies of the content be stored centrally at their sites to facilitate distribution. Although digital content is thought to be more amenable to distributed (as opposed to centralized) storage and access, all of the providers reviewed in this study maintain digital content centrally on their in-house servers. The technical challenges of distributed storage, including security, access, ease of use, and assured availability, have not been resolved to the satisfaction of providers, rightsholders, or users.

An alternative distribution strategy is to mount an entire copy of a repertoire locally at the user's site. This option minimizes infrastructure needs at the provider's end, and requires the user to take on the role of distributor. The universities that participated in both the MESL project and The University Licensing Project (TULIP) chose this alternative and were faced with formidable challenges (even with the reasonably sophisticated technical infrastructures of a university environment), in mounting the libraries, maintaining them, and redistributing them to end users such as campus systems, or to individuals such as faculty, students, and staff.[3]

Delivering copies of an entire repertoire to a user's site is feasible only if the amount of content in the repertoire is not too large and the user has an appropriate technical infrastructure for accepting and redistributing the content. Very few organizations can meet these criteria. AMICO, in planning for a large image library with a great deal of contextual information, is proposing an alternative two-pronged strategy for distributing its large repertoire: The consortium will make available low-resolution images and **tombstone data** from the library on the World Wide Web, and will use third-party information distributors to provide the full, detailed library to subscribers.[4]

Other mechanisms for distributing content from service providers to users are more straightforward, especially when the intellectual property being used is limited to only a few items (as opposed to an entire repertoire). Physical media such as transparencies, tapes, and slides are distributed using conventional delivery services (e.g., overnight mail). Digitized content is offered in fixed media such as CD-ROMs or high-capacity storage disks. Efforts to deliver digital content over electronic networks have met with mixed results. Although providers are willing to use their World Wide Web sites as distribution sources, bandwidth limitations on the user end do not make this a feasible alternative at present. Downloading files via **ftp** faces a similar limitation, and produces unacceptably high error rates in data transmission. The potential pitfalls of

online delivery has forced service providers to offer users several distribution and delivery options for digital content.

B. Usage

Electronic Environments

The seemingly infinite number of uses for intellectual property all derive from the five rights that are granted exclusively to rightsholders by U.S. copyright law, i.e., the right to reproduce a work, distribute it to the public, perform it publicly, display it publicly, and create derivative works from it. But uses occur within specific contexts, and what is permissible under one set of circumstances may be restricted in another—especially in electronic environments, where the ease of reproduction and dissemination has far greater consequences for a rightsholder. For this reason, service providers are cautiously defining usage in electronic environments to forestall illegal copying and dissemination. Permission for the digital reproduction of a work is subject to elaborate distinctions corresponding to the myriad ways one can copy in this environment. Downloading, printing, transferring, backing up, viewing, or displaying all require "copying" of content, and may be expressly permitted or prohibited. Electronic redistribution is subject to similarly fine distinctions. Intranet use may be allowed while Internet use may be restricted. Security measures (e.g., passwords, watermarks, encryption) may be required as a condition of use. Works may be electronically distributed only in fixed media on non-networked machines. Distinctions such as these are made to minimize or prevent rampant and unauthorized dissemination over electronic networks.

Display and performance uses in electronic media also bring forth distinctions absent from traditional media. Providers may insist that works displayed or performed in this environment are of low-fidelity (such as low-resolution images) or are digitally altered (by watermarking or other techniques) so they are not valuable enough to copy illegally. While most of these distinctions are made to forestall unauthorized copying and redistribution, the resulting diminution of quality is contrary to what most users want with intellectual property in other media (and perhaps in electronic media as well).

Arguably, the creation of derivative works in electronic media presents more of a dilemma for service providers than do other electronic uses. This problem may originate in definitions rather than permissions. What constitutes a derivative work in this environment? In the United States, creativity is the standard for determining whether a work is deemed "derivative." But how much creativity is warranted? Is a digital scan of a

photograph a derivative work or merely a conversion process? Is a pre-existing but digitally altered typeface a new work? What about images that have been color-corrected for display purposes? The distinctions for derivative works are much "grayer" in electronic environments, and the issues are far from being resolved.[5]

Permissible Uses

Uses are determined by a number of factors. The CCC has found that, over time, the uses made of its repertoire have been determined by rightsholders and users, with the former responding to the latter's demands.[6] Service providers that broker or resell intellectual properties most frequently determine the uses for works in their repertoires on the basis of market demands. Ultimately a rightsholder approves all uses, either directly or indirectly via a service provider.

Certain groups of rightsholders want more input into the permission process than a blanket agreement will allow. Artists' rights societies, for example, must accommodate individual artists' concerns about the use of their creative works, and frequently need to consult with individual artists before approving a use, particularly when merchandising is involved. This strategy, although time-consuming and inefficient for a service provider, is nevertheless an absolute necessity for these organizations because usage is strongly tied to moral as well as economic rights.

Frequency is another factor in determining permissible uses. A request for one-time use of an image may be granted, while an unlimited-use request almost certainly will not. Unlimited uses are allowed for specific periods of time in circumstances that warrant them and that can be controlled, such as in site licenses or blanket licenses.

Context is the most important factor in determining whether a use is permissible. Knowing how a work is to be used, where and when it will be used, and why it will be used allows providers to judge the risks and the rationale of the request. One of the first tasks service providers undertake early in their formation is identifying all acceptable uses so that they can forego the time-consuming process of contacting each rightsholder for each requested use of their intellectual property.

Restrictions

Usage restrictions are prohibitions that service providers or rightsholders place on users of intellectual properties. Since it is in the interest of both providers and rightsholders to maximize the usage of intellectual property, restrictions against use are levied only if the use:

- Adversely affects the ability of the rightsholder or service provider to control the intellectual property,
- Jeopardizes revenue streams,
- Neglects the moral rights of the creator,
- Is incompatible with the philosophy of the provider and its members,
- Is illegal or immoral (including uses that defame or violate the privacy and publicity rights of individuals, are obscene or illicit, or that violate state or local laws).

Prohibitions against physically altering or modifying intellectual properties are by far the most common of all restrictions. Musicians cannot change the lyrics of a composer's song, nor can software users modify underlying programming codes. Changes that alter the integrity of an intellectual property are interpreted as an affront to the moral right of a creator to control alterations to his or her work. A creator's moral rights are also breached when a work is used in circumstances that compromise his or her reputation, and users are cautioned against controversial uses that might lead to such interpretations.

Another restriction commonly placed on intellectual properties is copying outside of authorized formats. A user who receives permission to photocopy an article cannot then scan that photocopy into his or her computer without seeking further permission. Copy restrictions are imposed in order to limit uncontrolled (and thus uncompensated) distribution of intellectual properties. The increasing availability of creative works in digital form, and the ease of replication that new technologies allow, makes this restriction a particularly important one to owners and administrators of intellectual property. Providers may insist on preventive measures such as encryption, or deterrent measures such as low-fidelity versions, to minimize the chance of illegal downloading. Or they may simply prohibit outright any downloading, printing, or electronic transfer of their digital content.

Redistribution of content is also restricted to minimize uncontrolled use. The sublicensing, reselling, renting, or leasing of content may be restricted for this reason, as may retransmissions, rebroadcasts, and re-recordings of original content. Often restrictions on content redistribution are enforced to minimize overexposure of a work. Some commercial users want content that is unique, original, or uncommon, and service providers may impose limits on usage amounts to reduce the possibility of overexposing the content in their repertoires and decreasing its marketability. Merchandising and publishing uses may be limited to a particular product or print run for this very reason. Similarly, stock film footage or photography providers limit the amount of time that their content may be used contiguously (for film), or the number of works that may be used simulta-

neously (for photographs). Rightsholders who participate in music collectives are allowed to request that certain works be temporarily removed from the repertoire if they feel that excessive performance is harming marketability.

Fair Use

The increasing use of licensing as a tool for administering intellectual property has raised concerns about the place of fair use in and out of a licensed environment. Licenses can allow for uses that extend beyond the scope of fair use if the parties to the license so choose, but uses stated in the terms of a license are binding only to those who have entered into the license agreement. What about users who are not licensing content but wish to use it for purposes that fall under the doctrine of fair use?

The concept of fair use is interpreted quite variably among service providers. Commercial providers often dismiss it as irrelevant to their circumstances, since they make their repertoires available for licensing only to the for-profit sector, where fair use can rarely be claimed. Providers that serve noncommercial markets have more liberal interpretations of the fair use doctrine. The Publications Rights Clearinghouse, for example, takes an open position on fair use because its members want to encourage readership of their works. They do not, however, feel that the for-profit information industry's use of their works constitutes a fair use, and are focusing their efforts on collectively administering rights for this industry.[7]

But even providers that support the fair use doctrine express ambivalence about it because they fear it may erode their market and revenue streams. Artists' rights groups, for example, acknowledge the importance of fair use and accord it automatically for certain uses (e.g., art journals or magazines, news reports), but carefully monitor other fair use claims because their members believe that more liberties are taken with the fair use doctrine for their works than with other types of intellectual properties.

Service providers' philosophical stance on fair use reflects values that directly translate into their operations. If fair use is given no accord, then all uses must be contracted and all noncontractual uses are considered infringements. While one may contest the legitimacy of such views, until they are legally challenged the service provider will operate under these assumptions.

A newly emerging threat to fair use is coming not from service providers or increased licensing but from technology. Encryption, passwords, and other security measures that prevent digital content from being misappropriated also prevent access to those who wish to use the content for fair-use purposes. Maintaining fair use under these circumstances is a

challenge that has only recently been discussed, and it will become a more urgent problem as service providers continue to adopt technology-based security mechanisms to safeguard their repertoires on electronic networks.

Managing content and its usage is the core function of a service provider's activities. Many factors affect the way that providers perform this function: Among the most important considerations are tradition, context of use, and the nature, form, and location of content. Of late, service providers are expanding their operations into the digital arena. Cultural heritage organizations may well turn to these providers for assistance because of their experience and their infrastructure for managing and distributing content in a digital environment. But before they do so, cultural organizations need to be familiar with the many issues that are germane to rightsholders and users who enter into intellectual property management agreements with external organizations.

Notes

[1] The disagreement rests on whether the making of a digital image involves creativity (and therefore qualifies as a creative work protected by copyright law) or whether it is a "conversion" process (akin to a photocopy), which has no creative input.

[2] Sarah Sully, General Counsel and Director of Publisher Relations, JSTOR, personal communication (1997).

[3] See *TULIP Final Report* (New York: Elsevier Science, 1996), 74–80; and Christie Stephenson and Patricia McClung, eds. *Delivering Digital Images: Cultural Heritage Resources for Education.* (Los Angeles: Getty Information Institute, 1998). In the MESL project, the repertoires were first sent to a central distribution point (the University of Michigan), where some validation checks were undertaken, then sent on to individual university sites, where they were locally mounted and made available to end users. The decision to distribute the repertoires in this fashion was made largely because of the strict time constraints of the project, and not because this was necessarily the best model for content distribution. For specifics, see Christie Stephenson and Clifford Lynch's article entitled "The MESL Distribution Process," *Delivering Digital Images*: 62–69.

[4] David Bearman, Business and Technology Issues in the Formation of AMICO. Paper presented in a session entitled " The Art Museum Image Consortium (AMICO): A Collective Initiative for Digital Rights Management, Electronic Commerce, Education and Data Interchange," at the annual meeting of the Museum Computer Network, October 18, 1997, St. Louis.

[5] In 1997, a suit was filed by the Bridgeman Art Library against Corel Corp. charging that Corel had violated its copyright by using its transparencies without permission in a CD-ROM product entitled "Masters I–IV." Corel contends that the transparencies are of works in the public domain, and its defense is based on the premise that no copyright exists in photographs of public domain works. In November 1998, a ruling was made against Bridgeman in the case [97 CIV. C232 (LAK) 11/23/98]. This will have enormous implications for cultural heritage organizations, which often rely on income from reproduction rights to their collections. Bridgeman plans to appeal the ruling.

[6] Cheryl Redmond, Copyright Clearance Center, personal communication (1997).

[7] Irvin Muchnick, "Protecting Writers' Rights Online," *MacWorld* (July 1996): 236.

7. Rightsholder and User Issues

Although rightsholders and users are represented as two distinct groups in an intellectual property management relationship, cultural heritage organizations frequently find themselves in both roles simultaneously. Participants in museum licensing collectives such as AMICO or MDLC want to contribute their intellectual property to these organizations' repertoires, as well as gain access to the collective materials in these repertoires for their own uses. Thus it behooves cultural organizations to understand both rightsholders' and users' issues, and the areas in which they are in agreement or at odds.

A. Rightsholder Issues

"Rightsholder" is the term used for any individual, institution, organization, or estate that holds copyright to creative works. An individual or entity becomes a rightsholder in one of three ways: by creating a work, by having copyright of a work transferred in a purchase, gift, bequest, or other assignment, or by hiring someone to create a work on one's behalf ("work for hire"). In certain sectors (e.g., book or journal publishing) or for certain projects (e.g., MESL), rightsholders are predominantly organizations, while in other areas (fine art, music, photography) they are individuals or their estates.

Rightsholders must possess certain qualifications or meet certain criteria before they can enter into an agreement with a service provider. For individuals, these qualifications include proof of activity in a relevant field or profession. Productivity is the form of proof most frequently accepted, although it is defined uniquely from one organization to another. ASCAP, for example, has extensively defined membership requirements.[1] Other organizations may simply require proof of creative content: e.g., artistic works for an artist, a portfolio of images for a photographer, and so on.

Consortia require that their members have interests that are aligned with a given consortium's goals, and are willing to share—

financially, legally, and administratively—in supporting the consortium. Providers that have a founding relationship with a parent organization may require that all members belong to the parent organization as well. The Media Photographers Copyright Association, for example, requires its rightsholders to be members of its parent organization, the American Society of Media Photographers.

Rightsholders must offer warranties to service providers guaranteeing that they are the legal copyright owner for the intellectual property. These warranties usually take the form of contractual guarantees certifying that the rights they hold are unencumbered (except where explicitly stated), that the work does not infringe on the copyright, trademark, patent, privacy, or publicity of any person or entity, and that the content does not defame any person or entity. Some providers require additional warranties stating that the rightsholder is free to enter into an agreement with the service provider without violating any other agreements. This practice is frequent among stock photography agencies, where exclusive rights contracts are commonplace. Warranties may need to be backed up by indemnification clauses and insurance policies to cover breaches should the warranties prove invalid.

In addition to meeting certain criteria and providing appropriate warranties, rightsholders may also be charged a fee to join a service provider's organization. Frequently these fees are token amounts (ASCAP and the Authors Registry both have a $10 membership fee) but they can be significant contributions, particularly for consortium members whose fees are often the major source of financial support for all activities. Fees may be proportional to the size of an institution (as determined by factors such as operating budget, number of employees or members, etc.) or may be a fixed rate for all participants.

Rightsholder Incentives

Because transferring the administration and distribution of one's intellectual property to another source is a serious undertaking, significant incentives must be in place for a rightsholder to do so. Providers go to great lengths to promote their organization's benefits over another's. In reality, the distinctions are often subtle or inconsequential, and the decision to affiliate with a particular provider is based on a personal relationship or rapport as much as on favorable incentives offered by one provider or another.

The most common rightsholders' incentives cited or offered by service providers are:

1. **Centralized administration and management.** Most rightsholders seek arrangements with service providers because they cannot manage

the multitude of uses and user requests for their works effectively. Centralized administration eliminates the burden of large volume/ small rights licensing from the rightsholder. The marketing of content, negotiating of licenses, collection of fees, and distribution of royalties are all administered by the provider with economies of scale that decrease both costs and risks.

2. **Extensive marketing and distribution channels.** Strong marketing capabilities expose a rightsholder's work to new and larger audiences. Increased exposure results in more users and uses for the intellectual property, which translates into greater royalty potential. Providers also offer effective distribution channels that help rightsholders get their works to users in the form and manner they request.

3. **Monitoring uses and pursuing infringements.** Service providers monitor intellectual property use to determine fee structures and royalty distributions, as well as to ensure compliance with the terms of use. Some providers have devised complex monitoring schemes or use new technologies to facilitate this process. In addition, service providers often have the resources available to take a more vigilant stance on infringement, and are motivated to do so because infringements erode their income stream as much as they do the rightsholder's. Rarely do rightsholders have the resources to undertake these tasks on their own.

4. **Services and tools.** Providers routinely offer rightsholders special services such as market and sales advice, assistance with developing and improving the documentation of their works, knowledgeable staffs, and efficient office infrastructures. Many providers offer educational opportunities (e.g., workshops, seminars) to increase awareness about rights issues, and advocacy services to monitor or support policy decisions that may affect their rightsholders' interests.

Recently providers have started offering productivity tools to help rightsholders make decisions about potential market opportunities. For rightsholders who rely heavily on royalties from their intellectual property as a main source of income, or who want to develop such a revenue stream, these tools can be an important incentive. With them, rightsholders can view all their materials in a provider's repertoire, including licenses, usage patterns, and revenues associated with each work. Rightsholders can use this information to make determinations about markets and audiences, and can refine their intellectual property management strategy and create new works that take advantage of opportunities on the horizon.

Other tools in development include those that allow rightsholders to link their electronic publishing projects to a service provider's repertoire, and discipline-based search and retrieval tools that allow more effective use of the repertoire database. Image Directory offers an

example of the latter with its inclusion of search and retrieval tools such as the *Art & Architecture Thesaurus* and the *Union List of Artist Names.*

5. **Favorable terms and conditions.** Service providers may offer a particular rightsholder more favorable terms and conditions than are generally offered to others. Some of the more commonly offered incentives are higher royalties or advances, input into uses and license fees, and lower operating costs. Favorable terms may be offered to a particular rightsholder for any number of reasons: The provider may be eager to have the rightsholder's content because it contributes substantially to the repertoire, or the rightsholder offers important name recognition that reflects well on the provider. Interested but reluctant rightsholders may be offered favorable terms as a means of persuading them to affiliate with the provider, and as a bargaining point in negotiating an agreement.

6. **Economic incentives.** The potential for income from royalties is the major economic reason that rightsholders enter into an agreement with a service provider. Advances (against future royalties) are often offered as an impetus for rightsholders who cannot afford to pay upfront fees or other participation charges. Some providers will grant a higher percentage share of the licensing fee to rightsholders as an economic incentive. For rightsholders' collectives, a strong incentive is found in the ability to keep more royalty income in a particular community (by eliminating middlemen and their fees).

7. **Access to the repertoire.** Access to works in a service provider's repertoire is an incentive to rightsholders who also are frequent users of content. JSTOR offers all its rightsholders access to its digital archive of journals. AMICO and MDLC plan to offer rightsholders access to their digital libraries as well.

8. **Organizational affiliation.** A service provider's affiliation with a parent or founding organization may be an incentive for certain rightsholders. The credibility of parent organizations lends an unofficial imprimatur to the service provider's efforts, which, in turn, offers a measure of trustworthiness and security to rightsholders. The experience of parent organizations also provides expertise and stability that is sought by rightsholders.

9. **Experimentation and exploration.** Rightsholders may choose to work with a particular service provider because they want to explore or clarify areas in which they have a stake and gain experience for future initiatives. The MESL project, for example, offered museums and universities a unique opportunity to explore how museum images would be used in higher education, and clarified what the technological, administrative, and usage issues might be. Publishers like the Johns Hopkins University Press (sponsor of Project Muse) and Elsevier Press

(sponsor of TULIP) initiated their projects, in part, because they wanted to explore the costs and issues associated with the distribution of electronic journals.[2]

10. **Access to technology.** Many rightsholders do not have the resources to exploit new technologies and media that can help them expand the market for their works. Service providers using these technologies successfully for promotion, monitoring, and distribution are attractive to these types of rightsholders. Picture Network International, a large stock photography agency, attracted its participants (small stock photography agencies) in this way. By offering a sophisticated technological and administrative infrastructure that smaller agencies could never develop on their own, PNI successfully recruited these smaller agencies to participate in its service.[3]

Assigning Rights

When rightsholders enter into an agreement with a service provider, they assign distinct rights to the provider for the term of the agreement. The rights assigned typically include the right for the provider to represent the rightsholders in negotiating uses of the intellectual property, permission to litigate infringements on their behalf, and permission to place the intellectual property in particular media for storage and distribution.

Other rights assigned in the agreement are more specific to the service provider's needs. Academic Press's Image Directory, for example, requests only an assignment of rights to use the rightsholder's images and descriptions in an electronic database.[4] Because they simply broker access to content and do not administer rights or distribute works, no other assignments are needed. ASCAP requires the assignment of nondramatic public performances of each of the rightsholder's musical works, as well as permission to sue for misuses of their work in the name of the Society, in the name of the rightsholder, or in conjunction with any other members.[5]

Although the trend in assigning rights is to do so on a nonexclusive basis, providers are often uneasy with this notion because it allows for competition that can jeopardize their revenues. Collectives in particular are concerned that the management of their rightsholders' intellectual property by different sources eventually undermines their strength in representing the rightsholders as a group. Despite these apprehensions, providers may have little say in the matter, since many rightsholders shun agreements with exclusive rights provisions. Notable exceptions are stock photography and illustrations agencies, which have a tradition of exclusive rights assignment as a means of controlling materials in their repertoires and preventing their use by competitors.[6]

Terms of Agreement

The terms of an agreement between a rightsholder and a service provider vary between industries, although common clauses exist in nearly all agreements. Among these are warranties and indemnities, in which the rightsholder may be asked to certify that he or she is indeed the copyright owner, has obtained all releases and clearances necessary for use of the work, and holds the service provider harmless if any copyright claims are made on the work that the provider has licensed on his or her behalf. Other common clauses include automatic renewals, methods for handling disputes, term of the agreement, rights that are assigned, and conditions for termination of the agreement.[7]

The duration of agreements varies by industry. For music, it is typically one or two years, with an automatic renewal. Stock photography, footage, and illustration agencies require a three- to five-year agreement from their rightsholders, although at least one image provider requests as long as a ten-year term. Nearly all service providers agree to remove a rightsholder's intellectual property from their repertoires within a reasonable period of time if the rightsholder chooses not to renew the contract. To assure continuity and service to users who may have already entered into a license that includes the rightsholder's works, providers may require that the intellectual property under license at the time of a rightsholder's withdrawal be kept in the repertoire until the end of the user's license period.

Reporting

Providers track usage and activity information for their own internal purposes as well as to inform rightsholders, both individually and collectively, how their intellectual property is used. Usage reports are commonly distributed to each rightsholder when royalty payments are made. Older and more established providers distribute detailed usage reports outlining the intellectual properties used, who used it, when, why, the venue of use (if relevant, as it is in the music sector), fees assessed, the provider's share of the fee, and the rightsholder's royalty for that use. For an individual rightsholder, these reports are the only way to objectively review the intellectual property in terms of monetary worth and relevance, and to make informed decisions about the long-term intellectual property management and creation strategy. Newer and less established providers strive to report information to rightsholders in as much detail as possible, but many are still setting up the tracking and monitoring systems required to do so. Consequently the reports issued to rightsholders by new startups may be quite sparse.

In addition to reports to individual rightsholders, providers also report information on organization-wide functions and operations in their public relations literature. This information offers insights into the volume of activity by a service provider undertaken during the course of a year, and usually appears as cumulative summaries "polished" to highlight positive (or minimize negative) performance. While public relations literature is biased toward the provider's own interests, it can be a source of organization-wide information that outlines the provider's performance and future directions. This literature frequently includes information on annual revenues, total royalties distributed among members, overhead costs, percentage of revenues distributed as royalties, total number of members, new licenses negotiated, and infringements currently being pursued or settled.

Administrative Burdens

Transferring the administration of one's intellectual properties to another party does not relieve a rightsholder of all administrative tasks or responsibilities related to the use of his or her works. Rightsholder assistance is required in various ways throughout the term of agreement. In general, rightsholders may be expected to provide their time (and in some cases, assume the costs) for tasks that can be categorized broadly as notification and reporting requirements, participation requirements, content preparation, and other obligations.

1. **Notification and reporting requirements.** Service providers routinely require rightsholders to supply them with information on the status of their intellectual property to ensure that they are managing it in a legal and effective manner. Rightsholders are obliged to inform providers about changes in the availability and use of any of their intellectual property, including changes in copyright status (e.g., when copyright reverts to someone else, or when a copyrighted works passes into the public domain). Changes in the status of permissible or restricted uses, venues of use, or fees for use of particular works (when these criteria are set or determined by the rightsholder) must be reported to the service provider as soon as they occur.

 The specific types of notification, and the way it must be conveyed (e.g., in writing), are usually outlined in the rightsholder/service provider agreement. Minimally, rightsholders are required to supply providers with information on all the works they wish to have included in the repertoire, and on new works that come into existence during the term of their agreement. They also must inform providers of all works that have encumbrances of any sort (e.g., images that need

model releases, works for which copyright is contested or is jointly held, works that cannot be considered for certain uses, etc.). If works in a provider's repertoire are available through other channels (via non-exclusive licensing agreements with other agencies, or by direct licensing), the provider may request notification on these other agreements. This notification helps prevent the provider from mistakenly judging these other uses as infringements, and from using these particular works in undesirable circumstances (such as licensing content to a client with the understanding that it is "unique," only to find that the client's competitor has licensed the same content from a different source). The provider will also want to monitor the value, use, and availability of the works in other sources to ensure that its own management of these works is competitive.

2. **Participation requirements.** Rightsholders may be required to participate in various activities at the service provider's behest. These requests do require the rightsholder's time and sometimes funds. For example, participation in discussion and negotiations may be required for special circumstances that fall outside of the provider's purview, such as a non-traditional user request. Rightsholders are frequently asked to assess the appearance of their intellectual properties in the provider's online database and search tools to determine whether they are adequately represented or portrayed. Some providers ask rightsholders to participate in surveys and focus groups designed to assess their operations and services.

 Rightsholders who join consortia are subject to the greatest participation requirements of all. Consortium members are committed to a process as much as a product, and this commitment requires their presence and participation at all meetings of the consortium, in all online discussions, and in special projects that the consortium may assign to them.

3. **Content preparation.** Providers that distribute intellectual property in addition to managing rights generally expect more content preparation from rightsholders. These rightsholders are responsible for helping select the intellectual properties that are to be included in the repertoire, and delivering them to the service provider in a format that meets the provider's specifications. If the present format of the intellectual property departs greatly from these specifications, rightsholders may face an extensive amount of work to bring their content into line. More research and documentation may be needed, and new annotations (such as captioning, indexing, keywords attached to each work, affixation of copyright notices) may be required. Rightsholders may also be required to physically reformat the content (e.g., transparencies to scanned images, catalog entry to database record) so that it can be used in the provider's online management and distribution systems.

Content preparation is costly in both time and money. Some service providers will help rightsholders offset costs by offering advances against royalties, or by assuming some of the preparation (such as reformatting content) for a fee lower than the market rate. However, much of the work involved in content preparation, especially in its documentation, can be undertaken only by the rightsholder. As creator and/or caretaker of the work, he or she has the credibility that authenticates the content and makes it valuable both to the service provider and to users.

4. **Obligations.** Rightsholders are obliged to comply with certain criteria that providers set as a condition of acceptance for administering their works. For example, service providers often require rightsholders to secure model and **property releases** for their works, provide copies of these releases to the provider, and maintain the originals in their own files for the term of the agreement. Similarly, clearances for any works that have underlying or "layered" rights associated with them (e.g., a photograph of a contemporary artwork) may be an obligation that a provider places on the rightsholder before a work will be accepted into a repertoire.

Once an agreement has been signed, terms of the agreement will impose additional obligations on the rightsholder. Some of the more common ones are annual contributions of content into the service provider's repertoire, and a guaranteed initial content contribution shortly after the agreement has been signed. Remuneration for certain startup or duplication costs (e.g., scanning, duplicate transparencies, inclusion of works in the provider's catalog) within a fixed time frame also may be required.

B. User Issues

Any individuals, institutions, or organizations that wish to use the intellectual property created by others are termed "users." Because the numbers and types of users are so diverse, service providers group them by markets, then develop services that address the broad needs of these markets. How a provider defines a user market can be arbitrary, depending on its own perceptions and the importance of that market to its operations. Certain markets, such as commercial ones, tend to be identified similarly by different providers, while other markets, such as education, are interpreted in highly variable ways.

Providers may also define their users by venues of use. The music performing rights collectives identify their users in this manner, categorizing them by where their repertoire is used (e.g., dance and aerobics classes, funeral homes, cruise ships, restaurants). The Motion Picture Licensing Corporation is another service provider that defines its user base

by venue, licensing the right to play home videocassettes to establishments (e.g., daycare centers, libraries, correctional facilities, oil rigs) rather than to individuals.

User Incentives

Of the numerous reasons that users may wish to enter into agreements with service providers for the procurement of intellectual property, the most important are:

1. **Centralized administration and management.** The benefits of being able to locate content and rightsholders from a single source, and of being able to transact licensing, payment, and content procurement through that source, are the primary incentives for user participation in collective licensing of any type. In the marketing literature of service providers, these benefits are often referred to as "one-stop shopping." By providing a central mechanism for managing or distributing intellectual property, service providers eliminate the burden placed on users of locating and negotiating agreements with individual rightsholders, reduce the paperwork, administration, and risk associated with direct licensing, and offer a single content source that is easy and efficient to access. Thus centralized administration of intellectual property—a key incentive for rightsholders—is also important to users.

2. **Economic benefits.** Because service providers can generate economies of scale in their operations, their user fees may be smaller than those incurred by direct licensing. Cost savings can be realized in other ways as well. The use of already available content, if it is appropriate to the task, is cheaper than producing new content in-house. And providers themselves offer special financial incentives, such as quantity discounts to frequent users.

3. **Type and quality of content.** A user is initially drawn to a service provider by its repertoire, or by the rightsholders the provider represents. Thus the quality of the items in the repertoire is of major importance, and is measured in terms of fidelity (e.g., high-resolution digital images), the exquisiteness and exactitude of the creative work being used (e.g., the uniqueness of a work and whether or not it was created by a prominent or professional person in the field), and the richness and value of the contextual information accompanying the intellectual property (e.g., detailed, authoritative documentation). Equally important is that the repertoire contain a critical mass of materials to meet long-term user needs.

 Good-quality, comprehensive content is also valued for the inspiration that users can draw from it when developing their own ideas

and projects. Users of stock photography agencies find that these agencies' large, varied repertoires are an idea resource as much as an image resource.

4. **Assurances.** Because the stability of electronically delivered resources is still uncertain, users take great risks in relying on these resources. If a repertoire, or a product derived from it, is "pulled" because it is not proving economically feasible, users may face serious consequences of their own. Assurances that the repertoire will be available in some form, even if the provider ceases operations, is therefore of primary importance. Providers can minimize the risk that many users fear of investing in and using digitally based resources by agreeing to: 1) place a copy of their digital repertoire in escrow, 2) guarantee each user a complete set of the repertoire in the event of provider default, or 3) make good-faith efforts to turn over the administration of the repertoire to another reputable party should the provider cease operations.

5. **Tools.** Users value tools that allow them to access, license, and retrieve content on electronic networks. Service providers are now commonly building sophisticated search and retrieval tools for use with their repertoires. Other tools that enhance the use of the repertoire include image-viewers, **digital lightboxes** and **shared digital lightboxes**, large print viewers, and print tools. Data analysis tools, hypertext links, and annotation utilities are also being developed and made available for scholarly use. Online selection and ordering tools such as **shopping carts**, order history utilities, and real-time pricing calculations make order fulfillment easier. When providers start using online payment systems (still a rare occurrence), the concept of seamless "shopping" will come full circle.

 Automated rights clearance and licensing systems are now emerging in the intellectual property management industry. An actual implementation of such a system is in place at Index Stock Photography, which has developed a "Photos to Go®" application that allows personal, small business, and small publication users to "point, click and buy" (and download) images for use in limited contexts.[8] The purpose of this suite of tools is to reach new and untapped markets by offering "hassle-free shopping." As service providers streamline their operations and expand their infrastructures to include electronic networks, full-service licensing systems like "Photos to Go®" may become more frequent, especially for uncomplicated licensing situations.

6. **Services.** Providers tout their personal and ancillary services as factors distinguishing them from their competitors. Among the more popular services are research assistance, training, custom content development (i.e., commissioning artists to create specially designated materials),

sample catalogs, efficient and knowledgeable staff, and short turn-
around times.

7. **Securing legitimate access and use.** The opportunity to secure intellec-
tual property in a legally and socially responsible way is an important
reason for working with a service provider. Doing so not only respects
the rights that copyright grants to creators, but also ensures that the user
receives defense and indemnification against claims of infringement.

User Participation

Users discover service providers through marketing, word of mouth,
knowledge of industry traditions, or after they have been confronted with
a charge of infringement. Marketing remains a primary method for
attracting users, even for sectors in which the traditions for managing
intellectual property rights and content distribution are well known.
Standard marketing and public relations strategies are used (e.g., direct
mail, telemarketing, event sponsorship, etc.); many organizations work
with constituent groups (like sponsoring or founding associations) to dis-
seminate information through their organizational channels. Consortium
projects often inform their communities and others about their work in
professional journals, newsletters, World Wide Web sites, project reports
at conferences and other venues, and demonstration projects.

When a user identifies an appropriate service provider, contact is
initiated through conventional means such as written correspondence,
phone, fax, or e-mail. Full-fledged participation (beyond initial inquiries)
is increasingly taking place via a provider's Web site. Many of these sites
are equipped with features (e.g., searchable databases, selection and order
placement, licensing approval, payment, and content delivery) that make
it easier for users with electronic access to take full advantage of service
providers' offerings. Users who wish to make use of a provider's Web site
offerings may be required to register at the site before gaining online access
to its repertoire and tools. This registration requirement gives the provider
a chance to establish the user's identity and legitimacy, to track usage of
the site, and to cull out serious users from "visitors."

Providers that do not offer online access to their repertoires have
staff members who are available to work with users and help them identify
content relevant to their purposes. Some providers offer these services for
free; others charge an hourly fee. At least one provider (the Bridgeman Art
Library, an art image provider) allows users to visit its offices to personally
review the items in its repertoire.[9]

Users enter into one of a number of possible agreements with
service providers. The most commonly used agreement is a license, which

is a contract listing the issues that both the user and the service provider agree to. Licenses for the use of intellectual property typically define the type of content, how it can or cannot be used, authorized users, the means of distributing the content, warranties and indemnifications, security requirements, termination provisions, payment, and required acknowledgments. While certain clauses are standard in all licenses, in general a license is a variable document open to negotiation and amendment.[10] (For more information on licensing, see Chapter 8, Section D, "Licenses," pages 93 to 94.)

Another way for a user to access content is by subscription, which allows limited access to all the intellectual property in a repertoire for a set period of time, but severely restricts further use without a license. For consortium projects, permission to use content may be implied by virtue of participation in the project, although frequently consortium members develop consensus documents outlining commonly derived goals for use. These documents may not be legally enforceable instruments, but they clarify for all members the acceptable terms for uses within the consortium. Consortia may use these documents as the basis for subsequent licensing and subscription schemes.

User Fees and Costs

The primary fee that a user pays to the service provider is the contract fee (e.g., license fee, subscription fee). However, a user may incur other fees and costs when obtaining permission to use intellectual properties. Some providers charge service fees in addition to a license or subscription fee, or they may charge for content delivery or transfer of content to a user-preferred medium. Special features such as high-resolution viewing may incur a charge, and rental and late fees are common for content that is distributed in physical form (e.g., transparencies). Providers that advertise their repertoire in catalogs or on CD-ROMs (usually image providers) may charge the user for these products. If a user receives assistance from a service provider's research staff, he or she may be charged a fee for their time as well. Unknown but significant costs are also incurred by users who are required to keep detailed usage records.

The greatest costs are likely to be assumed by consortium members. When participating in a consortium project or program, an institution agrees to assume a number of administrative or overhead costs. These costs arise most frequently in the development of local site implementations, or in staff time and/or travel to participate in consortium meetings. Administrative costs of these kinds are significant even though they may be "hidden" or difficult to quantify.

Administrative Burdens

Those who obtain permission to use intellectual property from a service provider are obliged to contribute more than just a fee for these privileges. Reporting obligations and administrative commitments may present significant burdens to users who are unaware of the extent of the responsibilities they assume when they enter into agreement with a provider. The range of administrative responsibilities that service providers expect from users can be categorized by reporting requirements, participation requirements, and obligations.

1. **Reporting requirements.** Recordkeeping is the most common administrative requirement placed on users. Records may be requested on usage, sales figures, organizational finances, infringements, or proof of compliance. Providers rely on these records to:

 - Calculate payments and royalty fees,
 - Review license, subscription, or other user fees,
 - Track projected versus actual uses,
 - Report back to individual rightsholders about the usage of their particular intellectual properties,
 - Assure themselves that a user is in compliance with the terms of their agreement,
 - Identify new opportunities and services that the provider can offer.

 The service provider specifies how the recordkeeping must be structured and submitted. It may entail no more than the submission of already existing records (e.g., cue sheets from television stations, airplay logs from radio stations), or it may require that entirely new recordkeeping efforts be undertaken in order to comply with the service provider's specifications. The Copyright Clearance Center provides an example of the latter. Subscribers to its Transactional Reporting Service (TRS) must track the number of copies made from a particular work registered with the CCC. These tracking records must include the publication title, author, ISBN/ISSN number, publisher, publication year, number of pages copied, number of copies made, and payment. CCC has recently automated the tracking function for TRS subscribers, who now can report this information via the CCC's Web site.[11] Although this simplifies the reporting process, the burden is still on the user to do the reporting. For large-volume users, even the CCC's automated online reporting option requires extensive data entry time and efforts.

Typical recording methodologies include "logs," "hit lists" (for information accessed via Web sites), audit trails, sales records (for products that are sold), and yearly financial records. Sometimes a provider may request statistics on use rather than "raw data" records. Providers may also request information on circumstances of misuse: records of infringements that have occurred within an end user community (if the user is a university or corporate entity that redistributes the intellectual property to its employees or staff), and the steps taken to correct these infringements, are often a condition of licensing. If a provider is uncertain how works are used in a particular setting (e.g., in teaching, research, public performance, etc.), specific documentation on these uses may be requested as well.

2. **Participation requirements.** Like rightsholders, users may be required to participate in certain service provider activities. Users participating in consortium projects are required to participate as fully as rightsholders in these projects. Some providers (e.g., the CCC) require that their users participate in periodic surveys, which they analyze to determine usage characteristics for a particular industry or sector that they serve.

3. **Obligations.** The license agreements between users and service providers detail most of the obligations that users must meet. However, some obligations are assumed rather than formally stated. For users who accept content for redistribution and use by a larger community of end users (such as a university for its students and faculty, or a corporation for its employees), there are obligations to see that the intellectual property is satisfactorily distributed to these communities. The larger institutional user essentially functions as an intermediary between the service provider and the end user, and must meet the obligations of a contract on behalf of all the end users.

Other obligations are more time-consuming than onerous: appending or affixing copyright notices and credits on all copies of works that are redistributed, displaying content in specified ways, sending copies of all products that incorporate the intellectual property to the service provider, and destroying or returning all copies of intellectual properties upon termination or nonrenewal of a license. One particularly burdensome obligation is obtaining model and property releases, or clearing underlying rights to works. When a rightsholder has not obtained these clearances, a service provider may assign these tasks to the user as a condition of use.

A unique administrative burden is placed on users when they locate content through a type of provider who facilitates access to intellectual property, but does not administer rights or distribute this property. These types of providers offer a useful service by creating a centralized

repertoire of content that attracts both rightsholders and users. However, users who wish to license items in these repertoires must enter into direct negotiations with individual rightsholders. The burdens of direct administration can be particularly onerous, and users should be aware of the special tasks they will assume (see Chapter 2, Section E, "Direct Administration," pages 15 to 16) when locating content through these types of providers.

Cultural heritage organizations, which frequently wear the dual mantle of rightsholder and user, need to understand both roles when participating in an intellectual property management organization. These roles need not be as divergent as they are portrayed. Rightsholders and users do have distinct intellectual property management issues and concerns, but they share a common interest in fostering efficient and effective management of creative works. Their reasons for using intellectual property management organizations frequently overlap. Both groups highly value centralized administration, services and tools, access to repertoires, and economic benefits. Organizations that understand rightsholders and user perspectives understand both sides, and have an advantage that can lead to more enlightened relationships with intellectual property service providers.

Notes

[1] To qualify for membership in ASCAP, a rightsholder must have "a commercially recorded musical composition, or one for which sheet music is available for sale in a commercial edition or a musical work available for rental, or a musical composition performed in media licensed by the collective (i.e., radio, television, Internet, etc.). If the rightsholder is a music publisher, then proof is needed that the individual or organization is regularly engaged in the music publishing business or has works which are regularly performed by the society's licensees." Full membership information is available on the ASCAP Web site at [http://www.ascap.com/membership/membership.html#join].

[2] Ellen Sauer, Project Muse Manager, personal communication (1977) and *TULIP Final Report* (New York: Elsevier Science, 1996), 12.

[3] Nathan Benn, Founder and former President of Picture Network International and Consultant, personal communication (1997).

[4] Image Directory Contributor's License (template), 1997.

[5] See ASCAP License [http://www.ascap.com/membership/agreement/agreement. html] (1997).

[6] The Stock Illustration Source [http://www.sisstock.com] (1997).

[7] Many providers make their membership agreement templates available. For some diverse samples of rightsholder/service provider licenses, see ASCAP

Membership Agreement [http://www.ascap.com/membership/agreement/agreement.html] (1997); MPCA Membership Agreement [http://www.mpca.com/mpca_agreement.htm] (1997); Stock Illustration Source [http://www.sisstock.com/] (1997). Interested readers should also refer to the Checklist for Licensing Museum Images published by the Canadian Heritage Information Network (see [http://www.chin.gc.ca/Resources/Research_Ref/Reference_Info/e_reference.html#INTELLEC]), which describes the various issues addressed in rightsholder/service provider licensing agreements. For an international comparison of provisions in membership/collective agreements, refer to Lucie Guibault, "Agreements between Authors or Performers and Collective Rights Societies: Comparative Study of Some Provisions," L'Association Littéraire et Artistique Internationale (ALAI) International Congress, Montebello, Quebec, September 1997. In French, with English summaries.

[8] See "Photos to Go®" Index Stock Photography [http://www.indexstock.com/pages/ptogo.htm] (1997).

[9] See the Bridgeman Art Library [http://www.bridgeman.co.uk] (1997).

[10] For a thorough review of the licenses and their clauses, see The READI Project [http://www.cni.org/projects/READI/draft-rpt/] (1997) and the Association of Research Libraries publication entitled Principles for Licensing Electronic Resources [http://www.arl.org/scomm/licensing/principles.html] (July 1997).

[11] The Copyright Clearance Center allows nonusers to view a demo of its online reporting feature. To view this demo, go to the CCC Web site at [http://www.copyright.com] and click on the "Catalog of Titles" icon. Next, click on the TRS hypertext. Click on the TRS DEMO text at the top of the screen. Enter the Username "testuser" and the password name "testuser1." Click on "Search and Report." Select a publication from the CCC repertoire database, then select the publication you wish to "use." This will bring up the "Add Work" screen, where a user reports all the relevant usage information.

8. Economic Considerations

Economic issues are at the heart of all collective administration efforts. Indeed, one of the primary reasons for managing intellectual property collectively is to realize economies of scale that allow rightsholders to enforce their rights at costs lower than individual administration can achieve. To generate these economies of scale, service providers must establish basic business functions and procedures.

The most basic of these functions is revenue procurement. All providers, regardless of their mission or profit motive, need to pursue revenue sources in order to remunerate rightsholders, recoup the costs incurred in administering their intellectual property, and secure funds to continue operations. They also need to establish realistic pricing structures, which require cost assessments and determinations of the value of intellectual properties. Once pricing is established, fees must be assessed according to users and uses. Payments must be collected and redistributed among rightsholders and all other partners in the process, including the provider. Service providers have developed many different strategies for accomplishing these myriad functions.

A. Revenue Sources

Providers receive their income from a handful of sources, of which usage fees are by far the largest and most important. These fees are payments (in the form of license fees, subscriptions, transaction fees, royalties from the sale of products, etc.), made by users to service providers in exchange for the privilege of using a work. As a provider moves from startup phase to established organization, usage fees quickly become its greatest, and most vulnerable, revenue source.

Providers also receive revenue from additional services they offer to rightsholders and users in the normal course of business. Some of these services are:

- License upgrades
- Late cancellation fees
- Duplicating services (for transparencies, slides, or other image formats)
- Publishing services
- Offline content delivery
- Technical support
- Research
- Media transfer (e.g., transferring film footage to videotape)
- Commissioned or custom products
- Rental fees for copies of intellectual property
- Viewing fees
- Special marketing services.

These services can generate substantial fees for a provider, and probably constitute its second largest revenue source.

Membership fees are another source of revenue, for those organizations that choose to impose them. These fees tend to generate only very modest amounts of income, usually because they are set so low. The sole exception are consortia, for whom membership fees may serve as the most important revenue source, especially in their early years of operation.

Some service providers receive additional financial support from their founding or affiliate organizations in the form of startup funds or a yearly subsidy. These funds are generally temporary, designed to help the provider offset costs while it becomes established and moves toward self-sufficiency.

B. Assessing Economic Value

The value of intellectual property is a subject of great deal of discourse, and much has been written about it from economic and social perspectives.[1] Service providers face the practical challenge of putting an actual price tag on creative works. When establishing pricing structures for creative works, service providers consider some or all of the following factors:

1. **Context of use and user community.** The placement of an intellectual property in a particular context and its use by a particular community are key criteria in assessing monetary worth. A song used in a television advertising campaign will command more value (and thus higher fees) than if used as background music in a shopping mall, because television reaches a much larger market. The effect of context and user community on monetary value is driven largely by the economics of supply, demand, and distribution, but other factors play a role as well.

Providers may offer lower fees for educational or public service uses out of a sense of social responsibility, or to promote business/community relations.

2. **Associative value.** The process of compiling and organizing intellectual properties into a collection adds value to *each* property in the collection by virtue of association. Users place a premium on being able to locate many works from a single source; they also value the extra documentation and the organizational structure that can be found only in a compilation of works.

3. **Rights conveyed.** Value is closely aligned with the particular type of rights conveyed to a user. A grant of exclusive rights, for example, takes a property off the open market for an extended period of time, and a rightsholder may seek greater monetary compensation for this privilege. Worldwide rights are more valuable than national rights, and rights conveyed for a long period of time are more valuable than those conveyed for a short period.

4. **Timing, trends, and fashions.** The value of an intellectual property can fluctuate with current events or timely associations. A photograph of a disaster is more valuable if it can be published in conjunction with a late-breaking news story on that disaster. The current desirability of "baby boomer" music (e.g., 1970s and 1980s pop and rock music) by the advertising community for its marketing campaigns temporarily enhances the monetary value of the music from this period.

5. **Transformative use.** Value may accrue to intellectual properties through uses that render them more adaptable. For example, when a transparency is scanned into a digital image, it gains an extra layer of value: The digitized version becomes available for use in another environment (electronic media) and minimizes the need to use the original (a preservation "plus").

6. **Increased visibility.** The use of a creative work within another product also adds value to the work by increasing its visibility, which may in turn increase demand for the work or the author. The resurgent interest in W. H. Auden's poetry after the recitation of his poem "Funeral Blues"[2] in the film *Four Weddings and a Funeral* is an example of how a highly visible use can lead to increased market interest.[3]

C. Determining Costs

For a service provider, the reverse of assessing value is determining costs. Providers typically incur costs in two areas: 1) startup and initial overhead investment, and 2) maintaining and administering long-term services. Startup costs will vary depending upon the assets an organization has at its disposal when it begins operation, and the process it goes through to

become established as an intellectual property management provider. A preexisting organization (such as an advocacy agency or a membership society) may have lower startup costs, since administrative infrastructure, membership base, and background knowledge and experience are all in place. New initiatives will incur significantly more costs to position themselves on the same playing field.

The bulk of the costs incurred by service providers comes from maintaining an organizational and technical infrastructure (e.g., office, telecommunications, staffing, etc.). In addition, service providers incur ongoing costs in some or all of the following areas:

- Constructing and maintaining the repertoire,
- Creating tools (e.g., search engines) to enhance access to the repertoire,
- Developing licenses, products, and services for users and rightsholders,
- Negotiating with users and rightsholders,
- Processing requests,
- Distributing content,
- Providing training and support for rightsholders and users.

The costs to develop and maintain these resources are higher at startup, and should decrease once procedures and methods have been established and refined. However, when assessing their costs, service providers must acknowledge that there will be unanticipated costs brought about by new technologies, markets, and user demands. The music performing rights societies, for example, have recently had to develop new licenses for the use of music on the Internet. Image providers are exploring faster and more accurate means of online image delivery. The need for service providers to stay current is constant and acute, and requires continual resources to remain competitive.

D. Pricing

In any industry, there is a fine line between pricing a product high enough to recoup costs and generate profit, and pricing it out of the market. Because the market for intellectual properties on electronic networks is still being determined, pricing in this arena is highly erratic. Service providers and rightsholders are, to some extent, testing what the market can bear, and making sudden and often steep changes in response to market reception.

An important factor in the pricing equation are rightsholders, who expect some compensation for the use of their works. Providers must

be aware of the return and services their rightsholders expect, and see to it that their pricing structures will yield enough income to satisfy these expectations and still allow them to remain competitive. For the vast majority of rightsholders, compensation takes the form of monetary royalties. But some rightsholders forego all royalties for noneconomic returns that enhance different aspects of their operations. Income from the licensed works of the AMICO repertoire, for example, will be funneled back into the consortium's programs, which are designed to further the educational mission of its participating rightsholder-members.[4]

Other factors that affect pricing are the costs incurred in the course of doing business, the perceived market value of a work and its uses, the number of transactions a service provider will handle, and the number of actual or potential users. In managing and administering intellectual properties in the "offline" world, providers have developed elaborate methods for creating pricing structures that yield enough income to make them financially stable and (in some cases) profitable. In deciding upon a pricing strategy, the following issues merit consideration: 1) the entities involved in setting the fees, 2) fee structures, and 3) the licenses or other instruments that will be used to define and invoke the pricing structure.

Who Sets Fees?

Numerous entities may have a say in establishing fees. The large music performing rights societies determine their fees after negotiation with industry groups (like the American Hotel and Motel Association or National Religious Broadcasters Association), which bargain on behalf of their user-members. The resulting agreements reflect a compromise between the value that a particular industry places on its use of music, and the value that the music society places on this use.

For a small number of providers, fees are set by federal statute, as is the case with mechanical fees for the reproduction of music. Section 115 of the U.S. Copyright Act mandates that the right to make and redistribute **phonorecords** is subject to compulsory licensing. The statutory rate for this license is negotiated every few years, based on changes in the Consumer Price Index/Urban Consumers, using a formula submitted to the U.S. Copyright Office by the National Music Publishers' Association, the Songwriters Guild of America, and the Recording Industry Association of America, Inc.[5]

For-profit providers generally set their own fees based on proprietary terms and formulas. Some providers allow rightsholders to set fees for their own works, with the provider adding a "transaction charge" to each fee as compensation for its services. The CCC employs this strategy for some of its programs; for others it determines fees based on usage

characteristics among the various industries that the CCC serves. Industry rates may also be used as the basis for fee determination, with rates set at the fees that others are currently charging for a similar product. A few providers (most notably, artists' rights organizations) negotiate fees individually with each user and rightsholder, functioning as an intermediary in a direct licensing transaction.

Determining who sets the fees in an intellectual property management agency can be a political and economic decision. Many new organizations let rightsholders set fees for their works as an incentive to encourage them to join their agencies. But individualized price-setting is difficult for a service provider to manage, especially as a repertoire and its user base grows. It can also be a significant disincentive for users, who may face wildly different prices for similar properties. And rightsholders frequently do not understand the monetary worth of their intellectual property, and price it disproportionately to its true market value. For these reasons, only a few service providers allow their rightsholders to set prices, and those that do tend to have a low volume of use and smaller, more manageable repertoires.

Fee Structures

All fee structures fall within two broad categories: item-by-item pricing (also called **transactional pricing**) or volume pricing (also called **bundled pricing**). In the former, all works are priced separately and fees are highly variable and fluctuating. Each work is given a base price subject to significant adjustments (up or down) depending on some or all of the following factors:

- How the work will be used (e.g., for advertising, teaching, personal use),
- Format of use (e.g., television, Web site),
- "Uniqueness" of the work (e.g., original footage of a historical event vs. film of a sunset),
- Type of user (e.g., student, corporation),
- Frequency of use (e.g., print circulation, number of Web site hits),
- "Prominence" or "placement" of the work in the context of use (e.g., cover art vs. interior placement, Web site home page vs. secondary page),
- Geographic distribution of the work (e.g., within a country, worldwide),
- Duration of use (e.g., one-time vs. unlimited),
- Size of user organization (e.g., small, medium, large),

- Number of works licensed by one user at one time (e.g., one font vs. an entire family of fonts).

Volume pricing is the other pricing structure that service providers employ. In volume pricing, users are offered access to an entire repertoire for a single price. Users can take advantage of all the works in the repertoire as often as they like, as long as their uses fall within the terms of the licensing agreement. Volume pricing generally imposes fewer compliance costs on users because permissions do not have to be sought for each use and users do not have to track and monitor their uses. The music performing rights agencies employ this pricing strategy, as do many reprographic organizations and electronic journal licensing projects.

Bundled pricing is determined by a variety of criteria, including usage characteristics by industry, size of the "bundle" (for those providers that can offer customized segments of the repertoire), cost recovery, and profit margins. While these criteria may change and alter the bundled price, the fee remains set over the course of a year, regardless of type and amount of use.

There are some disadvantages to bundled pricing, the most important being that users may not need many of the intellectual properties offered in the "bundle," and feel they are paying for works they will never use. Some agencies address this issue by offering smaller "bundles" tailored to specific markets, or offering the option of licenses by "bundle" or by specific works.

For low-volume users of intellectual properties, transactional pricing is less expensive than bundled pricing. The user pays only for what is needed and used. Because transactional pricing is based on standard market indicators of value, such as distribution, size, duration, volume, and so on, users understand the market mechanisms behind the fees and know that fees are directly related to the circumstances of their use. However, transactional pricing is burdensome to high-volume users who need frequent and spontaneous access to large repertoires, because it requires detailed negotiation and pricing for each work licensed.

Licenses

User licenses, a legal instrument defining an agreement between a service provider (the authorizing agent) and a user, enable the user to use a work in a way that would otherwise be prohibited by law. Licenses take many forms, but the most common ones are site licenses, blanket or umbrella licenses, and transactional licenses.

A **site license** is an agreement whose terms are extended to a community of users located at a particular place. The "site" is usually

defined by a physical location (e.g., a place of business), or, in the case of software, by number of computers or CPUs, although this need not be the case. AMICO, for instance, has adopted a liberal definition of "site" that includes the many physical and virtual spaces where a university community might use its repertoire (e.g., at the university, at a student's home or dorm, in a distance-learning environment, etc.).[6]

A **blanket** or **umbrella license** allows a licensee to make unlimited uses of the particular rights for all the works in a repertoire for a single fee.[7] The licensee can be an individual, an organization, or an industry. Blanket licensing is desirable for very large repertoires that receive frequent use by many users. Under its terms, users have immediate and uninterrupted access to the works they need. Blanket licenses free providers from scrutinizing every use of a copyrighted work and from developing hundreds of thousands of customized agreements.

A **transactional license** (also called a **per use license**) gives a user permission to use a work for a specific purpose, at a specific time and place. Users have the flexibility of picking and choosing works in a repertoire and paying fees only for their selections. Transactional licensing is much more labor-intensive than volume licensing, and providers that offer it will have license templates and fee formulas based on predetermined types of usage to facilitate the process. Increasingly, service providers that offer blanket licenses are also offering transactional licenses as an option for those who want one-time access to a work residing in a large repertoire.

E. Collecting Fees

Service providers may employ any number of strategies for collecting fees from users. Licenses are the most frequent means used to date. Although the central purpose of a license is to outline the terms and conditions of an agreement between two parties, details of fee schedules and cost obligations are included in this instrument (or attached to it). By signing the license, users agree to comply with the terms of payment listed in these attachments. Subscriptions, another means used for collecting revenues, predominate in industries such as journal and newspaper publishing. This method is gaining popularity for network resources such as online versions of newspapers or databases.[8] Metering, a type of "pay-per-use" collection method, is also finding favor in electronic environments. By keeping track of actual uses, metering imposes a fee only when a work is used. To date, few intellectual property service providers rely on metering for revenue collection, although this situation may change as the infrastructure required to implement metering schemes becomes more robust and widespread.

Providers impose different fee collection schedules, payment plans, and payment methods. Those who offer volume licensing generally

require a prepayment of one year's fee, although some may request payment within thirty days from the date the license agreement was signed. Volume license payment plans follow a subscription model, where one receives a resource for an extended period of time (usually one year) after payment is received.[9]

Payment schedules for transactional licensing are more complex because fees are subject to variations with each work and with each type of use. The majority of providers still request payment within thirty days of receiving an invoice, signing a license agreement, or using a work. Payments are frequently required prior to use of a work, and many license agreements categorically state that licenses are not in effect until payment has been received. Providers with a steady flow of repeat customers may establish deposit or credit card accounts for these users, and withdraw fees from, or charge them to, these sources. Repeat or high-volume users are billed at regular frequent intervals (monthly or quarterly).

Payment can be made via traditional means such as check, credit card, or cash-on-delivery (for intellectual properties distributed to users in physical formats or by portable electronic media). Despite the trend toward providing services online, most providers do not allow users to make payments over electronic networks, although this situation may change as electronic commerce systems become more secure. (Only one provider reviewed for this study accepted payment via an online commerce system.) Providers that offer their users online order placement secure payment by establishing user accounts linked offline to the user's credit card or debit account.

While most providers charge a fee at or near the time of use, some fees are structured around more complex, long-term payment formulas based on advances and royalties tied to the sale of products. For example, fees for the use of art works often include a lump sum advance payment and royalty payments that accrue as sales of an approved product are made. These royalty "fees" are paid to the provider at regular, agreed-upon intervals.

F. Redistributing Revenues

Once usage fees are collected by a service provider, they must be redistributed among the provider, rightsholders, and any other party (e.g., technology partners) involved in the process. If the method for distributing revenues is based on accurate usage information, revenue allocation is fairly straightforward. In book publishing, for example, royalties may be allocated to rightsholders according to an agreed-upon percentage calculated from the number of sales of a published work. If an author negotiates a royalty rate of 10 percent of sales, and sales total $20,000, the royalty payment is $2,000.

But many industries do not employ exact usage-based formulas for royalty distribution. A number of arcane (and often proprietary) formulas have evolved in certain industries in response to a variety of factors. The music industry has perhaps the most complex method of calculating rightsholder compensation, with the music performing rights societies spending most of their overhead just determining and distributing payments.[10] The allocation strategies vary among each of the three societies,[11] but they are based on usage information gathered from statistical sampling, logs, chart rankings, and proxy measurements. This information is used in conjunction with a weighted scheme that places a value on each type of musical work. In the case of ASCAP, the valuation is based on criteria such as type of use (feature, theme, jingle), the medium or venue of use (television, radio), and the time of use (prime time, non-prime time). For example, a "feature work," or work that is the central focus of a listener's attention, is accorded the highest valuation, whereas a "jingle" is weighted at only 3 percent of the value of a feature work.[12]

The various survey and allocation strategies developed by the music societies evolved from years of balancing the costs of comprehensive usage tracking against the need for maximizing rightsholder royalties. There are many biases in the system, which are a frequent source of complaint among music rightsholders.[13] But these biases may be the price that has to be paid for collective administration of such large intellectual property repertoires. Comprehensive monitoring of all uses, venues, and media is simply not cost-effective for any provider with a big repertoire, a large number of rightsholders, and an extensive, diverse user base. Consequently service providers like the music societies have had to accept compromises in tracking usage in order to compensate rightsholders in the fairest way possible while maximizing overall economic gains. On an organization-wide basis this strategy yields impressive results, with the music societies routinely distributing 80 percent of their total revenues as royalties to rightsholders, one of the highest rates of return of any provider in any industry. However, the allocation of royalties to individual rightsholders is not always related to actual use. Rightsholders who are at a disadvantage because of biases in the allocation strategy generally still receive more money than they could obtain on their own by direct licensing, which is why they remain members of a less-than-perfect system.[14]

New technologies on the horizon may change the ways large providers track usage, at least in electronic environments. "Musicode™," a technology that places the equivalent of a digital watermark in musical recordings, will allow the music performing rights societies to monitor radio usage accurately. This emerging technology, combined with SESAC's use of a new song detection technology and BMI's use of an online robot to detect Internet uses, may hint at a music industry shift to a more accurate usage-based formula for calculating royalties.[15]

Other industries have less complex formulas for calculating and compensating rightsholders and providers. The most commonly used formula is a percentage "split" of all license fees and royalties. In certain industries, this split is a standard, across-the-board ratio. For example, the typical split for stock photography, footage, and illustration agencies is 50:50—i.e., rightsholders receive 50 percent of the revenue generated by the license fee and royalties, and providers retain the other 50 percent as compensation for their services. The split in other industries can be much wider. Collectives, because they are dedicated to serving their rightsholders' interests, offer a more favorable return to rightsholders than do third-party, for-profit providers. This return is often in the area of 70 percent to 80 percent of all revenues, with the remaining amounts channeled back into the collective to pay its overhead and continue its operations. Some service providers retain all the revenues they collect. If rightsholders charge no royalties for the use of their properties, or if the properties are in the public domain, a provider will keep all revenues as compensation for its administrative and distribution services.

Another common formula for distributing revenues is based on service fees and transaction charges. The Transactional Reporting Service administered by the CCC is an example of one program that uses this formula. CCC's rightsholders receive a royalty based on fees set by each rightsholder for their work. The CCC adds a transaction fee of $0.25 per copy to the rightsholder fee, and charges an annual service fee of $105 per user. The CCC keeps the income generated from the transaction and annual service fees as compensation for its services as a reprographics provider.[16]

Several factors can alter the formula for royalties, even in the simplest of circumstances. Among the more common factors that influence royalty calculations are:

1. **Risk.** Rightsholders who assume more risks in their relationship with a service provider may receive greater compensation. For example, rightsholders who affiliate with a provider during its startup phase shoulder more risk than those who sign on when the provider has become established and secure. Early signers may be offered greater royalty percentages as both an incentive to join and a reward for loyalty. Similarly, rightsholders who sign long-term agreements with an agency lock themselves into a riskier commitment than those who affiliate for a shorter period of time, and may be offered compensation in proportion to their risk.

2. **Use of an agent.** Rightsholders who use an agent as an intermediary between themselves and the provider may find that their royalty percentage will be less than if they represented themselves directly. Providers frequently impose a less favorable split with the rightsholder when an agent is involved to compensate for the revenues they lose in

dealing with a middleman (who often takes a "cut" from the provider), and to discourage the use of agents.

3. **Foreign licensing.** Rightsholders' royalty splits may decrease substantially with foreign licenses because several subagents are involved, each of whom takes a share of the royalty for his services. The standard 50:50 split for a stock photography agency has been known to drop as low as 10:90 (i.e., 10 percent to the rightsholder, 90 percent divided among the various agencies) in a foreign licensing deal that involves several subagents and is subject to the various licensing tariffs in other countries.

4. **High-profile marketing.** Providers of visual imagery frequently produce expensive print and electronic catalogs of selected works from their repertoires, which they distribute at no or low cost to various user markets. To recoup these marketing expenses, providers may alter the royalty split for rightsholders whose works appear in these publications. The 50:50 split offered by stock photography agencies may drop to 25:75 for a work that appears in the agency's print catalog or CD. The service provider justifies the lower rightsholder share as a way to offset its costs and efforts in marketing the work in high-profile expensive media.

The frequency and method of distributing royalties to rightsholders is influenced by rightsholder demands and by the efficiency of a service provider's accounting systems. Distributions may be monthly, quarterly, biannually, or yearly, with no apparent trend or preference in one industry over another. Foreign royalties tend to be distributed less frequently than domestic ones because they are more time-consuming to administer (although this may change as more properties are made available on global networks).

Some providers distribute royalties only after fees have been *collected* from the user; others distribute them within three to nine months after the works have been licensed, regardless of whether user payment has been received in that time period. The former policy can result in significant lag time between the licensing of a work and the receipt of royalties. From a rightsholder's perspective, the latter situation is preferable because compensation is not delayed over a delinquent payment. Also, the service provider has a greater incentive to follow up on a user who is in arrears when the provider is "out of pocket."

A few providers will pay rightsholders an advance against future royalties. This option may be offered as an incentive for rightsholder participation, or to provide the rightsholders with upfront funds to organize and format their intellectual properties so they can be included in the provider's repertoire. When royalties do begin to come in for these works,

the service provider retains all monies until the advance has been recouped. Subsequent royalties are then distributed to the rightsholder according to the particular formula the provider uses.

The economic relationships that develop with intellectual property service providers are grounded in basic structures of business and commerce. Identifying revenue sources, determining costs, and setting fees are tasks that must be assumed by all organizations that sell products or services. However, these relationships become more complex when the products or services are digital in form and distribution, in part because the economics of digital and networked information are still not clearly understood. Perhaps the greatest unknown factor resides in the concept of "value." How does one determine value in a networked environment? How is it calculated? And how is one compensated for it? Cultural organizations that enter into agreements with intellectual property service providers need to keep abreast of trends in the economic aspects of networked information, and gain a realistic understanding of how these trends may affect their intellectual property management strategy.

Notes

[1] See Esther Dyson, "Intellectual Value," *Wired* 3, no. 7 (1995): 146–141; 182–184 [http://wwww.wired.com/wired/3.07/features/dyson.html]; The OASIS Green Paper on Multimedia Asset Management and Trading [http://cobham.pira.co.uk/people/david/public/Everything/CTENT.HTML] (n.d.); and Hal Varian, The Information Economy: The Economics of the Internet, Information Goods, Intellectual Property and Related Issues [http://www.sims.berkeley.edu/resources/infoecon/] (June 1996).

[2] W. H. Auden, *The Collected Poetry of W. H. Auden* (New York: Random House, 1945).

[3] There is a fine line between increasing value through use and diminishing value through overuse. One user may desire a ubiquitous property because of its "recognition" factor, while another may find this recognition factor deleterious to his or her needs.

[4] Art Museum Image Consortium, Agreement I: To Form a Consortium for the Administration of Intellectual Property Rights, August 5, 1997 [http://www.amn.org/AMICO].

[5] The Harry Fox Agency, "New Statutory Mechanical Rate Available." Press release [http://www.nmpa.org/hfa/newrate.html] (November 17, 1995).

[6] Art Museum Image Consortium, Agreement II-1: Framework for a License Agreement for the University Educational Use of AMICO Licensed Digital Content, August 5, 1997 [http://www.amn.org/AMICO].

[7] Bennett M. Lincoff, Commentary: Everyone Covered by Online Blanket Licenses [http://www.ascap.com/press/lincoff-121695.html] (December 16, 1995).

[8] The *Wall Street Journal* Interactive Edition [http://interactive.wsj.com/std_regchoice.html] and Academic Press's Image Directory [http://www.imagedir.com].

[9] It differs from a subscription model in one important aspect: If a volume license is not renewed, the access to the repertoire ceases. If the works in the repertoire have been distributed to the user, all copies must be returned or destroyed.

[10] See Barry M. Massarsky, "The Operating Dynamics Behind ASCAP, BMI and SESAC, The U.S. Performing Rights Societies." Proceedings: Technological Strategies for Protecting Intellectual Property in a Networked Multimedia Environment [http://www.cni.org/docs/ima.ip-workshop](1994).

[11] The sampling and allocation processes used by the three societies vary in details. Generally ASCAP's survey approach focuses on generating highly precise information from small samples. BMI focuses more on gathering information from a large number of logged (versus sampled) performances, guaranteeing greater coverage but sacrificing precision in the process. Until recently, SESAC gathered its usage information from published title rankings (chart songs ranked by sales volume) and did not employ survey logs or sample uses. For more details, see Massarsky, "Operating Dynamics."

[12] Ralph Blumenthal, "King of the Jingle Hunts Royalties," *New York Times* (April 29, 1997): B4.

[13] Among the chief targets of complaint are the media and venues that are surveyed, the types of surveys, the inaccuracy of logs, and the fact that works used in unsurveyed media receive no compensation. For more details, see Blumenthal, "King of the Jingle," B4; Massarsky, "Operating Dynamics."

[14] Stanley M. Besen and Sheila Nataraj Kirby, *Compensating Creators of Intellectual Property: Collectives That Collect*, #R-3751-MF (Santa Monica: RAND Corporation, 1989), 9–10.

[15] "Music Mark," *Discover* 19, no. 7 (July 1998): 98; and Massarsky, "Operating Dynamics."

[16] See the Copyright Clearance Center's Transactional Reporting Service information sheet and application form. Available from the Copyright Clearance Center at 222 Rosewood Drive, Danvers, MA 01923 / Telephone: 508/750-8400 / Fax: 508/750-4744.

9. Summary—Issues, Trends, and Challenges

A. Issues

As intellectual property is used more frequently on electronic networks, new issues are emerging for rightsholders, service providers, and users. Unbridled ease of reproduction, matched with the ubiquity and worldwide distribution channels characterizing this environment, opens up a virtual Pandora's Box of challenges. The transforming effect of electronic networks adds to the complexity by altering our notions of place and community. These changes are making all partners in an intellectual property management relationship—rightsholders, service providers, and users—rethink the traditional ground rules for administering intellectual property.

Unlike other creative sectors, the cultural heritage community has little experience with intellectual property management providers, and few guidelines for reviewing their operations. This report synthesizes widely scattered information about these organizations, and analyzes some of the commonalties underlying their structure and function. In doing so, it clarifies the role these providers can play in the intellectual property management strategy of cultural and educational organizations.

To elucidate existing and emerging frameworks for managing intellectual property, a strategic analysis was conducted of U.S. organizations that administer these properties across various genres. Cultural and educational institutions will be considering some of these organizations as they move their intellectual properties into an electronic environment. They will not, however, abandon their current method of administering intellectual property directly, especially when artistic integrity and large remuneration are involved. Direct administration may also be the option of choice when managing works of a sensitive nature, or in instances when an institution wishes to maintain a special relationship with a user. In developing intellectual property management strategies, cultural and educational organizations, as rightsholders, must decide which rights they

prefer (and are capable of) administering directly, and which are best managed collectively.

The proliferation of digitally based technologies makes reproduction of intellectual property more economical and ubiquitous, and therefore burdensome for rightsholders to control individually. The number of intellectual property management service providers has surged as a result. These organizations fill a niche, and in many ways are a creative response to a flaw that exists in the "balance" that copyright strives for. In practice, this balance between the public's need for the free exchange of ideas, and the creator's need for an economic return on his or her efforts, is difficult for individual parties to achieve, particularly when the use of a work has small value relative to the costs of its administration. Rightsholders frequently cannot pursue infringements or maximize economic returns on their works because they do not have the means to do so. Users have difficulty locating works and identifying rightsholders. Even when rightsholders and users are matched successfully, they still face the onerous task of negotiation and administration, and the costs attendant on each.

Intellectual property management organizations can remove these hurdles by developing methods and procedures for administering large volumes of works. In the process, they create economies of scale that permit copyright holders to receive some measure of compensation, and users to procure works more efficiently. Their role may be defined broadly as facilitating mergers between "commerce and creativity."[1]

Fundamentally, all intellectual property management providers serve as intermediaries between rightsholders and users, but they vary considerably in the details of form and function. Some of these differences are the result of repertoire size, numbers and types of rightsholders, and the various intellectual property genres and their respective administrative traditions. But the distinctions frequently are rooted in philosophy and organizational vision as well. Rightsholders and users who review these organizations need to determine which ones provide them with the appropriate type of administration, and match them with their own philosophy and goals for the management of their intellectual property.

B. Newly Emerging Trends

The field of rights management is in a state of flux, but certain trends are apparent. The expansion of service offerings among providers is one emerging pattern. Nowhere is this more noticeable than with the plethora of online tools that are appearing on providers' Web sites. These tools enhance the productivity of users and rightsholders in innumerable ways. Some providers, for example, have made it possible for rightsholders to

monitor and track the uses of their works, the licenses or contracts in effect for these works, and the royalties generated. Users are being given access to tools that facilitate their decision-making and reporting obligations, such as proprietary viewers (i.e., "digital lightboxes" and "shared digital lightboxes"), search and selection tools, and automated licensing and reporting applications.

Services also are expanding beyond traditionally defined arenas. Providers now routinely play the role of "agent" for users who wish to commission special projects, and for creators looking for new commissions of work. Some providers are offering portfolio services to help their rightsholders market themselves and their works more effectively. Outsourcing services, such as the CCC's reprint rights management service, are providing a new source of income for providers, and are filling management niches in particular industries.

Another notable trend is the number of service providers that are expanding their scope to include rights management for different genres of intellectual property. Stock photography agencies now offer graphics and fonts in their repertoires (particularly graphics in high demand by Web developers). The CCC, previously a reprographics-only organization, is exploring the licensing of images and electronic resources. Mergers and alliances are occurring between membership collectives representing professionals from a variety of disciplines.[2] If this trend continues, several intellectual property management providers may evolve into large rights management clearinghouses that administer all types of creative works.

Rights management clearinghouses may be a more desirable administrative option for the digital arena, where multimedia applications predominate. These applications, which require works from many different genres, have long been hampered in their development by the arduous requirement of clearing rights to hundreds or thousands of works. This problem would ease if numerous, diverse types of intellectual properties could be centrally located and their rights centrally cleared.

Special technologies that administer, track, and distribute intellectual property are another new development in intellectual property management. Web robots, sound detection technologies, automated reporting applications, and electronic copyright management systems are some of the technologies service providers are adopting to monitor the uses of works, and to improve the administration and delivery of services. While many of these technologies are experimental, once their uses become commonplace they could result in greater economies of scale, more accurate usage reporting, and greater rightsholder compensation.

The increasing prominence of content brokers in the software, graphics, visual imagery, and font industries signals another trend toward

the use of "middlemen." Content brokers, who help facilitate access to intellectual properties (by compiling or locating disparate resources and making them accessible from a common site) may or may not administer rights and distribute properties. But their role as single content sources in industries that have traditionally been direct-licensed are increasingly valued among users and rightsholders, who are becoming overwhelmed and frustrated by the multitude of disparate resources on networks.

C. Continuing Challenges

Copyright

The relevance of the present copyright regime has been called into question by many who believe that its tenets do not translate to an electronic environment. The rigid interpretation of groups such as the National Information Infrastructure (NII) Task Force's Working Group on Intellectual Property Rights, as controversial as they are, have helped crystallize some of the issues. Key among them is what constitutes infringement in an environment where "copying" is a prerequisite for every use. The White Paper[3] issued by the NII Task Force implies that even an innocuous task such as browsing a Web site without permission could be construed as a copyright violation (because browsers copy Web pages onto a user's computer).

The issue of derivative works presents another challenge. What constitutes a derivative work in an electronic environment? Is a digitally scanned image a derivative work or just a copy? A digitally altered font? A color-corrected image? Arguments have been made for both sides in all three of these examples. What is clear is that the concept of a derivative work is much harder to define in an electronic environment. The body of case law that so often informs decision-making in other areas of copyright does not yet exist for uses in the digital arena.[4]

The role of fair use is also being questioned in the networked environment. Proponents of the fair use doctrine argue that it continues to be crucial, regardless of the media in which intellectual properties are conveyed. They express concern that the increase in licensing of digital content will result in a "lock-up" of resources that forces fair use out of the picture. Equally disconcerting is the effect that new security technologies may inadvertently have on fair use. These technologies, designed to prevent misappropriation, also prevent access for uses which would otherwise be considered fair use.

Those who try to overlay the current copyright regime onto the electronic environment will find that it must be twisted to fit the many circumstances that have no equivalent in the physical world. The difficulty

encountered in trying to get copyright law to "fit" in this manner, and the resulting highly controversial and unresolved debates, lead many experts to promote a tempered approach toward developing new intellectual property policy based on the belief that electronic networks are too new a technology for their impact to be gauged accurately. Any strictures imposed now may become outmoded or irrelevant as the environment matures. Proponents of this approach advise careful and considered changes to current law and practice, rather than broad moves that would alter the entire copyright regime.

Management in Electronic Environments

Several challenges remain in the administration of intellectual property. Perhaps the most far-reaching is the globalization fostered by networks, which runs contrary to our current forms of intellectual property administration. Managing intellectual properties on a national basis will become anachronistic in a networked environment, where audiences and uses are international, and geographical boundaries are ephemeral. The current method of international administration—reciprocal relationships with foreign affiliates—will grow cumbersome as the number of international users increases. A more efficient international form of administration will require harmonization of copyright laws, as well as of the laws regulating collective administration in various countries.

Another challenge arises from the use of electronic copyright management systems, which are being heralded for their ability to automate and track the numerous tasks that go into rights management and content delivery. However, these systems also collect an enormous amount of information that threatens the privacy rights of individuals.[5] It seems unlikely that the rich consumer information that these systems collect will be kept from marketers and others who seek to profit from it.

Cultural and educational organizations face a more practical challenge in developing an intellectual property management strategy for their own institutions. As they place their intellectual properties on electronic networks, demand for their works will increase, as will violations of copyright. In the absence of a management plan, cultural and educational organizations will lose control over, and remuneration for, their works, and will be helpless to do anything about it.

D. The Next Steps

The challenges for cultural and educational organizations as they move their intellectual property into the digital realm are great, and many professional arts and humanities groups are proposing strategies to address

them.[6] Cultural and educational organizations may wish to take advantage of this period of flux to experiment with different arrangements, to educate rightsholders, users, and service providers about arrangements that work best for their community, and to present workable compromises to those who advocate measures detrimental to the public interest.[7]

In a world in which technological developments burst forth at an unrelenting speed, but legal changes occur at a glacial pace, it is in the interests of the cultural heritage community to take a proactive stance in shaping how intellectual property will be administered in the electronic age. Failure to do so will result in an intellectual property regime shaped by events and defined by communities that do not consider or include the needs of cultural and educational organizations.

Notes

[1] *The Eye: VAGA Newsletter* [n.d., n.p.], 9.

[2] "Collective Copyright Licensing to Benefit Individual Photographers, Artists, and Writers." Press release that details a collective copyright licensing alliance among photographers, artists, and writers. Copyright Clearance Center [http:www.copyright.com] (1997).

[3] White Paper on Intellectual Property and the National Information Infrastructure [http://www1.uspto.gov/web/offices/com/doc/ipnii/execsum.html] (1995). A copy of the report may be obtained by calling the U.S. Patent and Trademark Office's Office of Public Affairs at 703/305-8341 or by sending a written request to: "Intellectual Property and the NII," c/o Terri A. Southwick, Attorney-Advisor, Office of Legislative and International Affairs, U.S. Patent and Trademark Office, Box 4, Washington, D.C. 20231.

[4] The recent ruling against the Bridgeman Art Library in its suit against Corel Corp. (see footnote 5 on page 69) offers a notable exception. Although this ruling is being appealed, the final outcome will greatly affect cultural heritage organizations since it addresses the issue of surrogate images as derivative works.

[5] See Julie E. Cohen, "A Right to Read Anonymously: A Closer Look at 'Copyright Management' in Cyberspace," 28 *Conn. L. Rev.* 981, 1996; and Jessica Littman, Reforming Information Law in Copyright's Image [http://www.msen.com/~litman/dayton.htm#fn0]. Forthcoming in the *University of Dayton Law Review.*

6 For information on work under way in intellectual property issues, public interest, and cultural and educational organizations, see the National Initiative for a Networked Cultural Heritage's Copyright Committee [http://www-ninch.cni.org/], the Association of Research Libraries [http://www.arl.org], and the Digital Futures Coalition [http://www.ari.net/dfc].

7 Pamela Samuelson, "Copyright and Digital Libraries," *Communications of the ACM* 38, no. 4 (April 1995): 110.

10. Another Perspective

A. Introduction

Legal and governmental infrastructures can greatly affect the form and function of intellectual property management organizations. Because all the organizations reviewed as background for this report function within the same sociopolitical system, distinctions born of different legal and government systems are not apparent.

In comparison with intellectual property management in other countries, the U.S. system is unique in imposing few legislative structures on organizations that collectively administer intellectual property. Most other Western nations have enacted some degree of legislative governance or oversight on intellectual property service providers operating in their countries. The following section, by Rina Elster Pantalony of the Canadian Heritage Information Network, describes how the legislative context in Canada affects one particular type of intellectual property management organization: the collective. By highlighting distinctions in Canadian legislation, tradition, and legal systems, Ms. Pantalony provides an example of how a country's legal and political landscape affects the form of collective management that evolves within that country.

Canada offers a particularly interesting counterpoint to intellectual property management in the United States. Canadian intellectual property collectives are authorized by federal legislative statutes, and fall under the jurisdiction of tribunals whose influence may affect certification, rate setting, and dispute resolution. As in the United States, Canadian collectives tend to form by genre (e.g., music, art, writing) or by type of right (e.g., public performing rights, reprographic rights). However, Canadian collectives are also influenced by language of publication, resulting in organizations that represent French-language works in Quebec and English-language works in English-speaking Canada.

Despite the increasing globalization of markets, properties, and interactions, the Canadian context outlined in this chapter vividly under-

scores how intellectual property management organizations are subject to the local influence of culture, place, and sociopolitical circumstances. Even the challenges imposed by digital networks, which affect all organizations regardless of origin, are being addressed within the context of the laws and traditions of individual nations. Until international harmonization of intellectual property law is achieved (a prospect not likely to occur any time soon), intellectual property management organizations will continue to be influenced and defined, in part, by the nations in which they reside.

B. Options for Administration of Intellectual Property Rights in Canadian Cultural Heritage Institutions*

Rina Elster Pantalony
Canadian Heritage Information Network (CHIN)[1]

Copyright law in Canada falls under federal jurisdiction. Canadian federal law is a composite of both the **civil** and **common law** systems.* Although Canada's Copyright Act is based on British legislation, reforms in the past ten years have incorporated many concepts from civil law (such as moral rights), and added exhibition rights, as well as a comprehensive system of collective administration of copyright.

The management of intellectual property in the electronic environment has become a topic of considerable interest in the Canadian cultural community, as it has elsewhere in the world. Of late, this community has been considering collective action to streamline access and administrative requirements. However, this approach may not suit every institution's needs. Given the public service and educational missions of cultural organizations, cost/benefit analyses should be undertaken before collective administration of intellectual property is considered.

Collective Administration in Canada: A Legal Framework

Collective administration in its current form is fairly new in Canada. Although the Canadian Performing Rights Society was founded in 1925 to administer performing rights, the Canadian Copyright Act provided only for collective administration for the public performance of musical works from 1931 until 1988. In 1988, collective administration of copyright was expanded to include literary, dramatic, and artistic works. Collective administration of the retransmission of distant broadcast signals was added in a separate amendment to the Act in 1988. Thus collective administration

*© 1999 Canadian Heritage Information Network. Definitions of terms in boldface type within this section are found in a separate Glossary on page 120.

of copyright is a relatively new phenomenon for most intellectual property in Canada, except for musical works, which have enjoyed the benefits of collective administration of copyright for over sixty years.[2]

With the 1988 amendments to Canada's Copyright Act, a new and comprehensive scheme for managing intellectual property was introduced. Unlike the U.S. experience, collective administration in Canada became subject to a Copyright Board, an independent administrative tribunal that rules on the rates that collective societies may charge for the use of works in their repertoires. The Board holds jurisdiction over collective societies filing their agreements with the Copyright Board.[3] In certain circumstances the Board also holds the jurisdiction to settle disputes over rates and, in very limited circumstances, can rule on the interpretation of the Copyright Act.

Collective Administration of Performing Rights

The Copyright Act provides that societies, such as the Society of Composers, Authors, and Music Publishers of Canada (SOCAN)[4] may administer rights associated with the performance in public of dramatic or musical works. Recent amendments to the Copyright Act have also introduced **neighboring rights** for musicians' performances, with such rights attaching to musical works.[5] The Copyright Act removes from performing rights societies any common-law rights (such as case law, contractual rights, and other rights for individually licensing works that common law provides) in musical works. Instead, it imposes a set of **tariffs** and provides the means to recover tariff fees, including injunctive relief and a statutory right of action.[6]

To determine what fees they can charge, a performing rights society must file its proposed list of fees with the Copyright Board and address any requests from the public for information concerning its repertoires in current use. The list of fees is then published in *The Canada Gazette*[7] to provide any interested parties with notice of the proposed fee schedule. Any objections to these fees may be filed with the Copyright Board, which considers these objections in determining the final fees the performing rights society can charge for the use of works in its repertoire. In this instance, the Copyright Board also has the jurisdiction to settle issues associated with the fee structure, such as notice requirements.[8]

Collective Administration of Retransmission Rights

Copyright subsists in works that are retransmitted via broadcast technologies when the works are retransmitted to the public. Royalties are owed to the copyright holders when their works are retransmitted to the public by

distant signal. The Copyright Board sets the fee schedule for these pay-
ments, and the Copyright Act provides for special collective societies to
collect and redistribute the fees associated with retransmitted works. As
with performing rights societies, the collective societies that administer
retransmission rights must file a proposed statement of fees with the
Copyright Board. Objections may be filed by interested parties, and the
Board must consider such objections when making final decisions about
fees. Collecting bodies do not hold a common-law right to license works
individually within their repertoires, but they hold statutory rights to
enforce the payment of fees through the court system.[9]

 If a copyright holder of a retransmitted work is not a member
of a collecting body, he or she must bring an application before the
Copyright Board to have a collecting body designated to act on his or her
behalf. Copyright holders hold no individual rights to collect royalties
owed them because of the retransmission of their works. Copyright Act
regulations require that copyright holders file their claims within two years
from the time the retransmission occurred.[10]

Other Collective Societies

The Copyright Act also provides for collective societies, associations, or
corporations that are not performing rights societies or retransmission
rights societies. In general, these other types of collective societies may
administer copyright and operate a licensing scheme for their particular
repertoire of works. They are free to enter into licensing agreements in any
form, but they must offer blanket licenses as well as transactional or indi-
vidual licenses for the use of a work. The Copyright Board does not
impose royalty rates on these collecting societies, but does act as an arbitra-
tion panel when a collective licensing body and a prospective user cannot
agree on rates or related terms and conditions of the licensing agreement.[11]

 The collective is responsible for redistributing the royalties col-
lected to its membership. Redistribution is based upon specified formulas
devised to obtain fair remuneration for the author. These formulas may or
may not depend on the exact use of the author's work. Depending on the
by-laws of the collective society, redistribution formulas may also ensure
that remuneration is split equitably among the members of the collective
society. In all cases, a certain percentage of the royalties collected is used to
cover administrative costs incurred in managing the collective.

 Many other rights-related associations do not issue licenses or
collect and redistribute royalties, but have an impact upon the collective
administration environment by fulfilling a lobbying function on behalf of
certain groups, or by serving as quasi-collective societies. An example is
the Canadian Musical Reproduction Rights Agency (CMRRA), which

acts as an agent for music publishers. CMRRA can negotiate individual licensing agreements on behalf of its members and can clear the rights to musical works held by members. However it functions primarily as an agent, and the **law of agency** imposes different responsibilities on it and provides different protections for the agents' clients.[12]

Other Legal Factors Affecting Collective Administration

1. **Anti-Competition Rules.** The Canadian Copyright Act encourages collective administration. Canadian legislators were very much aware of the potential conflict with anticompetition rules, such as those that exist in the United States. Antitrust accusations have marked the history of collective administration in the United States, and Canadian legislators sought to address this issue so that collective administration in Canada would not share a similar experience. By increasing the overseeing powers of the Copyright Board to set and review tariffs and other conditions associated with the allocation and collection of royalties, legislators sought to remove any potential conflict with Canada's Competition Act,[13] particularly Section 45 of the Act, which makes it is a criminal offense to conspire or agree to lessen competition by effectively enhancing the price of a good or service.[14]

 Canadian performing rights societies are protected from certain accusations of anticompetitive behavior because they are subject to the Copyright Board's jurisdiction in setting tariffs for royalties.[15] For all other issues, performing rights societies and other collective societies are subject to anticompetition laws.

2. **Exceptions to Copyright.** Amendments to Canada's Copyright Act[16] in 1997 introduced specific exceptions to copyright for educational institutions and museums, archives, and libraries, which are excepted from copyright violation if they make a copy of a work in order to manage or maintain their respective collections (specific conditions are provided in the text of the legislation), or to carry out limited interlibrary loans. Exceptions to copyright are also provided to educational institutions for use of works inside a classroom or as part of an examination.[17] Museums, libraries, and archives that are part of educational institutions may avail themselves of all of the exceptions. Certain exceptions for all these groups apply only when a copy of the work in question is not "commercially available," i.e., not available for licensing from a collective society.[18]

 Some of the amendments of the 1997 legislation are not yet in force, so the impact of the exceptions on a collective's potential market is not known. However, one can assume that since educational institutions are one of the primary users of intellectual property from cultural

heritage organizations, their direct use of this intellectual property for educational purposes may be exempt from copyright. In other words, educational institutions can use this intellectual property for the specific reasons defined by the Copyright Act (such as for use on a classroom overhead projector) without paying for such use or requesting prior authorization, as long as museums, libraries, and archives do not make their intellectual property commercially available through a collective society. If these organizations do make their intellectual property available through collective societies, then educational institutions are required by law to use these collectives to obtain the works. Thus, under Canadian law, it is in the interests of cultural institutions to join collectives if they wish to receive financial payments from the educational markets using their intellectual property.

3. **Fair Dealing.** "Fair dealing" is an exemption allowed in Canadian copyright law that allows a work to be used without prior authorization for purposes of research, private study, criticism, review, or reporting, without violating copyright.[19] The concept of fair dealing has been in existence since the Canadian Copyright Act was introduced in 1924. It is a defense that the user of copyright material can employ to justify use without prior authorization. Unlike its "fair use" counterpart in the United States, fair dealing does not generate a great deal of litigation, and there are no written criteria (such as the "four factors" of fair use) for assessing fair dealing in Canadian legislation.

Once a user establishes that the use of a work falls into one of the categories of use under fair dealing, he or she must determine whether his proposed use of the work is "fair." The test of "fairness" may be based on whether a substantial part of the work is being used, and whether that will diminish the quality of the work, or increase the quantity of the work in circulation so as to diminish the return to the author.[20] While the criteria of substantiality and effect on the market are similar to two of the four factors used in U.S. copyright law's fair use exemption, in Canada their interpretation has been much less precise. In the few court decisions that have interpreted fair dealing, what constitutes fair is based on a notion of "first impression." A leading court decision has described fair dealing as follows:

> To take long extracts and attach short comments may be unfair. But, short extracts and long comments may be fair. . . . after all is said and done, it must be a matter of impression.[21]

The end result is that fair dealing is a vague concept that both users and copyright holders grapple with in order to determine how far a user can go in using a work before such use becomes unfair. Collective societies administering copyright inherit this dilemma. While collective societies

do not try to define fair dealing in their licensing agreements, they do try to take fair dealing into account when setting royalty rates.[22]

The notion that fair dealing applies in a digital environment is contentious. What acts constitute fair dealing? Is browsing on the Internet fair dealing? The Canadian government's Information Highway Advisory Council[23] supports the conclusion that fair dealing applies to the electronic environment. The government will be addressing new media issues in its next stage of copyright reform, which will occur over the next few years. For collectives trying to determine their operational boundaries, the uncertainty of applying fair dealing in analog and print environments is compounded in an electronic one.

4. **The Status of the Artist Act.**[24] Canada's Status of the Artist Act, which provides minimum terms and conditions for freelance artists contracting with the federal government and its agencies, imposes a regulatory scheme for certifying associations of artists entering into freelance contracts with the federal government. Cultural heritage institutions that are agencies of the federal government are thus affected by this Act.

The Status of the Artist Act allows artists' associations to negotiate collective agreements establishing minimum terms and conditions for individual artists in their freelance contracts. Under this Act, artists' associations can collectively negotiate these terms and conditions on behalf of their members, but individual members must subsequently sign their own agreements with the contracting federal agencies.[25]

It is not clear whether artists' associations authorized to operate under the Status of the Artist Act can include royalty rates among the terms and conditions they negotiate. (Under the Copyright Act, the Copyright Board determines rates.) It is clear, however, that there is potential for overlap in this area between the Copyright Board and artists' associations authorized by the Status of the Artist Act.[26] The Copyright Board stated that replacing the administrative scheme in the Copyright Act with a system of collective bargaining (as provided for under the Status of the Copyright Act) is illogical if copyright is assigned to collective societies that are not part of the artists' associations and thus are not part of these associations' collective bargaining process.[27]

The tribunal responsible for administering the Status of the Artist Act has concluded that an artists' association can negotiate certain uses for artistic works in a collective agreement that includes copyrights. However, the element of exclusive representation, common in the accreditation process in labor law and under the Status of the Artist Act, does not have to apply to copyright negotiations. Therefore, even if an artists' association is given the jurisdiction to negotiate copyright,

each artist must have expressly assigned the copyright before the association can include copyright in its collective bargaining negotiations.[28]

Theory and Practice: The Operating Environment

Since the inception of Canada's comprehensive system for collective administration, various collective societies have been created and have filed their licensing agreements with the Copyright Board. These societies can be grouped by distinctive categories. The majority are based on genre, followed by language of publication.[29] Societies also group themselves on the basis of the types of rights they may represent.[30] For example, CANCOPY, the Canadian National Reprography Collective, represents authors' reproduction rights but not their public performance rights. Therefore, CANCOPY grants the right to photocopy a work but not the right to read it aloud in public. There are many more collectives operating in the province of Quebec or for French-language publications than operating in English Canada or for English-language publications. This phenomenon may be the result of historic, political, and legal developments.[31]

The spirit of labor law and the Status of the Artist Act had a significant impact on the practical, as opposed to the legal, practices of collective societies in Canada. Many areas of the Status of the Artist Act, which is a labor law, conflict with the Copyright Act, particularly in collective administration. Its certification system has the potential to affect collective administration, particularly when associations seek to act both as collectives for the purposes of copyright administration and as associations for the purposes of negotiating collective agreements under the Status of the Artist Act.

Quebec's Unique Environment

The convergence of labor law and the collective administration of copyright is particularly apparent in Quebec, resulting in a hybrid rights management system in this province. Artists' associations, which include collective societies, represent many different categories of artists (based on specific rights) and have large memberships. They wield enormous influence in negotiating conditions of use.[32]

Licensing agreements issued by collectives, particularly in the audiovisual field, become more like collective agreements with minimum terms and conditions. They cover areas such as how a work may be used, remuneration required, rights that may be licensed, and perhaps a "good will" clause (frequently required of artists of particular notoriety). If an association holds the express authority to negotiate copyright, agreements

will also stipulate royalty rates and tariffs.[33] If an association is not authorized to negotiate copyright, the government agency must enter into separate licensing agreements with the collective society, thereby creating further layers of negotiation in the licensing process.

When agreements are negotiated with nongovernmental bodies, artists' associations and collective societies often find themselves at the same bargaining table. However, issues become more complex because the minimum standards set in provincial and federal legislation do not apply.[34] Therefore, artists' associations, collective societies, and potential users must negotiate in an adversarial labor law environment and cannot avail themselves of any formal legislative structure that sets certain terms and conditions.

The Relationship between the Author and the Collective

Collective societies in Canada administer economic rights on behalf of their members. Frequently, members of collectives hold the copyrights for works held in the collectives' repertoires. The pivotal point in the relationship between the collective and its membership is when rights are assigned or transferred directly to the collective. The agreement that outlines this transfer may be either a license or a right to administer, depending on whether the member assigns property rights or merely the mandate to collect and distribute royalties. The nature of the relationship is not always clear because agreements often do not clarify these points.[35]

Moral rights cannot be assigned to collective societies (or anyone else) under Canadian law, but some collective societies will try and protect their members' moral rights as a matter of course. Certain collective societies, for example, may have bylaws that prohibit granting a license when there is a violation of moral rights, or may accept instructions from individual members and act as their agent with respect to moral rights.[36]

Many collective societies demand exclusive representation of their members' rights.[37] Copyright in Canada, as in the United States, involves a bundle of rights, and creators frequently assign different rights for the same work to different collective societies. In Canada, however, the author may not assign the same right to a work to more than one collective society at the same time. The sole exception is collective societies operating in mutually exclusive territories. In this instance, an author may grant the same right for a work to more than one collective society as long as the societies operate in nonoverlapping territories.[38] This situation is extremely rare. Most collective societies hold reciprocity agreements with each other that cover different jurisdictions.

The collective society manages the rights of the author, enters into licensing agreements on his or her behalf, collects royalties, and redistributes them according to agreed formulas. In addition, a number of col-

lective societies offer their members legal advice, intervene in legal disputes that may influence relevant issues, and play an advocacy role on behalf of their membership. Despite these interactions, the relationship between the collective and its members is somewhat paternalistic. The degree of control that a member may have over the day-to-day activities of the collective society, and over the administration of the rights assigned to the society, is not always clear.[39]

The Relationship between the Collective and the User

Most collectives offer users both transactional and blanket licenses. An exception occurs in collective societies that represent public performance rights for dramatic or musical works, such as SOCAN. Users may purchase blanket or transactional licenses from these collectives, or they may simply pay the tariffs the Copyright Board sets for the use of these works.[40]

Issues such as access, cost, and size of repertoire continue to be problematic for certain users in certain disciplines. For example, access and repertoire size are major issues for the educational community, which has traditionally advocated wide exceptions to copyright for educational purposes, claiming that the collectives that serve them offer terms that are too strict or do not hold the most popular works in their repertoires. Broadcasters have also advocated for certain exceptions, claiming that the costs associated with certain reproduction rights held by collectives are prohibitive. Many users feel that, with the exception of Quebec (where collective administration is well established), there is a vacuum in rights management options in Canada.

The collective management options that exist do offer advantages to users. In the ten years that have passed since collective management was introduced broadly in the Canadian market, access to a large number of works has increased. Collective societies make it their business to clear copyright, are experts in the field, and have to some degree created a system of "one-stop shopping" that facilitates access to works. For example, in areas such as reprography, blanket licenses have made it possible for scholars and students to copy required texts without violating copyright or applying the test for fair dealing.[41]

Potential for the Future—Licensing Electronic Rights

The administration of collectives may not have to change substantially in order to manage electronic rights.[42] What will need to be clarified is the concept of electronic rights and their legal interpretation.

The status of electronic rights as a unique type of right, or as part of an overall "one-time right" to publish, remains unclear. Certain freelance publishing agreements have no express provisions granting

electronic rights to publishers, but publishers nevertheless place their print materials on their respective Internet sites. A court action spearheaded by a number of writers' associations has recently been launched in Canada to contest such use.[43]

Of late, electronic rights have been challenged in a new way in Canada. The law affecting the copyright status of databases was changed substantially by a recent decision of the Federal Court of Appeal of Canada. Prior to the Court's decision, it was generally assumed that copyright subsisted on databases that held mostly factual information. The threshold test that determined whether a work was "copyrightable" was much lower in Canada than in the United States where a certain level of creativity is required for a database to be copyrighted. The Federal Court of Appeal in Canada agreed with the creativity requirement in place in the United States, and raised the threshold requirements for databases in Canada. Databases now receive copyright protection in Canada only if they can be considered "intellectual creations."[44] The end result of this decision is that many electronic works once considered copyrightable no longer enjoy copyright protection.

Collective societies in Canada are now addressing the issue of electronic rights. As an example, SOCAN has applied to the Copyright Board to obtain the authority to collect royalties for the use of musical works over the Internet. A new collective called The Electronic Rights Licensing Agency (TERLA)[45] is being launched to represent the rights of Canadian freelance writers, photographers, and illustrators. It hopes to provide convenient rights clearance services to publishers that wish to distribute Canadian written works electronically.

Another new project is Canadian Artists Represented Online (CAROL), which will make contemporary visual works of art available for licensing on an Internet-based system, thereby securing a place for visual artists in the new technology market. The economic model proposed by the CAROL project is based on "fair remuneration" for contemporary artists, including the coverage of overhead costs. The CAROL project is currently in the testbed stage, working with local collective societies and partners in the telecommunications industry, and incorporating the latest technologies in order to control use of its repertoire in an electronic environment.[46]

Finally, CHIN has embarked on a rights management initiative for its museum members. CHIN has managed museum databases for twenty-five years, and has been managing the electronic rights of its museum members since its inception. Museum members hold copyright on the information in the CHIN databases, and CHIN has assisted in the protection of its members' copyright and launched a subscription service to

the databases. CHIN has now launched a site licensing service and is also exploring the possibility of a more complex rights management program.[47]

Conclusion

Collective administration of copyright in Canada is not without its pit-falls. Initially, collective administration sought to balance the relationship between the copyright holder and the user of copyrighted material so that bargaining strengths were equalized. In attempting this alignment, a complex system of collective administration was introduced. To address anti-competition issues, an administrative tribunal with the jurisdiction to oversee royalty rates was deemed necessary.

Despite its complexity, the system has provided both the user and the copyright holder with certain advantages. Low-cost access to works protected by copyright has been provided by collectives operating in certain sectors of the cultural community. Reprography collectives, for example, have allowed educational institutions to access works at low cost. The system of collective administration has increased the circulation of information, thereby serving the public interest.

Canadian cultural heritage organizations could benefit greatly from collective administration of copyright, and the Canadian legal system offers incentives for doing so. While exceptions to copyright law in Canada may diminish the educational market for cultural organizations, this potential problem can be remedied by collective action, which secures educational markets under copyright law.

However, the Canadian form of collective administration also presents interesting limitations for the cultural community. Unlike its U.S. counterparts, collective societies in Canada face the Copyright Board's potential intervention in determining its royalty rates. A sound pricing policy can help maintain a collective's credibility before the Copyright Board, and reduce the possibility of Board intervention when consumers of intellectual property from cultural organizations object to usage fees.

Another concern is the exclusivity requirement mandated by many Canadian collective societies. Exclusivity limits an organization's control over its own intellectual property. Ideally, members should grant collective societies the nonexclusive right to manage their copyright so that cultural organizations can continue to control the exploitation of their own intellectual property.[48]

Many existing collectives or associations are just now facing issues presented by digital media, such as instant and almost perfect reproductions of works. Canadian law is playing "catch-up" at the moment, and many issues (such as copyright on databases and electronic reproduction

rights) are unresolved. Technology is ever evolving and will enable new ways to protect and exploit intellectual property. Cultural heritage organizations must ensure that the collectives they join stay informed of changes in technology and law, so that the collectives can continue to act in the best interests of their members.

Glossary

civil law: Derived from Roman law, civil law codifies legal principles into one statute. In Quebec, the Civil Code embodies most legal obligations, such as family law, property law, responsibility for negligent behavior (tort law does not exist), and commercial transactions. Most European countries, Scotland, the province of Quebec, and the state of Louisiana are governed by civil law.

common law: Derived from British legal traditions, common law relies on judicial precedents set by prior court decisions to determine the development of legal principles, rather than on legal enactments. Common law derives its authority from rules of the court, custom, judicial reasoning, prior court decisions, and principles of equity. Canada and the United States (with exceptions noted in the above definition), England, New Zealand, and Australia are common-law countries.

law of agency: A contractual relationship authorizing a person or corporation to act on behalf of another person or corporation under specific and limited circumstances.

neighboring rights: Recently introduced into Canadian law, neighboring rights protect performers and producers of recordings, and broadcasters' communication signals. They are similar to copyright but can be distinguished because they give additional rights to users of material already protected by copyright. Consequently, performers and producers of sound recordings and broadcasters (as well as copyright holders) can be remunerated for their use of copyright protected works.

tariffs: Similar in principle to royalties, tariffs are fixed by the Copyright Board upon application by a collective society of their proposed rates.

Notes

[1] The author would like to thank Lyn Elliot Sherwood, Director General of the Canadian Heritage Information Network, for her guidance and insightful comments concerning the structure of this paper. The author also thanks reviewers Lesley Ellen Harris, Paul K. Lepsoe, Mario Bouchard, and Barbara Lang Rottenberg for their helpful comments and suggestions.

[2] Marian Hebb, "Answers to Questionnaire from Professor Carine Doutrelepont on Collective Administration of Authors and Performers Rights," L'Association Littéraire et Artistique Internationale (ALAI) International Congress, 1997, 1.

[3] Collective societies are not required to file their agreements with the Copyright Board, but it is to their advantage to do so if they wish to benefit from an administrative tribunal (versus the courts) in problems that may arise.

[4] SOCAN was formed by the amalgamation of the Canadian Authors and Publishers Association of Canada (CAPAC) and the Performing Rights Organization of Canada (PROCAN). SOCAN represents composers, authors, and publishers of musical works. See also Claudette Fortier, "Réponse de Questionnaire de Madame Carine Doutrelepont," ALAI International Congress 1997, 1.

[5] Neighboring rights were introduced into Canadian law by amendments contained in the World Trade Organization Agreement Implementation Act, S.C. 1994, c. 47 and then expanded upon in the Copyright Act, S.C. 1997, c. 42.

[6] Robert T. Hughes et al., *Hughes on Copyright and Industrial Design* (Toronto: Butterworths, 1997), 491–492.

[7] *The Canada Gazette* is a government publication that generally notes the coming into force of new legislation, new regulations, etc.

[8] Hughes, endnote 6.

[9] Ibid., endnote 6, 499f.

[10] Ibid.

[11] Ibid., endnote 6, 495f. In very limited circumstances, a licensing body may remain subject to the control of the Director of Investigation and Research acting under the auspices of the Copyright Board.

[12] For a full discussion on agents and other forms of quasi-collectives, see Glenn Bloom, *Administering Museum Intellectual Property* (Ottawa: Canadian Heritage Information Network, March 1997), 6.

[13] Ibid., 14.

[14] Ibid.

[15] Ibid. See also Hughes, endnote 6, 495f. It is a principle of Canadian competition law that economic behavior specifically regulated by a government agency pursuant to a statutory scheme, as found in the Copyright Act, cannot violate section 45 of the Competition Act. Other collective societies that are not performing rights societies are still protected from prosecution under section 45 of the Competition Act as long as they file their licensing agreements with the Copyright Board within fifteen days of completion. The act of filing the agreement has the effect of acknowledging the Board's jurisdiction to oversee the pricing of royalties charged for the use of a work.

[16] Hughes, endnote 6.

[17] Ibid.

[18] Ibid.

[19] Lesley Ellen Harris, *Canadian Copyright Law* (Toronto: McGraw-Hill Ryerson Ltd., 1995), 124; *An Act to Amend the Copyright Act* S.C. 1997, c. 24, s.s. 29, 29.1, 29.2.

[20] For a complete discussion of many of the factors that have already been taken into account by the courts in trying to apply fair dealing, see David Vaver, *Intellectual Property Law: Copyright, Patents, Trademarks* (Toronto: Irwin Law Publishers, 1997), 102–103.

[21] *Hubbard & Anon. v. Vosper & Anon.* [1972] 2 Q.B. 84 (C.A.)

[22] An observation made by lawyers who have worked with collectives in Canada.

[23] *Ensuring a Strong Canadian Presence on the Information Highway*, Canadian Content and Culture Working Group Report, Ottawa: Government of Canada, 1995.

[24] Status of the Artist Act, S.C. 1992, c. 33.

[25] Ibid., endnote 2 and endnote 4.

[26] Ibid. Mona Mangan, an attorney for the Writers Guild of America, East, Inc. suggested in her comments at the ALAI International Congress 1997 that the Canadian system, providing both for collective administration of copyright and collective bargaining under the Status of the Artist Act, is the most modern and unique approach for protecting authors' rights.

[27] Copyright Board Publication of Tariff No. 2, *The Canada Gazette*, Part 1, January 31, 1998, 51f.

[28] Colette Matteau and Éric Lefebvre, "Les Décisions du Tribunal canadien des relations professionelles artistes-producteurs visant le droit d'auteur," *Les Cahiers de propriété intellectuelle* 10, no. 2 (1998), 401.

[29] Fortier, ALAI International Congress 1997, 1.

[30] For a full description of the collective societies that currently operate in Canada, see Fortier, endnote 29.

[31] Quebec is a civil-law jurisdiction that has looked to Europe for inspiration and markets in the development of its cultural industries. Collective administration of copyright has long been established in the civil-law jurisdictions of Europe.

[32] Yves Légaré, "La Gestion syndicale des oeuvres audiovisuelles dans les productions de langue francaise au Canada," ALAI International Congress 1997, 3.

[33] Ibid., endnote 2, 5.

[34] Ibid., endnote 2, 9.

[35] Lucie Guibault, "Agreements Between Authors or Performers and Collective Rights Societies: A Comparative Study of Some Provisions," ALAI International Congress 1997, 11.

[36] Ibid., endnote 2, 4.

[37] The Director of Investigation and Research, acting under the auspices of the Copyright Board, has the authority to challenge the practice of exclusive representation.

[38] Ibid.

[39] Ibid., and endnote 2.

[40] Ibid., endnote 6, 492.

[41] Ibid., endnote 19, 158.

[42] ALAI International Congress 1997, author's notes from panel discussions.

[43] *Electronic Rights Defence Committee et al. v. Southam Inc. et al.* An action has been commenced in the Federal Court. A court date has not yet been set.

[44] *Teledirect (Publications) Inc. v. American Business Information Inc.* (heard at Montreal, October 6–7, 1997; judgment delivered at Ottawa October 27, 1997) not reported (FCA). Leave to appeal to Supreme Court of Canada denied May 21, 1998.

[45] The Electronic Rights Licensing Agency's founding members are the Periodical Writers Association of Canada, the Writers Union of Canada, the Canadian Association of Photographers and Illustrators of Canada, and the Association of Photographers and Illustrators in Communication. It has not yet started licensing works.

[46] For more information on the CAROL project, see [http://www.caro.ca/gallery].

[47] For more information about this project, see [http//:www.chin.gc.ca/about_CHIN/]. In 1998, CHIN will publish the results of a marketing study for museum intellectual property.

[48] Ibid., endnote 35, 86.

Acronyms

ADAGP
Societé des Auteurs des Arts Graphiques

AMICO
Art Museum Image Consortium

ASCAP
American Society of Composers, Authors and Publishers

ASMP
American Society of Media Photographers

BMI
Broadcast Music Inc.

BSA
Business Software Alliance

CANCOPY
Canadian National Reprography Collective

CAROL
Canadian Artists Represented Online

CCC
Copyright Clearance Center

CHIN
Canadian Heritage Information Network

CMRRA
Canadian Musical Reproduction Rights Agency

CONFU
Conference on Fair Use

ERMS
Electronic Rights Management Systems

JSTOR
Journal Storage

MDLC
Museum Digital Library Collection

MESL
Museum Educational Site Licensing Project

MLPC
Motion Picture Licensing Corporation

MPCA
Media Photographers Copyright Association

NII
National Information Infrastructure

PNI
Picture Network International

PRC
Publication Rights Clearinghouse (of the National Writers Union)

RRO
Rights and Reproductions Organization

SESAC
Society of European Stage Authors and Composers, Inc.

SOCAN
Society of Composers, Authors, and Music Publishers of Canada

SPA
Software Publishers Association

TERLA
The Electronic Rights Licensing Agency

TRS
Transactional Reporting Service, a service of the Copyright Clearance Center

TULIP
The University Licensing Project

VAGA
Visual Artists and Galleries Association

WIPO
World Intellectual Property Organization

Appendix A

A Note on Methodology

Hundreds of intellectual property management organizations worldwide oversee the licensing and/or distribution of intellectual property for a broad range of creative pursuits. Their sheer number, and the varying legislative and national structures under which they operate, preclude a comprehensive survey. However, a sense of the range of variation in these organizations—in infrastructure, types of rightsholders and users, licensing strategies, etc.—can be garnered from even a limited review. The information in this report is based on a strategic survey and review undertaken in the spring and summer of 1997 of more than thirty U.S.-based intellectual property service providers representing different industries and professions. The organizations included in the review (see Appendix B) are those that manage rights and/or distribution in publishing (for books and journal publishers, and for writers such as journalists and freelancers), reprographics (photocopying), music (including performance, mechanical, and synchronization rights), visual imagery (still and moving images), software, graphic art (illustrations, clip art, and fonts), fine arts (for artists and their estates), and museums. Most organizations were reviewed individually; for industries that had dozens of organizations managing intellectual properties (e.g., clip art/graphics and stock film footage and photography), collective assessments were made after a review of several organizations of varying sizes within that industry.

The service providers reviewed for this report administer intellectual property that falls within the copyright regime. (The management of other types of intellectual property—i.e., trademarks and patents—is more amenable to direct licensing because it occurs less frequently, is transaction-based, and involves context-specific negotiations.) A decision was made to focus on U.S-based organizations because copyright law (and the actual meaning and scope of "rights") differs dramatically among nations, as does the government regulations and laws under which these organizations operate. For instance, the collectives in Germany, the Netherlands, and Luxembourg are regulated by various governing acts and agencies, while United States collectives are under no such strictures. A focus on U.S.-based organizations undoubtedly biases the report toward a U.S. audience, but it also highlights the unique variations that can emerge to address rights management needs under one set of copyright laws.

The selection of service providers was based on a number of different factors, including industry prominence, innovative approaches, novelty, availability of information, and relevance to the cultural heritage community. Some organizations were selected (e.g., the CCC) because they are the only ones in the United States

managing intellectual property for a particular segment of their industry (e.g., reprography). New entrants into the intellectual property management arena were chosen for the insights they offered about startup issues and current intellectual property trends. Included in this latter category are organizations of direct interest to the cultural heritage community, such as AMICO and the MDLC.

To gather information systematically, a set of questions was developed (see Appendix C) as a guide. The questions were designed to extract information about the service provider's background; operational structure and models; uses for the intellectual property administered; rights administered; rightsholder, user, and economic issues; and administrative duties or burdens placed on all those who participate in the rights management relationship (i.e., provider, rightsholder, and user).

Information was gathered from a variety of sources, including promotional materials from the service provider (brochures, information packets for potential and new members and users, sample licenses and templates, annual reports, newsletters, World Wide Web sites). In several instances, telephone interviews were conducted with strategic individuals within the organization. There is the obvious risk of bias in any study based on information provided solely by those being studied. To minimize this risk, service provider information was examined in the context of independently derived materials, when they were available. A great deal of independent literature and assessments exist (i.e., published studies and reports, newspaper, journal, and Web articles), especially for the older, more established organizations like those in the music or reprographics industries. Equally important in providing a balanced perspective were discussions and interviews conducted with key experts who are knowledgeable about issues of rights management, but are not directly involved with any particular rights management organization. A survey of rightsholders and users affiliated with various service providers was not conducted, although a few such individuals offered additional independent insights during interviews. A more thorough study of these groups is outside the purview of this study, but would offer a useful adjunct to information reported here.

The degree of detail varies from one organization to another. Organizations in a "startup phase" are just developing operational methodologies and procedures, and often have not determined economic or use issues. In some sectors, the marketplace for intellectual properties is so competitive that service providers decline to answer specific questions for fear that doing so would compromise them. Even in less competitive industries, information is frequently deemed proprietary, and generic data or insights are all that were offered.

Another factor in the unequal reporting of information is the complexity inherent in certain types of intellectual property management. Administering rights and content in some industries is less problematic than in others for reasons as diverse as usage, the nature of the intellectual property, tradition, distribution, and markets. Agencies that administer and distribute type fonts, for example, can manage the rights and usage of their content in a more straightforward manner than music rights organizations, which have more rightsholders, more content, and more venues to administer.

A final factor contributing to the unequal availability of information is the impact of new technologies within a particular rights management organization. Most of the newly emerging rights organizations are incorporating technologies into their management and distribution structures, and are developing strategies for managing intellectual property in digital form on networks. Older organizations are often not yet positioned to take advantage of these newer, technology-based delivery systems, and are just beginning to address the digital uses of the content they manage.

The types of providers reviewed range in size from large, multimillion-dollar operations with headquarters and field offices to small, individually run offices staffed by a few people. Their revenue figures (when they were made available) range from zero for new startups to hundreds of millions of dollars for older, established organizations. The rightsholders they represent were as few as a dozen or so institutions to as much as two hundred thousand individuals. Their content repertoires incorporate as little as eighty-five hours of film footage to over three million musical compositions. Their organizational objectives are just as likely to be profit- and product-motivated as they are to be embedded in educational goals and rights advocacy. While all organizations reviewed are U.S.-based, most manage intellectual property rights internationally through channels with affiliate organizations. The variability in types and ways of managing and distributing intellectual property is a testament to ingenuity and adaptation as much as it is a response to legal, market, and community forces.

Appendix B

Organizations and Projects Reviewed

Artists

Artists Rights Society (ARS)
65 Bleecker Street
New York, NY 10012
Telephone: 212/420-9160

Visual Artists and Galleries Association (VAGA)
521 Fifth Avenue, Suite 800
New York, NY 10017
Telephone: 212/808-0616

Authors, Freelance Writers, Journalists

The Authors Registry, Inc.
330 West 42nd Street, 29th Floor
New York, NY 10036-6902
Telephone: 212/563-6920
http://www.webcom.com/registry/

Publication Rights Clearinghouse (PRC)
National Writers Union (West)
337 17th Street, Suite 101
Oakland, CA 94612
Telephone: 510/839-0110
http://www.igc.apc.org/nwu/prc/prchome.htm

Fonts

The Font Bureau
175 Newbury Street
Boston, MA 02116
Telephone: 617/423-8870
http://www.fontbureau.com/cgi-bin/index.cgi

FontShop
350 Pacific Avenue, 2nd Floor
San Francisco, CA 94111
Telephone: 888/FF-FONTS
http://www.fontfont.com/

Index Stock Photography TruType Fonts
213 West 18th Street
New York, NY 10011
Telephone: 212/929-4644
http://www.indexstock.com/pages/fonts.htm

Monotype Typography, Inc.
985 Busse Road
Elk Grove Village, IL 60007-2400
Telephone: 847/718-0800
http://www.monotype.com/

Phil's Fonts, Inc.
14605 Sturtevant Road
Silver Spring, MD 20905
Telephone: 800/424-2977
http://www.philsfonts.com

Graphics

(analog and digital graphics, including animation, clip art, illustrations, special effects, Web backgrounds and textures)

The graphics industry, particularly the area of digital graphics, has expanded exponentially since the development of the World Wide Web. There now are thousands of sites that offer digital graphics: Many are offered freely as public domain works, some are offered through stock suppliers, and others are direct-licensed from the creators. No single organization has emerged as a leader in the licensing and distribution of these works (although the Graphic Artists Guild may do so—see the press release entitled "Collective Copyright Licensing to Benefit Individual Photographers, Artists, and Writers" issued by the Copyright Clearance Center and available at http://www.copyright.com). For a sense of how graphic arts are managed and distributed over electronic networks, several different types of sites must be examined. Some reference sites that offer extensive links to individual Web graphics sites are:

Web Reference at http://www.webreference.com/graphics/

Web Graphics Resources at http://desktopPublishing.com/webgraphics.html

Clip Art and Image Paradise at http://desktopPublishing.com/cliplist.html

INDIVIDUAL PROVIDERS REVIEWED IN DETAIL WERE:
Cascom International, Inc.
(supplier of graphics, animation, and special effects for multimedia)
631 Mainstream Drive
Nashville, TN 37228
Telephone: 615/242-8900
http://www.cascom.com/

Iconomics
The Global Illustration Resource
155 North College Avenue, Suite 225
Fort Collins, CO 80524
Telephone: 970/493-0087
http://www.iconomics.com/

Illustration Works
3033 13th Avenue West
Seattle, WA 98119-2021
Telephone: 206/282-3672
http://www.halcyon.com/artstock/main.html

Master Series Illustration Library
Telephone: 800/641-1803
http://www.masterseries.com/welcome1.html

The Stock Illustration Source, Inc.
16 West 19th Street, 9th Floor
New York, NY 10011
Telephone: 800/446-2437
http://www.sisstock.com/

Images (Moving and Still Images)

Archive Films/Archive Photos
530 West 25th Street
New York, NY 10001
Telephone: 212/620-3955
http://199.173.199.107/Archive/default.html

The Bridgeman Art Library
65 East 93rd Street
New York, NY 10128
Telephone: 212/828-1238
info@bridgemanart.com
http://www.bridgeman.co.uk/

Cascom International, Inc.
(stock still and footage agency)
631 Mainstream Drive
Nashville, TN 37228
Telephone: 615/242-8900
http://www.cascom.com/

Corbis Corporation
15395 SE 30th Place
Bellevue, WA 98007
Telephone: 206/641-4505
http://www.corbis.com

FOOTAGE.net
(Note: Not a service provider but an online stock, archival, and
news footage Web site that allows single source access to several
film and audiovisual repositories.)
35 South Main Street
P.O. Box 168
Hanover, NH 03755-0168
Telephone: 603/643-0515
http://www.FOOTAGE.net/

Image Directory (ID)
Academic Press
525 B Street, Suite 1900
San Diego, CA 92101
Telephone: 619/699-6387
http://www.imagedir.com

Index Stock Photography
213 West 18th Street
New York, NY 10011
Telephone: 212/929-4644
http://www.indexstock.com/

Media Photographers Copyright Association (MPCA)
14 Washington Street
Princeton Junction, NJ 08550-1033
Telephone: 609/799-9677
http://www.mpca.com/

Motion Picture Licensing Corporation (MPLC)
5455 Centinela Avenue
Los Angeles, CA 90066-6970
Telephone: 800/462-8855
http://www.mplc.com/

Picture Network International—Publishers Depot (PNI)
2000 14th Street North
Arlington, VA 22201
Telephone: 800/764-7427
http://www.publishersdepot.com

The Stock Market Photo Agency
360 Park Avenue South
New York, NY 10010
Telephone: 212/684-7878
http://www.stockmarketphoto.com/asp/main.asp

The Stock Solution
307 West 200 South, Suite 3004
Salt Lake City, UT 84101
Telephone: 801/363-9700
http://www.tssphoto.com/

Journal Projects

Journal Storage (JSTOR)
188 Madison Avenue
New York, NY 10016
Telephone: 212/592-7345
http://www.jstor.org

Project Muse
2715 North Charles Street
Baltimore, MD 21218-4319
Telephone: 800/548-1784
http://muse.jhu.edu/

The University Licensing Program (TULIP)
Elsevier Scientific
655 Sixth Avenue
New York, NY 10010
Telephone: 212/633-3787
http://circe.engin.umich.edu/tulip/

Museum and Library Initiatives

Art Museum Image Consortium (AMICO)
c/o Archives and Museum Informatics
2008 Murray Avenue, Suite D
Pittsburgh, PA 15217
Telephone: 412/422-8533
http://www.amn.org/AMICO/

The Museum Educational Site Licensing Project (MESL)
c/o The Getty Information Institute
1200 Getty Center Drive, Suite 300
Los Angeles, CA 90049
Telephone: 310/440-7310
http://www.gii.getty.edu/mesl/home.html

Museum Digital Library Collection (MDLC)
Geoffrey Samuels
530 Park Avenue
New York, NY 10021
Telephone: 212/980-5720
http://www.museumlicensing.org/

The Research Libraries Group
1200 Villa Street
Mountain View, CA 94041
Telephone: 800/537-7546
http://lyra.rlg.org/toc.html

Music Rights Organizations

MECHANICAL RIGHTS
The Harry Fox Agency, Inc.
711 Third Avenue
New York, NY 10017
Telephone: 212/370-5330
http://www.nmpa.org/hfa.html

PERFORMING RIGHTS
American Society of Composers, Authors and Publishers (ASCAP)
One Lincoln Plaza
New York, NY 10023
Telephone: 212/621-6000
http://www.ascap.com/

Broadcast Music Inc. (BMI)
320 West 57th Street
New York, NY 10019
Telephone: 212/586-2000
http://www.bmi.com

Society of European Stage Authors and Composers, Inc. (SESAC)
55 Music Square East
Nashville, TN 37203
Telephone: 615/320-0055
http://www.sesac.com

Reprographics

Copyright Clearance Center (CCC)
222 Rosewood Drive
Danvers, MA 01923
Telephone: 508/750-8400; 508/750-4283 x218
http://www.copyright.com/

Software

Apple Computer, Inc.
Software Licensing M/S 198-SWL
2420 Ridgepoint Drive
Austin, TX 78754
Telephone: 800/793-9378; 512/919-2645
http://devworld.apple.com/mkt/registering/swl/swl.shtml

Business Software Alliance (BSA)*
1150 18th Street, NW, Suite 700
Washington, D.C. 20036
Telephone: 202/872-5500
http://www.bsa.org

Microsoft Corporation
One Microsoft Way
Redmond, WA 98052-6399
Telephone: 425/882-8080
Licensing information available at:
http://www.microsoft.com/syspro/technet/servsup/
service/piracy/licqa95.htm

Software Publishers Association (SPA)*
1730 M St. NW, Suite 700
Washington, D.C. 20036-4510
Telephone: 202/452-1600
http://www.spa.org/textd.htm

*The Business Software Alliance and the Software Publishers Association are trade organizations that represent various segments of the software industry. They are not intellectual property service providers, but safeguarding intellectual property rights and software distribution is a key issue for their members. Because software usage is direct-licensed throughout the industry, BSA and SPA offer a broad, comprehensive perspective that is difficult to ascertain from a review of individual software companies. Consequently they merit inclusion in any review of intellectual property management for software.

Appendix C

Review Questions

The following questions were used as a guide for gathering information on the more than thirty intellectual property management organizations reviewed as background for this report.

Service Provider Information and Background

Name/Contact

Year of formation

General description of the organization

Sponsoring or "incentive" organizations (i.e., external organization(s) or projects instrumental in the creation or development of the service provider)

Size/Representation (number of rightsholders represented by the organization /number of items in its repertoire)

Size of staff/Staff positions

Operations and Model

Does the organization follow a particular business or structural model? (e.g., consortium, brokerage, collective, reseller, other)

Is it "for-profit" or "not-for-profit?"

What kinds of property rights does the organization manage? (e.g., reprographics, art, music, film, etc.)

Does the organization distribute content as well as manage rights?

 If so, what is the distribution mechanism for the content? (e.g., ftp, CD-ROM, print, etc.)

 Where is the content located/stored? (e.g., centralized on one machine/at one site, decentralized at various sites or on rightsholders' sites, other)

 Who selects content for inclusion? (i.e., rightsholder, agency, both)

 In what format(s) is the content accepted? (e.g., digital, catalog card, transparencies)

How is foreign rights distribution handled?

What added services does the organization offer? (e.g., scanning, data formatting, indexing, product development, value-added content, etc.)

 What are the fees for these services?

How does the organization market itself to potential user communities?

Does the organization pursue infringement? To what extent?

How are rights permissions or privileges granted to users? (e.g., license, subscription, per program/use)

How are works licensed? (e.g., site, item, blanket, other)

What is the term (time frame) of the license? Is it variable? Is it negotiable?

Has the organization considered and abandoned any particular kind of licensing arrangement?

 If so, why?

Uses

Has the organization set predetermined categories for use?

 If so, what are the categories?

Does the organization accommodate the "fair use" doctrine?

How does it define "fair use"?

Who determines the appropriate types of use for intellectual property? (e.g., rightsholders, rights organization, both)

Are there any restrictions on use?

How/when is usage reported to rightsholders?

Rightsholders

Who are the rightsholders? (e.g., musicians, museums, photographers, writers, graphic artists, publishers)

Relationship between the organization and the rightsholder:

 Are there membership qualifications or fees?

 What rights are transferred to the organization?

 What rights are retained by the rightsholder?

 What warranties are required of rightsholders to prove that they have clear rights to their content?

 What are the incentives for a rightsholder to join or contribute their intellectual property to the service provider's organization?

 Are there incentives for rewarding rightsholders who contribute high-quality content? (e.g., greater royalty fees, greater/cheaper access to agency services, etc.)

Users

What is the user market for the particular content or rights? (e.g., teachers, students, photographers, studios)

Relationship between the organization and the user:

What are the end-user licensing categories? (e.g., education, commercial, nonprofit)

How do users participate—what is the method? (e.g., online applications/preregistered accounts/subscriptions/searchable database repository)

What are incentives for users to use services provided by this particular organization as opposed to another?

Are there any other costs that the user must assume (besides license fees) in order to participate?

Is the user the "end user" of the product/service or an intermediary? (e.g., a library is an intermediary for its patrons, a corporation is an intermediary for its employees)

Economic Issues

What is the annual revenue of the organization?

What is the organization's chief source of revenue?

What is the organization's ratio of revenue to royalty distribution?

What is the total amount of royalties dispersed over time?

Besides licensing fees, what other sources of revenue does the rights organization have? (e.g., usage fees, sell-back of value-added services/content to rightsholders; subscriptions to database, cancellation fees, etc.)

Pricing and royalty strategies:

Who sets fees? e.g., rightsholders, rights organization)

How are fees determined? (e.g., by census, by formula, flat rate, percentage, etc.)

How are fees assessed on users? (e.g., by end-user category, by search, by access time, usage of a work, etc.)

When are fees collected? (e.g., at time of use, prior to use, within thirty days of use, etc.)

How are fees collected? (e.g., credit card transactions, debit transactions, Digicash, etc.)

How are royalties determined? (e.g., by gross sales, by percentage split, by risk factor, by formula or calculations based on selected criteria, etc.)

How are royalty payments distributed to rightsholders? (e.g., by check, bank transfer)

When are royalties distributed to rightsholders? (e.g., yearly, monthly, "advances")

Administrative Duties/Burdens (paperwork and personnel)

What are the administrative duties or burdens on the *rightsholder* if he or she joins a rights organization?

For example:

Does the rightsholder have to regularly contact or contribute information to the organization?

Does the rightsholder have to appoint personnel as a single point of contact for the rights organization?

Does the rightsholder have to contribute intellectual property to the rights organization at regular intervals?

Does the rightsholder have to assume order fulfillment, billing, updates?

Does the rightsholder have to reformat and retrospectively document his or her intellectual property prior to its acceptance by the service provider?

What are the administrative duties or burdens on the *user* if she or he joins a rights organization?

For example:

Does the user have to collect, record, and report usage information?

Does the user (if it is an organization) have to appoint personnel as a single point of contact for the service provider?

Appendix D

Questionnaire for Reviewing Intellectual Property Management Service Providers

How to Use This Questionnaire:
As intellectual property management organizations proliferate, cultural and educational institutions will face a daunting challenge in culling through the offerings and services provided by these organizations. This questionnaire was developed to assist with this task. The questionnaire is a tool for collecting information about the services and operational logistics of intellectual property management providers, and offers institutions a structured way to gather and record this information. Its primary purpose is not to yield statistical information but to provide a service provider "snapshot" compiled from primary (i.e., contract templates, presentations, etc.) and alternative information sources (i.e., articles in journals, World Wide Web sites, discussions with affiliated rightsholders and users, etc.). Readers may choose to use the questionnaire singly to examine one organization, or may copy it and use it as a template to standardize comparisons among several organizations.

The questionnaire is organized by topical areas corresponding to issues discussed in various chapters of this report. Each area (and in some instances, a particular question) is keyed into the report with a notation (e.g., Chapter 4, pages 33 to 34) so that readers can refer to a broader discussion of issues that underlie the question if they so choose. Some questions will be irrelevant for certain organizations and unanswerable for others. (Organizations in a startup phase, for example, may not be able to answer certain questions because their policies and procedures will not have yet been established.) However, rightsholders and users must consider all the issues identified in the questionnaire, even if they cannot get answers to them, in order to make an informed decision about who is best suited to address their various intellectual property needs.

The questionnaire may also be useful for those cultural and educational institutions that are in the early stages of reviewing their intellectual property management needs. In these circumstances, the questionnaire functions not as an instrument for data gathering, but as a touchstone for provoking thought and careful consideration of one's own intellectual property. Its topics may be used as discussion points to foster dialogue and commentary that can help an institution frame internal requirements for the management of its intellectual property.

Permission is granted to individuals to copy this questionnaire for use as a template to assess intellectual property management organizations. Any other use is prohibited without express permission.

Questionnaire for Reviewing Intellectual Property Management Service Providers

CONTACT INFORMATION

Legal Name of Organization:

Year of Founding: Year of Incorporation:

Address of Corporate Headquarters:

Telephone: Fax

E-mail: URL:

Contact Name:

BACKGROUND INFORMATION

A. HISTORY OF FORMATION (SEE CHAPTER 5, SECTION A, "HISTORY AND STARTUP RELATIONSHIPS," PAGES 41 TO 42)

What are the circumstances behind the organization's creation? Why was it created?

What other groups or associations were involved in its formation? (e.g., foundations, membership associations, umbrella groups, etc.)

Are these groups or associations still involved with the organization?

Yes _____ No _____

Is their relationship with the organization temporary or long-term?

If temporary, when will the relationship formally cease?

Do these groups or associations have input into the current governance and administration of the organization?

Yes _____ No _____

If yes, what role do they play in governance or administration?

B. ORGANIZATIONAL CONTEXT, SIZE, AND SCALE (SEE CHAPTER 5, SECTION A, "SIZE AND SCALE," PAGES 42 TO 44)

How many works does the organization represent in its repertoire of intellectual properties?

How many rightsholders (individuals and/or institutions) does the organization represent?

How many employees does the organization have?

What are their titles?

Is an organizational chart available?

Yes _____ No _____ Copy attached _____

What is the organization's total annual revenue?

What is the ratio of revenue to royalty distribution?

C. ORGANIZATIONAL GOALS AND PLANS (SEE CHAPTER 5, SECTION A, "ORGANIZATIONAL MISSION," PAGES 44 TO 45)

Does the organization have a mission or corporate statement of purpose?

Yes _____ No _____ Copy attached _____

Does the organization have a strategic or corporate growth plan?

Yes _____ No _____ Copy attached _____

Are other planning documents available?

Yes _____ No _____ Copy attached _____

D. OPERATIONS (SEE CHAPTER 5, SECTION B, "MODELS OF OPERATION" AND "BASIC SERVICES," PAGES 50 TO 53)

What genres of intellectual property does the organization administer? (e.g., literary works, visual imagery, graphic arts, music, etc.)

Does the organization administer the rights to the works in these genres?

Yes _____ No _____

Does the organization distribute the works (or copies of the works)?

Yes _____ No _____

What is the organization's policy on pursuing infringement? (see Chapter 4, Section B, "Joining a Rightsholders' Collective," pages 37 to 38) (e.g., doesn't pursue, issues cease and desist notices, litigates, etc.)

What ancillary services does the organization offer? (see Chapter 5, Section B "Basic Services," pages 51 to 53)

Technical services: (specify)

Offered to: _____ Rightsholders _____ Users _____ Both. Fees:

Data enhancement services: (specify)

Offered to: _____ Rightsholders _____ Users _____ Both. Fees:

Training and support: (specify)

Offered to: _____ Rightsholders _____ Users _____ Both. Fees:

Member benefits: (specify)

Offered to: _____ Rightsholders _____ Users _____ Both. Fees:

Other services: (specify)

Offered to: _____ Rightsholders _____ Users _____ Both. Fees:

E. TYPES OF RIGHTS ADMINISTERED (SEE CHAPTER 5, SECTION B, "OTHER OPERATIONAL ISSUES," PAGES 53 TO 56)

What specific types of rights does the organization administer? (e.g., performance, mechanical, electronic use, display, etc.)

F. MARKETS AND MARKETING (SEE CHAPTER 5, SECTION B, "OTHER OPERATIONAL ISSUES," PAGES 53 TO 56)

What is the organization's marketing strategy?

How does the organization implement this strategy? (e.g., through a parent organization, an internal marketing department, etc.)

How effective is the marketing? (ask the provider for statistics on effectiveness)

What communities does the organization currently market to?

Are there any new markets that the organization has targeted?

What types of materials does the organization use to market itself? (if possible, obtain copies of print and electronic marketing materials for review)

G. GOVERNANCE STRUCTURE (SEE CHAPTER 5, SECTION A, "GOVERNANCE STRUCTURES," PAGES 45 TO 46)

What is the organization's governance structure? (e.g., government department, for-profit corporation, etc.)

Is it legally registered in the state where it operates as an independent entity, or is it a program administered by a larger independently registered organization? (e.g., a consortium operated by a parent organization)

If it is legally registered, what category is it registered under? (e.g., 501(c)3 organization, New York State Membership corporation, etc.)

Who serves on the organization's Board of Directors?

What interests/audiences/markets do they represent that are relevant to the organization?

Does the organization report on its operations to the public?

Yes _____ No _____

If so, in what forum or format? (e.g, annual report, press conference, newsletter, etc.)

H. INTERNATIONAL ADMINISTRATION (SEE CHAPTER 5, SECTION B, "OTHER OPERATIONAL ISSUES," PAGES 53 TO 56)

Does the organization administer foreign rights?

Yes _____ No _____

Does it do so individually or through reciprocal agreements with foreign affiliates?

If through agreements with affiliates, which affiliates?

In which countries?

How does the organization address usage requests from foreign countries in which it has no reciprocity arrangement with an affiliate?

Does the organization distribute works internationally?

Yes _____ No _____

Does the organization charge an additional fee for foreign administration of works?

Yes _____ No _____

How much is this fee? How is it calculated?

Who pays the fee? _____ Rightsholder _____ User

Does the foreign affiliate charge a fee?

Yes _____ No _____

How is it calculated?

Who pays the fee? _____ Rightsholder _____ User

INTELLECTUAL PROPERTY AND ITS USAGE (SEE CHAPTER 6, SECTION B, "USAGE," PAGES 64 TO 68)

Who selects the intellectual property that will be included in the organization's repertoire?

_____ Rightsholder _____ Organization _____ Both

What criteria are used for selecting this intellectual property? (e.g., marketability, quality/fidelity, documentation, availability, no criteria, etc.)

What types of content will *not* be accepted into the repertoire? (e.g., contemporary works of art, works with uncertain copyright)

What are the biases in the repertoire? (e.g., older works, works of a particular genre or subject matter)

Where are works in the repertoire located?

_____ Organization's site _____ Rightsholders' sites _____ Other site (specify):

In what forms or media are the intellectual properties distributed? (e.g., CD-ROM or other fixed digital media, online distribution (via ftp, World Wide Web), digital version of repertoire mounted at user's site; physical formats (i.e., slides, transparencies), etc.)

A. USES: (SEE CHAPTER 6, SECTION B, "USAGE," PAGES 64 TO 68)

1. Permissible Uses:

Who determines permissible uses for the intellectual properties in the repertoire?

_____ Rightsholder _____ Organization _____ Both

When is the decision about permissible uses made?

 At time of participation?

 Ongoing throughout the term of agreement?

What factors are considered in determining permissible uses? (e.g., frequency of use, context of use, type of user, medium, other)

2. Electronic Uses:

What electronic uses are allowed? (e.g., displaying, printing, downloading, backups, transferring, etc.)

What electronic uses are prohibited? (e.g., displaying, printing, downloading, backups, transferring, etc.)

What kind of electronic distribution is allowed? (e.g., Intranet or Internet distribution, fixed media on non-networked machines, etc.)

What kind of electronic distribution is prohibited? (e.g., Intranet or Internet distribution, etc.)

What security measures are in place or are required as a precondition for use in electronic formats? (e.g., encryption, watermarking, passwords, low-resolution display)

 Who is responsible for implementing these measures?

_____ Rightsholder _____ Organization _____ User

Does the organization have a statement on derivative works in electronic media?

 Yes _____ No _____ Copy attached _____

If not, what is the organization's opinion on controversial uses that may or may not constitute derivative works?

> Examples: Is a digital scan of a photograph a derivative work?
> Is a color-corrected digital image a derivative work?

3. Restrictions on Use:

What restrictions are imposed on use? (e.g., physically altering a work, copying in unauthorized formats, unapproved redistribution, etc.)

Who imposes these restrictions?

_____ Rightsholder _____ Organization _____ Both

4. Fair Use:

What is the organization's stance on the fair use doctrine?

How does the organization accommodate fair use in its day-to-day operations?

RIGHTSHOLDER ISSUES (SEE CHAPTER 7, SECTION A, "RIGHTSHOLDER ISSUES," PAGES 70 TO 78)

How does the organization market itself to rightsholders?

What qualifications must a rightsholder have to affiliate with an organization? (e.g., proof of professional activity, content, membership in a professional association, etc.)

What warranties must rightsholders provide the organization as a condition of participation? (e.g., legal documents, contractual guarantees)

Are rightsholders required to pay a fee to join the organization?

Yes _____ No _____

If so, what is the fee?

How is it calculated?

Is it one-time or annual?

What other fees might rightsholders have to assume? (e.g., costs of data preparation, marketing materials fee, scanning fees, distribution copy fees, processing fees for incorporating content into a repertoire, etc.)

A. INTELLECTUAL PROPERTY CONTRIBUTION (SEE CHAPTER 6, SECTION A, "CONTENT," PAGES 59 TO 64)

What is the minimum number of works a rightsholder must contribute to the repertoire in order for the organization to agree to administer its intellectual property?

How soon must these materials be submitted to the organization once an agreement has been signed?

Must the rightsholder contribute a minimum number of works to the repertoire on regular basis as a condition of participation?

Yes _____ No _____

If so, what is the minimum number of works that must be contributed regularly?

How frequently must these works be submitted?

What kind of contextual information (documentation) must accompany the works?

How must this information be structured and formatted?

Who is responsible for structuring and formatting it?

_____ Rightsholder _____ Organization

Are there any processing fees associated with the submission of intellectual property to the organization?

Yes _____ No _____

If so, what are these fees?

When must they be paid?

B. INCENTIVES (SEE CHAPTER 7, SECTION A, "RIGHTSHOLDER INCENTIVES," PAGES 71 TO 74)

Besides centralized administration, management, and distribution of intellectual properties, what other incentives does the organization offer rightsholders? (e.g., marketing channels, use of the repertoire, access to technology, favorable terms and conditions, advice and consultation, etc.)

C. RIGHTS ASSIGNED (SEE CHAPTER 7, SECTION A, "ASSIGNING RIGHTS," PAGE 74)

What specific rights does the rightsholder assign to the organization? (e.g., right of representation in litigation, right to represent rightsholders in negotiating uses of properties, right to place rightsholder's works in particular media, right to distribute works, electronic usage rights, etc.)

D. TERMS OF AGREEMENT (SEE CHAPTER 7, SECTION A, "TERMS OF AGREEMENT," PAGE 75)

Does the organization have a "boilerplate" rightsholders agreement that can be reviewed?

Yes _____ No _____ Copy attached _____

What is the term of the rightsholder/service provider agreement? (e.g., two years, ten years, one year with automatic renewals, etc.)

Is it exclusive or nonexclusive?

What are the conditions for terminating the agreement?

What are the warranties and indemnities for both the rightsholder and the organization?

What are the rightsholder's requirements in terms of intellectual property contribution, preparation, reporting?

What guarantees are offered for the availability of the repertoire should the organization go out of business?

For the return of materials to the rightsholder (if the properties are physically stored at the organization's offices?)

Under what conditions can a rightsholder request removal of a work (or works) from the repertoire?

(Note: Prior to signing an agreement with any organization, all rightsholders should have an attorney review the terms and conditions of their specific agreement.)

E. REPORTS TO RIGHTSHOLDERS (SEE CHAPTER 7, SECTION A, "REPORTING," PAGES 75 TO 76)

How does the organization report usage statistics to the rightsholder?

How frequently is this information reported (e.g., quarterly, annually)

Does the organization report on organization-wide activities to rightsholders?

Yes _____ No _____

If so, how frequently?

By what means? (e.g., annual report, annual rightsholder meeting, newsletter etc.)

F. RIGHTSHOLDER ADMINISTRATIVE BURDENS (SEE CHAPTER 7, SECTION A, "ADMINISTRATIVE BURDENS," PAGES 76 TO 78)

What specific administrative duties does the organization expect the rightsholder to perform in the area of:

Notification to the organization? (e.g., changes in the status or availability of a work, new works, etc.)

Participation requirements of the organization? (e.g., does the rightsholder have to participate in specific activities of the organization like censuses, focus groups, evaluation groups, etc?)

Preparation and delivery of intellectual properties to the organization? (e.g., how does the rightsholder have to prepare his or her works in order to comply with the organization's submission requirements? What must be documented and formatted and how?)

Other obligations? (e.g., securing model and property releases, clearing underlying rights, fees, etc.)

USER ISSUES (SEE CHAPTER 7, SECTION B, "USER ISSUES," PAGES 78 TO 79)

How does the organization market itself to users?

What kind of users does the organization serve?

What kind of markets are these users grouped into?

How are these markets defined by the organization?

How are these markets serviced by the organization?

Are users mostly individuals or institutions?

If institutions, who are the end users? (e.g, university: end users are students, faculty, staff)

A. INCENTIVES (SEE CHAPTER 7, SECTION B, "USER INCENTIVES," PAGES 79 TO 81)

Besides centralized administration, management, and distribution of intellectual properties, what other incentives does the organization offer users? (e.g., repertoire of high-quality works, access to technology and tools, research)

B. USER PARTICIPATION (SEE CHAPTER 7, SECTION B, "USER PARTICIPATION," PAGES 81 TO 82)

How does a user communicate with an organization? (e.g., via traditional communication means such as telephone and fax, online access, visits to the organization's offices, etc.)

C. TERMS AND CONDITIONS (SEE CHAPTER 7, SECTION B, "USER PARTICIPATION," PAGES 81 TO 82)

Does the organization have a "boilerplate" user's agreement that can be reviewed?

Yes _____ No _____ Copy attached _____

What sort of contractual arrangement does a user enter into when obtaining permission to use a work? (e.g., license, subscription, pay per use)

What is the term of the user/service provider agreement? (e.g., two years, ten years, one-time use)

Is it exclusive or nonexclusive?

What are the conditions for terminating the agreement?

What are the warranties and indemnities for both the user and the organization?

What are the obligations on a user if a rightsholder withdraws a work (or works) from the repertoire during the user's term of agreement?

What requirements are made of the user in terms of usage reporting?

What guarantees are offered for the availability of the repertoire should the organization go out of business? (e.g., copies in escrow, copies to users in event of default, etc.)

(Note: Prior to signing an agreement with an organization, all users should have an attorney review the terms and conditions of their specific agreement.)

D. USER FEES (SEE CHAPTER 7, SECTION B, "USER FEES AND COSTS," PAGE 82)

What fees are assessed on users for use of intellectual properties? (obtain a copy of the organization's fee schedule, if available)

What other ancillary fees may be incurred by a user? (e.g., late fees, rental fees, research fees, service fees, media transfer fees, etc.)

E. ADMINISTRATIVE BURDENS (SEE CHAPTER 7, SECTION B, "ADMINISTRATIVE BURDENS," PAGES 83 TO 85)

What specific administrative duties does the organization expect the user to perform in the area of:

Usage reporting requirements? (e.g., type and kind of recordkeeping required, frequency of usage reporting)

Participation requirements of the organization? (e.g., mandatory surveys, evaluations, census participation)

Other obligations? (e.g., securing rights clearance, display and credit specifications, redistribution to a larger end-user community, etc.)

ECONOMIC ISSUES (SEE CHAPTER 8, SECTIONS A–D, PAGES 87 TO 94)

(Note: Obtain copies of the organization's latest annual report [if it has one], rightsholder report, or other documents that explain the organization's finances.)

From what sources does the organization receive its revenue? (e.g., usage fees, membership fees, ancillary service fees, etc.)

What percentage of total gross revenues do each of these sources constitute?

Where does the organization incur costs? (e.g., constructing the repertoire, developing products, processing requests, delivering content, etc.)

What percentage of total costs does each of these areas constitute?

How does the organization determine its pricing structure for works?

What criteria does it use to assess monetary value?

Who sets usage fees?

_____ Rightsholder _____ Organization _____ Both

What is the fee structure? (e.g, transactional [item-by-item] pricing, volume pricing, both)

If transactional, what are some of the factors that add to the base price of a work? (e.g., distribution, type of use, etc.)

A. FEE COLLECTION (SEE CHAPTER 8, SECTION E, "COLLECTING FEES," PAGES 94 TO 95)

How does the organization collect fees from users?

When? (e.g., at or near time of use, at time of licensing, etc.)

What are acceptable forms of payment? (e.g., check, COD, credit card, online payment)

What are the terms of payment? (e.g., in full at time of use, lump sum advance and royalty installments, within thirty days, etc.)

B. REDISTRIBUTING ROYALTIES (SEE CHAPTER 8, SECTION F, "REDISTRIBUTING REVENUES," PAGES 95 TO 99)

How does the organization monitor or track usage in order to determine royalties? (e.g., sampling, logs, census, exact usage, etc.)

Does the organization track usage or does it rely on information supplied by user records and reports?

What formula does the organization use for redistributing revenues to rightsholders, itself, and other parties involved (i.e., middlemen)? (e.g., formula, revenue split, combination of royalties and transaction charges, etc.)

What factors affect royalty calculations? (e.g., risk, domestic vs. foreign licensing, use of an intermediary agent, etc.)

How do these factors affect the calculation? (specify):

How frequently are royalty payments made? (e.g., monthly, quarterly, when a minimum amount has accrued)

Does the provider offer the rightsholder an advance against royalties?

Yes _____ No _____

If so, under what circumstances?

Are royalty distributions made only after user payment has been received, or within a guaranteed time period after use is granted?

Glossary

Art & Architecture Thesaurus (AAT)

A reference work that identifies and organizes art and architecture terminology. Developed by the Getty Information Institute and used as a standard for art and architecture terms in the arts and humanities.

Berne Convention for the Protection of Literary and Artistic Works

A multilateral agreement that recognizes copyrights that arise in other member countries. The Berne Convention has two key precepts: 1) the concept of "national treatment," whereby every member nation agrees to extend the protection of its own copyright laws to works that originate in other member nations, and 2) minimum standards of protection by which all treaty members must abide.

blanket license

A type of license agreement that grants users authorization to use every work in a repertoire as often as one wishes during the term of the license.

bundled pricing

A pricing structure that offers users access to and use of all the intellectual properties in a service provider's repertoire for a single fee.

collecting societies

A term used for intellectual property management providers whose role is to collect royalties from users and distribute them to rightsholders in a centralized fashion.

compulsory license

In music, a mandatory license issued on behalf of the copyright owners after the public release of the first recording of a musical composition. In the United States there are compulsory licenses for jukeboxes, phonorecords, cable broadcasting, and satellite transmissions.

consent decree

A judicial decree sanctioning a voluntary agreement between parties in dispute. (From Merriam Webster's WWW Dictionary: http://www. m-w.com/cgi-bin/mweb.)

content broker

An individual or entity who facilitates access to information ("content"), usually by compiling select information from worldwide sources into a single resource, organizing it according to a particular intellectual scheme, and making it available to potential users.

copyright

A legal protection for "original works of authorship," including literary, dramatic, musical, artistic, and certain other intellectual works fixed in a tangible medium of expression. Copyright includes five basic rights: the right to reproduce a work, to distribute it to the public, to perform it publicly, to display it publicly, and to create derivative works from it. Ideas, concepts, procedures, and processes cannot be copyrighted until they are converted from a mental construct to a physical form.

derivative work

A creative work based on one or more preexisting works, such as a translation, musical arrangement, dramatization, fictionalization, motion picture version, sound recording, art reproduction, abridgment, condensation, or any other form in which a work may be recast, transformed, or adapted. A work consisting of editorial revisions, annotations, elaborations, or other modifications that, as a whole, represent an original work of authorship, is a "derivative work." (From Section 101 of the U.S. Copyright Code.)

digital lightbox

An online space where one can store and view images preselected from a searchable database of items in a service provider's

repertoire. The term "lightbox" is borrowed from the concept of a slide lightbox. Digital lightboxes allow users to "line up" their selected images in a similar manner, so the user can review the images next to one another.

digital object

Content whose native form is digital rather than physical. Digital objects are created in a digital environment and can be used, transferred, or destroyed only in a digital environment. Examples include software, Web pages, hypertext fiction, and digital art.

digital watermarking

A method of embedding identifier information into image, audio, video, or multimedia data for the purposes of protecting copyright and uses on the Internet. A digital watermark is an invisible identification code that is permanently embedded in the data. For an example of digital watermarking, see http://www.thomtech.com/mmedia/becker/wmark.htm.

electrical transcription rights

The rights that permit reproduction of music in recordings made for the purpose of facilitating radio broadcasts or purposes other than distribution to the public for their private use. Examples include themes or introductions to radio programs, commercial advertisements prepared for radio broadcast, and transcription for background music services (e.g., Muzak).

electronic rights management systems (aka electronic copyright management systems)

Software applications that administer information on copyright, licenses, and usage for various types of intellectual properties. Although these applications vary greatly, all of them are networked databases that combine information on users, licenses, and

rightsholders. Many allow users to clear rights and retrieve intellectual properties online, reducing the time and expense placed on rightsholders.

encryption

A method of securing information on networks that involves mathematically transforming a digital object so it can be used only by someone who has the information needed to reverse the mathematical transformation.

exclusive rights

Rights transferred to a specific individual or entity to the exclusion of all others.

first-use rights

The rights granted for the first-time use of an intellectual property. Writers, for example, usually grant first-time use rights to their publishers for publication of a book or article in print form. Any uses of the work after this original publication (such as reprinting the work in an online magazine) is considered a secondary use.

ftp

An acronym for "file transfer protocol," a common method for moving files between two Internet sites.

grand rights

All dramatic performance rights associated with large theatrical productions such as comedy, opera, ballet, and theater. Because rights associated with these productions have a great monetary value and frequently involve issues of artistic control, they are usually negotiated and granted via direct licensing between the rightsholder and the user.

intellectual property

A concept in which the tangible expressions of intellectual/creative pursuits (such as inventions, designs, creative works, etc.) are treated in legal and social spheres as property, with all its attendant implications (e.g., ownership, use, economic transactions, etc.). In the United States, intellectual property is protected under the legal regimes of patent, trademark, and copyright law.

license

A type of contract between an authorizing party ("licensor") and another party ("licensee") that allows the licensee to exercise a privilege that he or she normally does not have the right to exercise.

mechanical rights

The rights from a music publisher or agent that allow one to make a mechanical reproduction of a musical composition for the purpose of distributing it to the public for private use. Mechanical reproductions include such items as audiocassettes, audio compact discs, record albums, computer chips in birthday cards, piano rolls, and music boxes.

mechanical reproduction

Reproduction of music in a form that must be heard with the aid of a "mechanical" device, such as a compact disc player, audiocassette recorder, or phonograph.

model release

A legal agreement between a photographer and the person (or persons) he or she has photographed that grants the photographer permission to publish the images that contain the person's (i.e., the "model's") likeness.

moral rights

Privileges believed to be innate to a creator of a work. These generally include the right to make the work available, to claim authorship, to insist on respect for the integrity of the work, to withdraw or rescind a work, and to disavow and disassociate oneself from a work if the work has been altered by someone else in an unagreeable fashion.

nonexclusive rights

A set of rights that can be transferred (usually by sale) to any number of individuals or entities any number of times.

online shopping cart

A concept borrowed from grocery shopping and metaphorically applied to a parallel online function. Users select items from a service provider's online repertoire and add them to their shopping cart. When the users

are finished searching, they can access their shopping cart to review their selections, remove or add items, and place a final order.

patent

A grant of a property right by the federal government to the inventor which excludes others from making, using, or selling the invention. In the United States, patents are granted for a term of twenty years (fourteen years for design patents), which may be extended only by a special act of Congress (except for certain pharmaceutical patents). After expiration of the term, the patentee loses rights to the invention. (For further information, see http://www.uspto.gov/ web/offices/pac/doc/basic/geninfo.html.)

per use license

Used synonymously with transaction license.

phonorecords

A term used in the U.S. Copyright Act to define any object in which sounds are fixed and from which the sounds can be perceived, reproduced, or transmitted directly or with the aid of a machine. Examples of phonorecords include audiocassettes, audio compact discs, and records.

property release

A legal agreement between an individual or entity and a property owner that authorizes the individual or entity to photograph or portray a property in an image, or to use an already existing image portraying the property.

public domain

Intellectual property rights that belong to the community at large, are unprotected by copyright or patent, and may be appropriated or used by anyone. (Modified from Merriam Webster's WWW Dictionary: http://www. m-w.com/cgi-bin/dictionary.) Intellectual property comes into the public domain in one of the following ways: 1) the copyright has been lost or expired, 2) the intellectual property was created by the federal government, or 3) the property was specifically relegated to the public domain by the copyright owner.

public performance

In music, any vocal, instrumental, and or mechanical rendition and representations in any manner or by any method, or reproductions of performances and renditions by means of devices for reproducing sound recordings in synchrony or timed relation with the taking of motion pictures. (From ASCAP's license definition of public performance: http://www.ascap.com/membership/agreement/agreement.html.)

repertoire

The total number of intellectual properties represented by a service provider.

rights and reproductions department

The office or department in an organization that administers and oversees permissions for use of intellectual property owned by the organization. Some common organizations with rights and reproductions departments are museums, visual resource repositories, and publishing houses.

rightsholder

Any individual, institution, organization, or estate that holds copyright to creative works. An individual or entity becomes a rightsholder in one of three ways: by creating a work, by having copyright of a work transferred in a purchase, gift, bequest, or other assignment, or by hiring someone to create a work on one's behalf ("work for hire").

sampling

The process of using sound bytes from a master recording in a device and incorporating them within another musical composition.

service provider (aka intellectual property service provider)

Organizations or entities that offer intellectual property management and administration services to rightsholders and users. These organizations include, but are not limited to, content brokers, membership-based collecting societies, stock agencies, rights and reproduction organizations (RROs), and consortia.

shared digital lightbox

A digital lightbox that can be shared with one or more clients or colleagues on the Internet. Shared digital lightboxes are useful tools for projects where content selection is a group effort because they allow images to be preselected once and temporarily saved into a file where they can be reviewed thereafter by colleagues or clients.

shareware

Software distributed by its creator to users on a conditional basis. The software is freely available for trial use. If a user wishes to continue using the software, he or she is expected to pay the creator a (usually nominal) use fee.

shopping cart

See online shopping cart.

site license

A type of license whose terms extend to all users at a particular location. A university site license, for example, allows all users affiliated with a university to use a product or service under the terms of one license.

small rights

A term used for intellectual property rights in which the cost of administration far exceeds the income that can be generated from their use. For example, the nondramatic public performance rights for music are considered "small rights" because the economic returns (often only a few cents per use) is not great enough to offset the costs that songwriters would incur in trying to administer these rights individually.

software piracy

The illegal distribution or copying of software for personal or organizational use. (From the Business Software Alliance: www.bsa.org/piracy/piracy.html.)

stock photography agency

An organization that makes existing photography available for commercial or editorial use under a licensing scheme. The stock agency functions as a third-party intermediary between creators and commercial end

users. The content is either a preexisting body of work that the agency "recycles" in the commercial market, or works created specifically for use in various types of markets. Stock agencies also exist for other types of content like fonts, illustrations, and digital graphics.

superdistribution

An approach to distributing digital information in which digital information is made available freely and without restriction, but a user must pay for each use he makes of the information.

synchronization rights

The rights to use recorded music in timed combination with visual images ("synchronization") such as music in films, television, videos, computer programs, Web sites, etc.

tombstone data

Minimal categories of information that identify an object, image, or work. The phrase appropriates the idea of the minimal identifying information found on tombstones or gravemarkers, which generally list only the most succinct data needed (e.g., name, birth and death dates) to identify the deceased.

trademark

A word, phrase, symbol, or design (or combination thereof), which identifies and distinguishes the source of the goods or services of one party from those of others. A service mark is the same as a trademark except that it identifies and distinguishes the source of a service rather than a product. (From the U.S. Patent and Trademark Office: http://www.uspto.gov/web/offices/tac/doc/basic/basic_facts.html.)

transactional pricing

A pricing structure in which users are charged a fee for each use of each work.

transactional license

A type of license in which a user must seek permission, and is separately charged, each time he or she uses a work or works.

umbrella license

A synonym for blanket license.

Union List of Artist Names (ULAN)

A reference work that identifies biographical and bibliographical information on artists and architects, including their variant names, pseudonyms, and language variants. Developed by the Getty Information Institute and used as a standard for artist and architect names in the arts and humanities.

Universal Copyright Convention

An international treaty for intellectual property which sets out the same provisions as the Berne Convention (see above) but is less protective of an author's moral rights. Note: If a country is a signatory to both the Berne and Universal Conventions, the provisions of the former override the latter.

user

Any individuals, institutions, or organizations that wish to use the intellectual property created by others.

warranty

An assurance that certain conditions exist and will continue to exist for the duration of a term of an agreement.

watermarking

See digital watermarking.

work for hire

A work prepared by an employee as part of his or her employment, or commissioned for use by another person. In "work for hire" situations, the employer is considered the author or creator of the work and owns copyright to the work.

World Intellectual Property Organization (WIPO)

A United Nations organization "responsible for the promotion of the protection of intellectual property throughout the world through cooperation among states, and for the administration of various multilateral treaties dealing with the legal and administrative aspects of intellectual property." (From the WIPO Web site: http://www.wipo.int/eng/.)

Bibliography

General References:

Balas, Janet. "Online Treasures: Copyright in the Digital Era." Computers in Libraries 18, no. 6 (June 1998). [http://www.infotoday.com/cilmag/jun/story2.htm]

Barlow, John Perry. "The Economy of Ideas." *Wired* 2, no. 3 (1994): 84–90ff. [http://www.hotwired.com/wired/2.03/features/economy.ideas.html] (1994).

*Berkeley Digital Library SunSITE. *Copyright, Intellectual Property Rights, and Licensing Issues*. [http://sunsite.berkeley.edu/Copyright/] (1997).

Bettig, Ronald V. *Copyrighting Culture: The Political Economy of Intellectual Property*. Boulder: Westview Press, 1996.

Boyle, James. Intellectual Property Policy Online: A Young Person's Guide. [http://www.wcl.american.edu/pub/faculty/boyle/joltart.htm] (1997).

Dyson, Esther. "Intellectual Value." *Wired* 3, no. 7 (1995): 146–141; 182–184. [http://www.wired.com/wired/3.07/features/dyson.html] (1995).

Gaines, Jane. *Contested Culture: The Image, the Voice, and the Law*. Chapel Hill: University of North Carolina Press, 1991.

Harris, Lesley Ellen. *Digital Property: Currency of the 21st Century*. Toronto: McGraw-Hill Ryerson Ltd., 1997.

Hoeren, Thomas. *An Assessment of Long-term Solutions in the Context of Copyright and Electronic Delivery Services and Multimedia Products*. European Commission Directorate-General XIII E-1. Luxembourg: Office for Official Publications of the European Communities, 1995.

*International Federation of Library Associations and Institutions. Information Policy: Copyright and Intellectual Property. [http://www.nlc-bnc.ca/ifla/II/cpyright.htm#IFLA] (June 1997).

Littman, Jessica. Reforming Information Law in Copyright's Image. [http://www.msen.com/~litman/dayton.htm#fn0]. Forthcoming in the *University of Dayton Law Review*.

National Federation of Abstracting and Information Services. The Rights & Responsibilities of Content Creators, Providers, and Users: A White Paper. [http://www.pa.utulsa.edu/nfais/whitepaper.html] (December 9, 1997).

Norris, Paul F., and Mark J. Bolender. Potential Pitfalls in Multimedia Media Product Development: Clearing the Necessary Content Rights. [http://www.oikoumene.com/oikoumene/nobomediarights.html] (1996).

Okerson, Ann S. Who Owns Digital Works? [http://www.library.yale.edu/~okerson] (July 1996).

*Varian, Hal. The Information Economy: The Economics of the Internet, Information Goods, Intellectual Property and Related Issues. [http://www.sims.berkeley.edu/resources/infoecon/] (June 1996).

Collective Administration:

Bearman, David. "New Economic Models for Administering Cultural Intellectual Property." *The Wired Museum*. Ed. Kathy Jones-Garmil, Washington, D.C.: American Association of Museums, 1997: 254–259.

Besen, Stanley M., and Sheila Nataraj Kirby. *Compensating Creators of Intellectual Property: Collectives That Collect*. #R-3751-MF, Santa Monica: RAND Corporation, 1989.

Bloom, Glen. *Administering Museum Intellectual Property. A Report Prepared for the Canadian Heritage Information Network*. Ottawa: Cultural Heritage Information Network, March 1997. [http://www.chin.gc.ca/Resources/Research_Ref/Reference_Info/e_reference.html#INTELLEC.] (1997).

*Broadcast Music Inc. BMI's Links to International Copyright Organizations. [http://www.bmi.com/reading/intlinks.html] (1997).

Claverie, Ariane. "The One-stop Shop and Arguments for or Against Individual or Collective Administration of Rights. Minutes – Part 2 in European Commission Legal Advisory Board." The Information Society: Copyright and Multimedia. [http://www.strath.ac.uk/Departments/Law/diglib/ec/min2.html] (April 26, 1995).

Guibault, Lucie. "Agreements between Authors or Performers and Collective Rights Societies: Comparative Study of Some Provisions." L'Association Littéraire et Artistique Internationale Canada, 1997. In French, with English summaries.

International Federation of Reproduction Rights Organizations. Collective Management of Digital Rights: A Position Paper of the International Federation of Reproduction Rights Organizations. [http://www.copyright.com/ifrro/collective.html] (October 1996).

*_____. Directory of RROs.
[http://www.copyright.com/ifrro/drm.html] (1997).

Kaufmann, Thomas. "Competition Issues Relevant to Copyright and the Information Society" in European Commission Legal Advisory Board. The Information Society: Copyright and Multimedia. [http://www.strath.ac.uk/Departments/Law/diglib/ec/kaufmann.html] (April 26, 1995).

Kreile, Reinhold, and Jurgen Becker. Collecting Societies in the Information Society.
[http://www.gema.de/eng/public/jahr97/index.html] (1996).

Maier, Paul-Alexandre. "Intellectual Property Rights and the Role of Collecting Societies" in European Commission Legal Advisory Board. The Information Society: Copyright and Multimedia. [http://www.strath.ac.uk/Departments/Law/diglib/ec/maier.html] (April 26, 1995).

Simpson, Shane. Review of Australian Copyright Collecting Societies: A Report to the Minister for Communications and the Arts and the Minister for Justice.
[http://www.dca.gov.au/pubs/simpson/] (June 1995).

Trant, Jennifer. "Exploring New Models for Administering Intellectual Property: The Museum Educational Site Licensing (MESL) Project." Digital Imaging Access and Retrieval. Papers presented at the 1996 Clinic on Library Applications of Data Processing, March 24–26, 1997, Graduate School of Library and Information Science, University of Illinois at Urbana–Champaign. Ed. P. Bryan Heidorn and Beth Sandore.
[http://www.archimuse.com/papers/jt.illinois.html] (1996).

World Intellectual Property Organization. Collective Administration of Copyright and Neighboring Rights, ref. 688. Geneva: World Intellectual Property Organization, 1990.

Copyright:

Copyright Law of the United States of America. Contained in Title 17 of the United States Code. U.S. Copyright Office, Library of Congress.
[http://lcweb.loc.gov/copyright/title17/#top] (June 1998).

Acheson, Keith, and Christopher Maule. "International Conventions, Agreements, and Organizations Affecting Copyright and Related Rights. May 1995." Copyright and Related Rights: The International Dimension. [http://edie.cprost.sfu.ca/cjc/amb/interntl.html] (April 17, 1998).

Carter, Mary E. Electronic Highway Robbery: An Artist's Guide to Copyrights in the Digital Era. Berkeley, CA: Peachpit Press, 1996.

Harper, Georgia. Copyright Crash Course: Copyright Law in the Electronic Environment.
[http://www.utsystem.edu/OGC/IntellectualProperty/faculty.htm] (January 5, 1998).

Headley, Tim, Randall E. Colson, and John Moetteli. Copyrights for Literary, Performing, and Visual Artists.
[http://www.hayboo.com/hayboo/briefing/headley3.htm] (1997).

Levine, Melissa Smith, and Lauryn Guttenplan Grant. "Copyrights of the Rich and Famous." Museum News 73, no. 6 (November/December 1994): 48–49, 52, 54–55.

Okerson, Ann S. "Copyright or Contract?" Library Journal 122, no. 14 (Sept. 1, 1997): 136–139.

*O'Mahoney, Benedict. The Copyright Website.
[http://www.benedict.com/index.html] (1997).

Samuelson, Pamela. "Copyright and Digital Libraries." Communications of the ACM 38, no. 4 (April 1995): 15–21, 110.

Strong, William S. The Copyright Book. Cambridge: MIT Press, 1990.

Tulchin, Harris. Copyright and Related Issues for Multimedia and Online Entrepreneurs. Lecture Notes for UCLA Multimedia Law Classes.
[http://www.medialawyer.com/lec-copy.htm] (1997).

Vercken, Gilles. Practical Guide to Copyright for Multimedia Producers. EUR 16128. Luxembourg: Office for Official Publications of the European Communities, 1996.

Electronic Rights Management Systems:

Digital Rights Management Technologies. Report Prepared for the Committee on New Technologies of the International Federation of Reproduction Rights Organizations.
[http://www.ncri.com/articles/rights_management/ifrro95.html#RTFToC2] (October 1995).

Gervais, Daniel J. Electronic Copyright Management Systems (ECMS) in a Network Environment.
[http://www.copyright.com] (1997).

Hinds, Isabella. Electronic Rights Management.
[http:www.copyright.com.] (1997).

Hoeren, Thomas. "Technical Solutions." An Assessment of Long-term Solutions in the Context of Copyright and Electronic Delivery Services and Multimedia Products. European Commission Directorate-General XIII E-1. Luxembourg: Office for Official Publications of the European Communities, 1995: 43–54.

Intellectual Multimedia Property Rights Model and Terminology for Universal Reference.
[http://www.imprimatur.alcs.co.uk] (1997).

Roosen-Runge, Peter. *The Virtual Display Case: Protecting Museum Images. A Report Prepared for the Canadian Heritage Information Network.* Ottawa: Canadian Heritage Information Network, 1996.

Fair Use:

American Library Association Joint Statement by Libraries and Cultural Organizations. Conference on Fair Use of Copyrighted Works Concludes without Consensus; Educators, Scholars, Librarians to Explore Next Steps. [http://www.ala.org/washoff/confu.html] (June 6, 1997).

Consortium for Educational Technology in University Systems. *Fair Use of Copyrighted Works: A Crucial Element in Educating America.* Seal Beach, CA: California State University Chancellor's Office, 1995. [http://www.cetus.org/fairindex.html].

Hall, Virginia. "Fair Use of Digital Art Images and Academia: A View from the Trenches of the Conference on Fair Use (CONFU)." *Copyright and Fair Use: The Great Image Debate.* Ed. Robert Baron. *Visual Resources* 12, no. 3–4, (1997): 393–399.

Harper, Georgia. Will We Need Fair Use In The Twenty-First Century? [http://www.utsystem.edu/ogc/intellectualproperty/fair_use.htm] (1997).

_____. CONFU: The Conference on Fair Use. [http://www.utsystem.edu/ogc/intellectualproperty/confu.htm] (1997).

Hoffman, Barbara. "Fair Use of Digital Art Images and Academia: A View from the Trenches of the Conference on Fair Use (CONFU)." *Copyright and Fair Use: The Great Image Debate.* Ed. Robert Baron. *Visual Resources* 12, no. 3–4, (1997): 373–392.

Green, David. CONFU Continues? Is It Time to Re-Group? National Initiative for a Networked Cultural Heritage. [http://www-ninch.cni.org/News/Confu_Report.html] (May 23, 1997).

Shapiro, Michael S. "Not Control, Progress." *Museum News* 76, no. 5 (September/October 1997): 37, 38, 41.

*Stanford University Libraries. Copyright and Fair Use. [http://fairuse.stanford.edu/] (1997).

Steiner, Christine. "The Double-Edged Sword: Museums and the Fair Use Doctrine," *Museum News* 76, no. 5 (September/October 1997): 32–35, 48.

U.S. Patent & Trademark Office. Report to the Commissioner on the Conclusion of the First Phase of the Conference on Fair Use. [http://www.uspto.gov/web/offices/dcom/olia/confu/conclutoc.html] (September 30, 1997).

Weil, Stephen E. "Not Money, Control." *Museum News* 76, no. 5 (September/October 1997): 36, 38, 41.

Glossaries:

Broadcast Music Inc. A Guide to Music Publishing Terminology. [http://www.bmi.com] (1995).

World Intellectual Property Organization. *WIPO Glossary of Terms of the Law of Copyright and Neighboring Rights.* Pub. No. 819: (EFA). Geneva: World Intellectual Property Organization, 1980.

Guidelines for Managing Intellectual Property in Digital Environments:

National Humanities Alliance. Basic Principles for Managing Intellectual Property in the Digital Environment. [http://www-ninch.cni.org/ISSUES/COPYRIGHT/PRINCIPLES/NHA_Complete.html] (March 24, 1997).

Society of American Archivists. Basic Principles for Managing Intellectual Property in the Digital Environment: An Archival Perspective. [http://www.archivists.org/governance/resolutions/nha%20response.html] (October 6, 1997).

Selection, Negotiation, and Licensing of Electronic Resources:

Association of Research Libraries. Principles for Licensing Electronic Resources. [http://www.arl.org/scomm/licensing/principles.html] (July 1997).

Brennan, Patricia, Karen Hersey, and Georgia Harper. *Licensing Electronic Resources: Strategic and Practical Considerations for Signing Electronic Information Delivery Agreements.* Washington, D.C.: Association of Research Libraries, 1997. [http://scomm/licensing/licbooklet.html].

Coalition for Networked Information. Draft Preliminary Findings of the Rights for Electronic Access to and Delivery of Information (READI) Project. [http://www.cni.org/projects/READI/draft-rpt/] (September 29, 1992).

_____. Negotiating Networked Information Contracts and Licenses. [http://www.cni.org/projects/READI/guide/] (November 1994).

Cornell University. Report of the Committee on Electronic Resources. [http://www.library.cornell.edu/DLWG/CERREPOR.htm] (August 1996).

Harper, Georgia. University of Texas' Software and Database Licensing Checklist. [http://www.utsystem.edu/OGC/IntellectualProperty/dbckfrm1.htm] (March 1997).

Kesse, Erich. Negotiation and Documentation of Distribution Rights for Imaged Resources.
[http://palimpsest.stanford.edu/bytopic/repro/kesse/negotiat.txt] (1994).

Noel, Wanda. *Checklist for Licensing Museum Images.* Quebec: Canadian Heritage Information Network, 1997.

Rush, Andrea. "Copyright Licensing within an Electronic Environment." *Copyright World* 53: 36–38 (1995).

Steiner, Christine. Electronic Media Agreement Issues: Negotiating Museum Licensed Products. Paper presented for the American Law Institute–American Bar Association (ALI-ABA) Legal Problems of Museum Administration. March 20–22, 1994.

Yale University. Licensing Digital Information: LibLicense Home Page.
[http://www.library.yale.edu/~llicense/liclinks.shtml] (1997).

Selected Works by Intellectual Property Genre:

Art Works and Museums:

Bearman, David, and Jennifer Trant. "Museums and Intellectual Property: Rethinking Rights Management for a Digital World." *Copyright and Fair Use: The Great Image Debate.* Ed. Robert Baron. *Visual Resources* 12, no. 3–4 (1997): 269–280.

McClung, Patricia, and Christie Stephenson, ed. *Images Online: Perspectives on the Museum Educational Site Licensing Project.* Los Angeles: Getty Information Institute, 1998.

Stephenson, Christie, and Patricia McClung, ed. *Delivering Digital Images: Cultural Heritage Resources for Education.* Los Angeles: Getty Information Institute, 1998.

Walsh, Peter. "Art Museums and *Copyright: A Hidden Dilemma."* *Copyright and Fair Use: The Great Image Debate.* Ed. Robert Baron. *Visual Resources* 12, no. 3–4 (1997): 361–372.

Dance:

"Aspects in Dance." CopyRong
[http://edie.cprost.sfu.ca/~jacsen7/dance.html] (January 26, 1998).

Fonts:

Fontworks. Fontworks Guide to Typeface Licensing.
[http://www.type.co.uk/fw/l/gtlt-1.html] (1997).

Typeright.
[http://www.typeright.org/} (March 1998).

VanderLands, Rudy. "Copping an Attitude." *Emigre* 38.
[http://www.emigre.com/Copping.html] (1996).

Images:

Day, Joel. Frequently Asked Questions about Stock Photography.
[http://www.s2f.com/stockphoto/index.html] (January 1, 1998).

Gidwani, Bahwar. Licensing Still Images: Some Basic Information for Multimedia Producers.
[http://www.indexstock.com/pages/whiteppr.htm] (1997).

*Sundt, Christine. Copyright Information: Copyright and Art Issues.
[http://oregon.uoregon.edu/~csundt/cweb.html] (December 1997).

*Visual Resources Association. Copyright—Intellectual Property Rights—Fair Use.
[http://www.oberlin.edu/~art/vra/copyright.html] (1997).

Literary Works:

Besen, Stanley M., and Sheila Nataraj Kirby. "III. Reproduction Rights Organizations." *Compensating Creators of Intellectual Property: Collectives That Collect.* # R-3751-MF, Santa Monica: RAND Corporation, 1989: 45–63.

Day, Colin. "The Economics of Electronic Publishing: Some Preliminary Thoughts." Gateways, Gatekeepers and Roles in the Information Omniverse. Proceedings from the Third Symposium.
[http://www.arl.org/symp3/day.html] (November 1993).

Fisher, Janet H. "The Role of Subsidiary Rights in Scholarly Communication." Gateways, Gatekeepers.
[http://www.arl.org/symp3/fisher.html] (November 1993).

Givler, Peter. "Copyright." Gateways, Gatekeepers.
[http://www.arl.org/symp3/givler.html] (November 1993).

Guthrie, Kevin. "JSTOR and the University of Michigan: An Evolving Collaboration." *Library Hi Tech* 16, no. 1 (1998): 9–14.

Hinds, Isabella. "Repertory Licensing in a University Environment." Gateways, Gatekeepers.
[http://www.arl.org/symp3/hinds.html] (November 1993).

Hunter, Karen. "Electronic Journal Publishing: Observations from the Inside." D-LIB Magazine (July/Aug. 1998).
[http://www.dlib.org/dlib/july98/07hunter.html]

International Federation of Reproduction Rights Organisations—Authors Coalition. Joint Statement on Electronic Use of Copyright Works. [http://www.copyright.com/ifrro/author.html] (May 1994).

National Writers Union. Authors in the New Information Age. A Working Paper on Electronic Publishing Issues.
[http://www.igc.apc.org/nwu/docs/aniabeg.htm] (April 28, 1996).

Music:

Besen, Stanley M., and Sheila Nataraj Kirby. "II. Performing Rights Organizations." *Compensating Creators of Intellectual Property:*

Collectives That Collect. # R-3751-MF, Santa Monica: RAND Corporation, 1989: 15–44.

Jacobson, Jeffrey E., and Bruce E. Colfin. Mechanical Royalties Today.
[http://www.he.net/~thefirm/articles/mechroyl.html] (August 1997).

Kohn, Al, and Bob Kohn. Kohn on Music Licensing.
[http://www.kohnmusic.com] (January 1998).

Massarsky, Barry M. "The Operating Dynamics Behind ASCAP, BMI, and SESAC, The U.S. Performing Rights Societies." *Proceedings: Technological Strategies for Protecting Intellectual Property in the Networked Multimedia Environment.* Interactive Multimedia Association.
[http://www.cni.org/docs/ima.ip-workshop/] (1994).

Software:

Geisman, Jim. A Useful Benchmark: The OURS Licensing Principles.
[http://www.globetrotter.com/ms_ours.htm] (1995).

Gurguras, Fred, and Sandy Jane Wong. Software Licensing Flexibility Complements Digital Age.
[http://www.globetrotter.com/art5.htm] (December 1994).

Lucash, Richard. Licensing Strategies in the Global Marketplace. Outline for a presentation before a Massachusetts Continuing Legal Education Seminar. [http://www.lgu.com/con51.htm] (1997).

*Denotes a general reference site on the World Wide Web that offers extensive links to related information.